The Complete Book of

Oil Painting

The Complete Book of

Oil Painting

The history, materials, techniques, theory and practice of oil painting

José M. Parramón

Phaidon Press Ltd 140 Kensington Church Street London W8 4BN

Copyright © 1983 José M. Parramón Vilasaló Copyright © Parramón Ediciones, S.A.

Cover design © copyright 1993 Phaidon Press Limited

First published in Great Britain 1993

ISBN 0714828289

A CIP catalogue record for this book is available from the British Library.

All rights reserved. No part of this publication may be reproduced, stored in a retrieval system or transmitted, in any form or by any means, electronic, mechanical, photocopying, recording or otherwise, without the prior permission of Phaidon Press Limited.

Printed in Spain

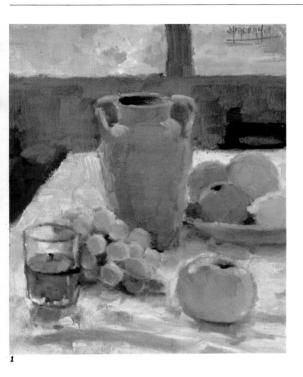

Contents

	Introduction	9
	History of oil painting	11
The painter's studio		47
	History of the painter's studio	48
	The painter's studio today	50
	Lighting the studio	52 54
	Contents and illumination of the studio	54
	Furniture for the artist	55
	Auxiliary furniture	56
Materials and tools		57
	The easel	58
	The palette	60
	Paintboxes	61
	Canvas, cardboard, surfaces	62
	International stretcher measurements	64
	How to construct a stretcher with canvas	66
	Brushes for oil painting	68
	Taking care of brushes	70
	Palette knife, painting knives, mahl stick	71
	Solvents and varnishes	72
	Oil colours	74
	Oil colours in tubes	78
	Liquid oil colours	79
	Oil colour chart	80
	Currently used oil colours	84
Theory and use of co	lours	85
	Colours of light	86
	Pigment colours	88
	Complementary colours	90
	Colour of the subject	92
	Painting with two colours and white	94
	Problems of construction and perspective	95
	Previous study in lead pencil	98
	Use and abuse of white	102
	Use and abuse of black	104
	The colours of the shadows	106
	Harmonizing colours	108
	Range of warm colours	110
	Range of cold colours	112
	Range of broken colours	114
	The colour of flesh	116
	Contrast of tone and colour	118
Technique and skill in	oil painting	121
	Learn to see and mix colours	122
	Mixing with three colours and white	123
	Composition of warm colours	124
	The Complete Rook of Oil Pais	ating 5

Composition of cold colours	127
Composition of broken colours	130
Painting with three colours and white	133
How to begin a picture	134
Direct painting	138
Painting in several sessions	140
Painting a picture with a knife	148
ou paint as you draw	145
Construction of form and volume	146
Light and shadow, evaluation of tone	147
Contrast and atmosphere	148
Parallel and oblique perspective	150
Division of spaces, mosaics and guides	152
Selecting the theme	154
Interpretation	155
Basic rule of the art of composition	156
A classic norm	157
Symmetry, asymmetry	158
Schemes and balance	159
A third dimension	160
il painting in practice	161
Painting a figure in oils	162
Painting an urban landscape in oils	169
Painting a seascape in oils	173
Painting a landscape in oils	178
Painting a still life in oils	182
Glossary	188

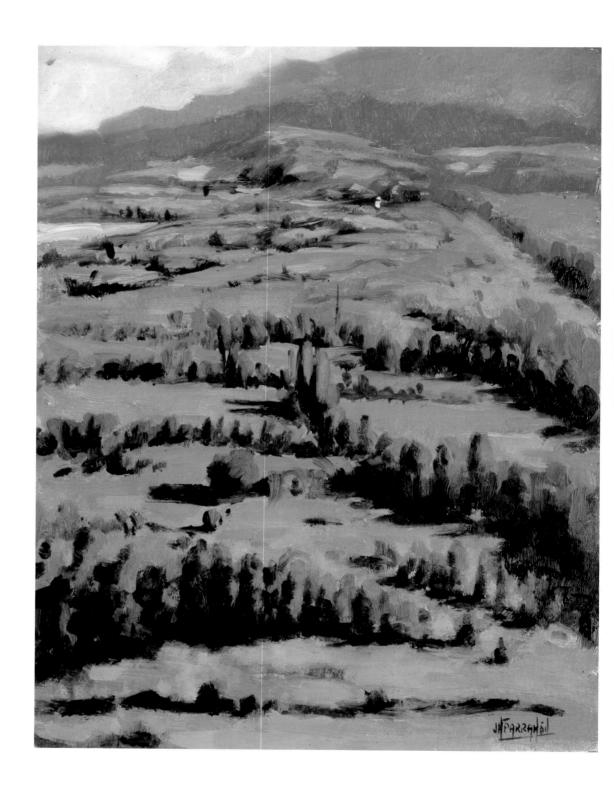

A picture by the author, José M. Parramón, published in his book *Landscape in Oils*, as an example of painting *alla prima* directly on the canvas without subsequent revision.

Introduction

Jean-Auguste-Dominique Ingres, the famous French painter of the last century, offered his pupils this rule, which is as simple as it is effective:

'You learn to draw by drawing.'

It's good advice. Nothing can teach as well as doing. I am wholly in favour of learning by doing, of dirtying your hands and doing it again and again, of 'drawing a hundred times the same stove in the studio', as Cézanne used to say to anyone who asked how to learn to draw. 'Why, then,' I have sometimes asked myself, 'write books that aim to teach drawing and painting?'

I have two answers to this question. When I was fourteen or fifteen, I met a Majorcan painter named Forteza, who painted fabulous seascapes, small coves in Ibiza and Minorca with a transparent blue sky and a sea full of light. One day I asked him, 'Señor Forteza, how do you manage to get such a luminous blue?' He answered with another question: 'Which blues do you use for painting?' I told him ultramarine and Prussian blue. 'And cobalt blue? It's essential for creating luminosity!' That day I learned that there was such a thing as cobalt blue.

A short time ago my friend Piera, the owner of a shop selling drawing and painting materials, talked to me about brushes made of synthetic bristles: 'They are wonderful, they're the brushes of the future, cheap and with excellent properties. Not many know about them yet, but when they try them...'

Señor Forteza and my friend Piera are like paragraphs from one of my books. They explain, they give information, they show the difference between ultramarine and cobalt blue, between a brush of natural hair and one made of synthetic materials. They indicate also that there are brushes of sable and of squirrel.

Books can explain a process, and they

can explain it while 'doing' it. In this book, for example, you will find a short history of oil painting from the technical point of view. It will help to improve your knowledge of oil-painting techniques in general. It is useful to know how Titian, Rubens, Rembrandt and Velázquez painted, and to know what each of them contributed towards perfecting and varying basic techniques. It is useful to know what a professional painter's studio is like, what his materials and tools are and how they are used - all the materials and tools, from the traditional mahl stick to liquid oil paint sold in tins.

It is helpful to be familiar with aspects such as cracking and the method 'fat over lean', to read and know that 'fat' means rich in oil and 'lean' is a paint greatly diluted with turpentine; to know about the harmonizing of colour and the ranges of colours, noting what is meant by, and what is the use of, tertiary or broken colours.

To do, learn by doing, learn to paint by painting, follow the exercises which are explained step by step with photographs illustrating the first, second and third stages of development. In spite of everything, the pages of this book and of all other books are not much use if you don't take your drawing block and draw, if you don't go out with easel and canvas and paint. I am with Ingres.

'You learn to paint by painting.'

Well, then, paint. I know of many who, thanks to one of these books, one day began and now paint. I also know of many who, because they did not persevere, did not do it every day, ended by giving it up. You must feel the need to paint, not to leave it for tomorrow, to do it every day, today!

There is a story about Corot which tells how one day a friend went to see him to show him a picture. 'It's good,' said Corot, 'but you'll have to redo and intensify this area.' 'You're right,' answered the friend, 'I'll do it tomorrow.' Corot was alarmed and looked at him seriously: 'What? Tomorrow? Not until tomorrow? And what if you die today?'

José M. Parramón

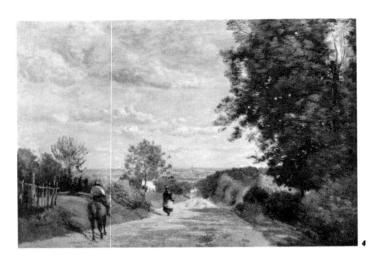

Corot, *Road to Sèvres*, Louvre, Paris.

Botticelli, *The Birth of Venus* (detail), Uffizi Gallery, Florence.

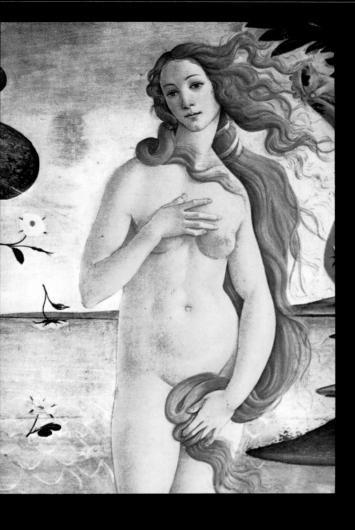

History of oil painting

'The least essay write painter will advance theory of the art better a million volumes.'

How they painted before the 15th century

Until Giotto there was no painting.

Before the close of the Middle Ages, from the 4th to the 13th centuries, the art of painting stood still. The human figure was represented schematically, out of proportion, unrealistically, and influenced by religion. In the West, from the 6th to the 8th centuries, people moved from the cities to the country; kings had to leave too, fleeing the barbarians. 'During this time,' writes the historian Arnold Hauser, 'nobody was capable of painting a human figure.'

In the 11th century Romanesque art appeared. The paintings were still impersonal, religious, but in the late Romanesque period there was already a freer and more individual form of expression. It was the prelude to Gothic art. Starting from the 12th century, life returned to the city, and craftsmanship and trade gave rise to a new bourgeoisie. The artist belonged to a guild. He no longer worked only inside churches and under the direction of architect monks. Now he carried out the orders in his own workshop. He was the owner of his time and of the materials he used. He could imagine and work on any theme.

In Italy, Giotto appeared (c.1267-1337), an artist who painted real figures, real things, real scenes.

People painted in tempera with egg yolk, on wooden boards. Up until the year 1410 artists painted in this medium. Tempera was used indiscriminately to paint miniatures, illustrations in manuscripts and missals, pictures, wooden boards, icons, decorative panels, and walls.

Some artists had found that by applying linseed oil to a picture painted in tempera, the colours revived and recovered their intensity and gloss. There were painters who experimented with mixing linseed oil with egg yolk. In the year 1200, the monk Theophile Rugierus wrote the treatise on painting, *Diversarum Artium Schedula*, in which he recommended the use of linseed oil and gum arabic.

It turned out that the oils and varnishes made from these formulas dried very slowly, making it necessary to expose a painting to the sun for days, which involved the very serious risk of the paint deteriorating, the colours turning black, and the whites turning yellow.

Fig. 7 In the 15th century, the artist painted on a desk like the one that can be seen in this illustration, especially for painting medium-size and small panels.

Fig. 6 Giotto, Meeting at the Golden Gate, Scrovegni Chapel, Padua. Giotto, founder of modern painting with Cimabue, painted with a realism, passion and imagination that had never been seen in the long night of the Middle Ages.

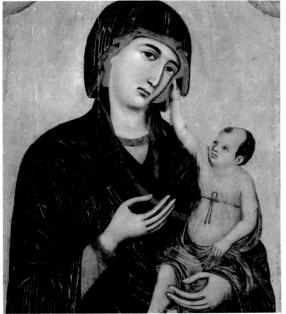

Fig. 8 (Above) Mediaeval art, Christ in Majesty (detail), Valltarga, Rossellón, France.

Fig. 9 Duccio, The Virgin and

Child Enthroned (detail), Cathedral Museum, Siena. Duccio di Buoninsegna was one of the greatest artists of the Siena School at the end of the 13th century.

What is tempera paint with egg yolk?

The kind of colours used by artists in the Middle Ages and the beginning of the Renaissance were tempera colours, which were made of pigments or colours in powder form, mixed together with a liquid made of:

One fresh egg yolk

An equal part of distilled water

The technique of tempera painting is similar to that used for gouache. With tempera you can paint to give an opaque, all-covering layer, or you can paint with transparent layers or glazes, depending on the extent to which you dilute the colours with the liquid.

Any type of paint, just like tempera, is made of colouring agents and a *medium* or *emulsion* that makes the pigments stick together. Thus, a stick of wax colours, a tube of watercolour paint, and a tube of oil paint – all three cobalt blue in hue – have the same colouring agent, *cobaltous oxide and alumina*, but different binding agents: wax in the first case, water and gum in the watercolour, and drying oils and solvents in the oil paint. From these we can deduce that: *The medium decides the kind of paint.* The medium also decides the painting technique.

Fig. 10 Distilled water and a fresh egg yolk are the ingredients needed to mix together the coloured pigments in tempera paint.

11

Jan van Eyck's discovery

Legend has it that in the year 1410, in the city of Bruges, a young painter named Jan van Eyck put a picture painted in tempera and treated with oils, as recommended by the monk Theophile, to dry in the sun. Two days later, when he went to see how the drying was proceeding, he found to his disgust that the

paint had cracked.

According to the story, from then on, Jan van Eyck did not rest until he had found an oil that would dry in the shade. After many months of trying oils and resins of all kinds, he found that by mixing a small part of 'white Bruges varnish' with linseed oil he obtained a mixture which allowed the picture to dry in the shade with no trouble. (Some researchers have concluded that the 'white Bruges varnish' was spirit of turpentine, the same thing that we use today for thinning oil colours.)

Jan van Eyck then began to paint with white Bruges varnish and linseed oil, using them to mix the same pigments he had used to paint in tempera, and found that the colours responded better and that by increasing or decreasing the amount of varnish, the colours would dry more quickly or more slowly. He found that he could apply thin layers (without linseed oil) or heavy ones (with more oil than varnish) and that while the colours were drying he could rectify or repaint without the previous colours being affected. The colours looked freshly painted and the picture would dry in the shade with no problems or risks. The 'king' of painting had been born. Jan van Eyck had discovered the ideal painting medium.

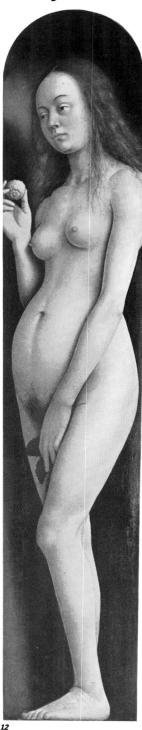

Fig. 13 In the early 15th century, in Flanders, feminine fashion conditioned, to a certain extent, the shape of the female body, which presented narrow shoulders and full abdomen, as can be seen in the figure in the adjacent painting (fig. 14), here reproduced schematically.

The Flemish School

Jan van Eyck, who was then better known as 'Jan of Bruges', had an older brother, Hubert van Eyck, who was also a painter. The van Eyck brothers worked together in the same workshop until September 1426, when it is thought Hubert died. Jan finished the monumental Ghent altarpiece in 1432, and from that date painted the pictures which have made the surname van Eyck famous. Jan van Eyck was an exceptional man and artist. When he was thirty years old he headed a movement rebelling against the prejudices and conventions of Gothic painting, defending and propagating the idea that 'the men and women, the trees and the fields should be painted as they really are'. Putting this philosophy into practice, Jan van Eyck convinced several artists of his time, among whom were the Master of Flémalle, the famous Rogier van der Weyden, and the young Petrus Christus, all Flemish, who tried to paint with the realism and naturalness preached by Jan of Bruges.

This group created the famous Flemish School, which was then to be maintained and consolidated in the following years by Bouts, van der Goes, Memling, Bosch, Bruegel the elder, Rubens, van

Dyck, Jordaens and Rembrandt.

Fig. 14 Jan van Eyck, The Arnolfini Marriage, National Gallery, London. Here we have one of the best-known pictures of the Flemish School of the 15th century. Observe the extraordinary quality of the details which today could be called, with reason, more than realistic. Note that this attention to detail was achieved with successive layers of colour or glazes.

Fig. 12 Jan van Eyck, Eve from the Ghent Altarpiece, St Bavon, Ghent. The naked figure of Eve, with the realism and human quality Van Eyck imparted to his work, attracted a lot of attention and became one of the symbols of the Flemish School.

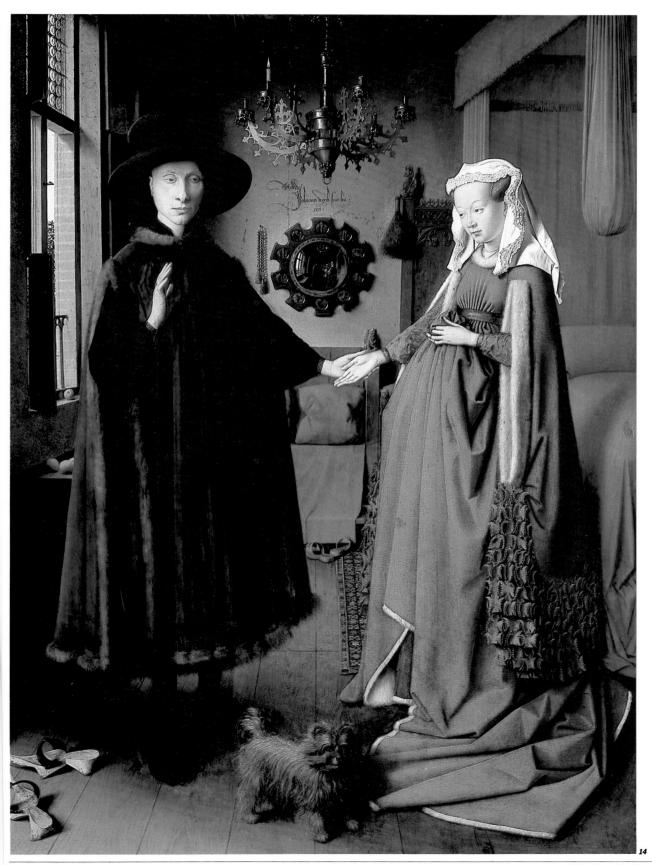

How the van Eycks painted in oils

In 1437 in Florence, a painter who was nearly eighty years old was imprisoned for debt. His name was Cennino Cennini, and thanks to the period he spent in prison, his name has become part of history as someone who understood and was a master of painting. While he was in prison he wrote *Il Libro dell'Arte*, which explains step by step all the processes and techniques, all the materials and styles, that existed in painting in the 14th and 15th centuries. Therefore, it seems that thanks to Cennino Cennini we can understand and reconstruct the way that Jan van Eyck and the artists of the Flemish school painted.

At the time there were already some artists who had experimented with painting on canvas, but the great majority painted on thick wooden panels prepared with glue. Cennini said: 'You should choose a panel of lime or willow without any defects. You should take glue made of parchment trimmings and boil it until three parts are reduced to one. You should test this glue with the palm of your hand and when you feel one palm sticking to the other, you will know that then the glue is satisfactory.' And Cennini continued with his literary instruction, which can be summarized in this way: onto the board apply six layers of glue and several strips of old linen cloth. Put the board to dry and later apply a layer of Volterra plaster and glue. Dry again and add other layers of gesso sottile. At last clean with coal dust and pumice stone until the finish is white, hard, and smooth as ivory.

On this board, the laborious preparation of which had taken several days (the glue and the plaster was from two to five millimetres thick), Jan van Eyck and the artists of his time put into practice the following oil-painting technique.

The construction of the picture was begun by first drawing with charcoal. Says Cennini: 'You should take willow charcoal and you should draw carefully. And you should go over the drawing with a fine pointed brush, soaked in the colour which in Florence is called

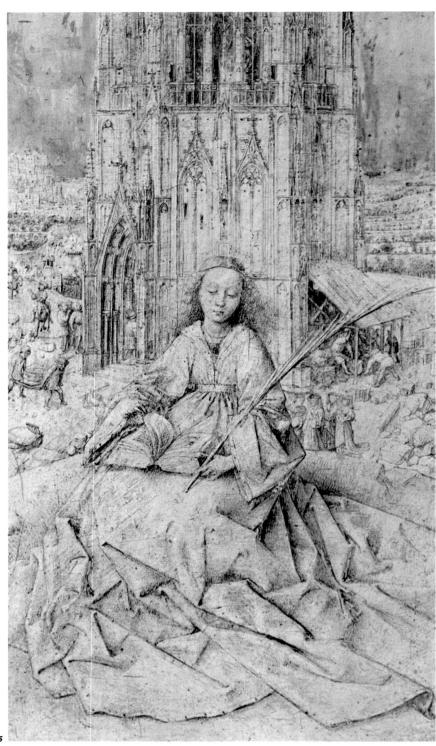

15

Fig. 15 Jan van Eyck, Saint Barbara, Royal Museum of Fine Arts, Antwerp. This is the final finish of a panel before Leginning painting it in colours, as part of a laborious process of fine glazes. The picture reproduced above is about half the size of the original picture. Thus, it is obvious that in the original panels, the artists of that time had to work in miniature.

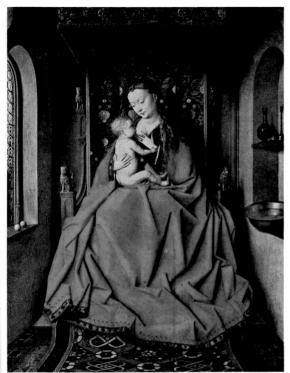

Fig. 16 Jan van Evck. Virgin Enthroned with Child. Städelsches Kunstinstitut, Frankfurt.

verdaccio.' Verdaccio was a mixture of black, white, and ochre.

Once this drawing was finished the picture looked like the reproduction here, Saint Barbara by van Eyck (fig. 15), which the artist left in this condition.

On top of this drawing they applied a fine layer of the same verdaccio colour, carefully working on the shadows, lights and reflections, until they had a perfect monochrome picture. In some cases, where the artist foresaw the later application of a bright colour (for example, space which in the end had to be bright red), he would leave this area with just the initial drawing, but without the later wash of verdaccio.

They began by painting the clothing, continued with the architectural forms, the areas where there were landscapes, and so forth, and left the faces and flesh areas until the end. This order followed the idea of having the whole canvas covered with colour when beginning to paint the faces. In this way they managed to counteract the effect of simultaneous contrasts, which we are going to talk about in the following pages.

Fig. 17 On top of the initial shadowing carried out with verdaccio, the artist applied one or more layers of the local colour of the clothing.

Fig. 18 With a relatively dark red, he applied the second tone, working on the shadowed parts.

Fig. 19 Finally he applied a lighter red tone, mixed with white, to highlight the lights and the shining parts.

They painted with three tones for each colour area, that is to say, for a red article of clothing, they prepared a red tone the same colour as the clothing (local colour), a second dark red tone for the shadows of the clothing (dark tonal colour), and a light red tone for the illuminated parts (light tonal colour). Van Eyck and company painted with these colours in a way that is similar to how we now paint with watercolours. They used lavers of colour glazes diluted with varying amounts of oil and solvent with the white of the background acting like the white of the paper in watercolour

They painted by areas. The artist painted, for

example, the

Virgin's mantle: supposing this were red, he began by painting a layer with a red tone of the local colour. This layer covered the white of the background, but allowed the shadowing of the original drawing to show through. Darkening this red provided a slight sense of volume (think how watercolour works). On top of this first red laver, van Evck painted with the second tone, the dark tonal red colour, working on the shadows of the clothing, fusing and breaking down so that he could model the volumes created by the folds and wrinkles in the clothing. Lastly, with the light tonal red he highlighted the light and shining parts of the clothing.

Once this first general scheme of colour was finished, they painted the faces and flesh of the figures. Remember, these still presented the patina of the original layer of verdaccio. On top of this patina, they painted with the three corresponding tones of flesh colour - in transparent colours, obviously - so that the flesh colours would mix into the verdaccio colour, producing a drab green colour which then needed pink and reddish tones to supply the shades of flesh colour.

The work was finished with care and patience. Final reliefs and emphasis were produced with layers of light colours, or occasionally white, dark brown, and black. The picture was left to dry for several days and was varnished.

The technique of glazes

The technique of glazes

A glaze is a transparent layer of oil paint, applied with a brush on an area of the painting, in order to add a colour or to modify a colour that has already been applied. The glaze is made up of oil paint diluted with linseed oil and turpentine. The resulting mixture must be liquid, not thick. The technique of applying a glaze is similar to water-colour technique. Basically it consists of applying successive layers of colour until you achieve the desired tone.

There is, however, an important difference. While a good watercolour painter tries to obtain the desired colour with only a single layer, the oil painter, through glazing, will use several layers of colour to obtain the desired transparency, luminosity, and richness that is

typical of layers painted in oil.

In order to achieve a luminous glaze the background must be light. A brilliant red dress, painted in glazes, must be painted on a white or light background. The glaze may be applied when wet, in which case the colour of the most recent layer mixes with that of the previous one, losing effectiveness. However, if it is painted on top of dry or semi-semi-dry paint, all the qualities and effects of glazing are strengthened. In any case, a lean glaze should never be painted on top of a fat glaze, that is to say, a glaze with a lot of turpentine and not much oil (lean) should never go on top of a layer with a lot of oil and not much turpentine (fat), as the upper layer may crack. (We will talk about fat over lean later on.)

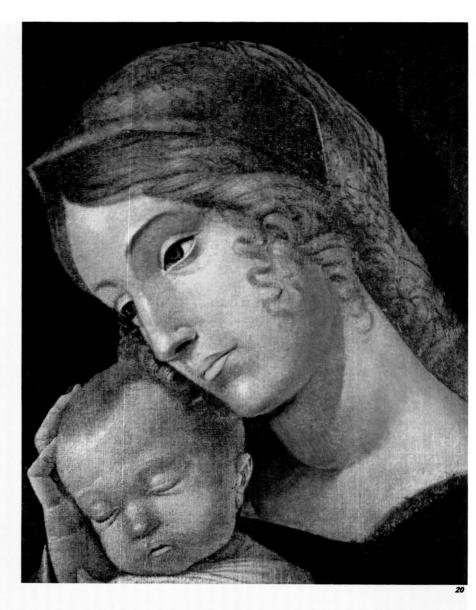

Figs. 20 and 21 Mantegna, Virgin and Child, Staatliche Museum, Berlin. On the right, a reproduction of Mantegna's unfinished picture (fig. 21), in a state somewhat more advanced than the Saint Barbara on page 16. It must be noted that Mantegna painted here on canvas, and we can see

its texture in the reproduction. Note the extraordinary quality of the drawing wash in verdaccio in fig. 20. I myself have begun the process of layers on the Virgin's face and neck, proving that it was a difficult, very skilled job, that was extraordinarily slow. This skill – and I confess that I don't

possess it, as it has to be acquired with practice – allowed fantastic results to be obtained with the use of lacquer or enamel, which, in its time, must have been much admired.

18 The Complete Book of Oil Painting

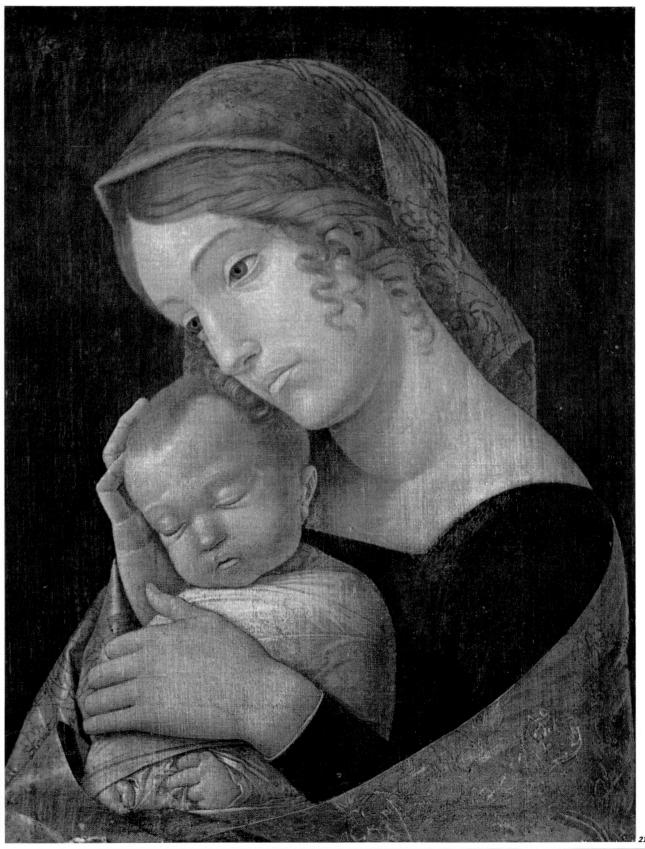

How Leonardo da Vinci painted

Ian van Evck died in 1441.

Years later, a painter of the Flemish School, Justus de Gante, who was a teacher in Antwerp and in Ghent, left for Rome. Soon the Flemish techniques of oil painting were put into practice by artists in Rome and Florence, among whom was Leonardo da Vinci.

As you know, Leonardo da Vinci, as well as being a painter, was a sculptor, engineer, doctor, inventor ... so it is not strange that all his life he was testing and experimenting with formulas for preparing surfaces, not to mention oils, resins and varnishes. Some of these experiments turned out to be expensive. For example, in the case of *The Last Supper*, which he painted in oil on a plaster wall, the paint began to deteriorate before it had dried. But Leonardo da Vinci was one of the greatest and most versatile men of the Renaissance, considered, together with Michelangelo and Raphael, as one of the three creators of the High Renaissance of the 16th century. His way of painting was completely personal. He dominated the sfumato and chiaroscuro techniques like no other artist, achieving volume in shadow and penumbra, painting the most gentle transitions in the tones from light to shadow.

Of course, Leonardo da Vinci knew van Eyck's oil painting techniques, and fortunately he left us two of his pictures that illustrate his knowledge.

We can see them reproduced on the following page. Above, left (fig. 25), the picture Saint Terome shows a man and lion in front of a background of rocks and a building with a kind of window formed by the rock formation. It is an unfinished picture, for which Leonardo followed the process of the van Eycks. First, he drew the subject and all elements of the picture, painting with dark verdaccio. Second, he painted the figure of Saint Jerome in the same verdaccio colour, diluted with oil and turpentine. See how in the illustration this figure seems to have been painted in watercolours. Note that Leonardo didn't paint anything else in this monochrome watercolour technique. The lion, for example, is in the first stage of linear drawing. Third, using a very dark brown, he painted the rocky background and the earth, using several glazes. Lastly, he applied a few layers of colour to the left, upper background, painting the sky, outlining some rocks, and marking out what would probably be a sea horizon. And that was where he decided to stop.

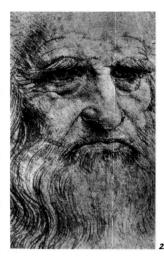

Fig. 22 Leonardo da Vinci, Self-Portrait, in red charcoal pencil.

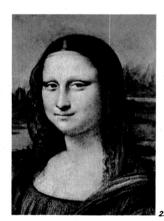

Fig. 23 Leonardo da Vinci, Mona Lisa (detail), Louvre, Paris.

Fig. 24 Leonardo da Vinci, Leda and the Swan (detail), Borghese Gallery, Rome.

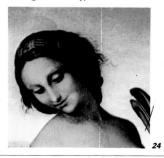

Now look at the picture The Virgin and Child with Saint Anne (fig. 26), which is in a more advanced phase that Saint Jerome. Observe how in this picture Leonardo used the following process: on a panel prepared with gesso, so it was completely smooth and white, he drew the subject, first with charcoal and then with a brush and light brown oil paint similar to verdaccio. Next, he painted the four figures with this same colour, diluted with turpentine and oil, applying several glazes, until he achieved a kind of monochrome watercolour, thus reaching the same stage as the figure in Saint Jerome. But it is understandable that he should dispense with the order followed by the Flemish painters and paint according to his own inspiration. Thus, Leonardo began to finish the four figures, giving us the opportunity to see what the old-time painters really did after the stage at which van Eyck left Saint Barbara. The answer is here in the picture by Leonardo, and can be seen even more clearly in the enlarged reproduction of the Virgin's head (fig. 27). We can see the effects of shadow accentuated by greenish grey colour (was this then really the verdaccio colour mentioned by Cennini?), and the effects of light painted with white to create a whole, tonal composition of extraordinary quality. On top of this Leonardo - and, like him, the artists of the time - began a series of glazes which would complete the colouring, volume and contrasts of the picture.

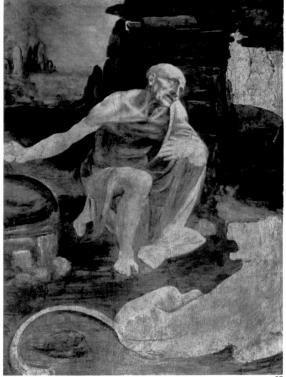

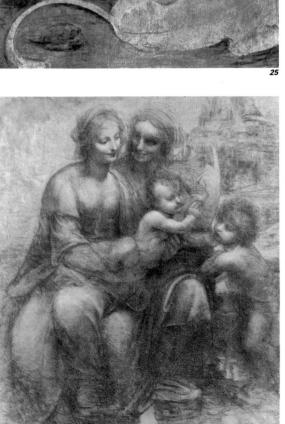

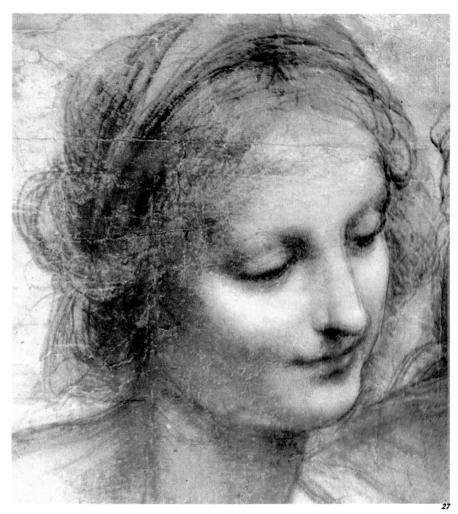

Figs. 26 and 27 Leonardo da Vinci, The Virgin and Child with Saint Anne, National Gallery, London. The original measurements of this work, which I saw exhibited in the National Gallery, London, are 159 x 101 cm, that is to say, more than a metre and a half high by one metre wide. Seeing it hanging in the museum, you

can understand what Leonardo da Vinci did, how he constructed, how he began the colouring, how he studied the values and the light and shadow effects. It represents a masterly lesson from the greatest artist of the Renaissance. If you get the chance, I recommend you see this picture.

Fig. 25 (Top) Leonardo da Vinci, Saint Jerome, Vatican Pinacoteca.

How Michelangelo painted

Almost everyone knows of Giorgio Vasari, born in Arezzo in 1511, painter, sculptor, and architect. But rather than for his works of art, Vasari is known for a book he published in 1550 when he was thirty-nine, entitled: *Le Vite de' più eccellenti Architetti, Pittori et Scultori Italiani*, an excellent and well documented account of the life and works of artists from ancient Rome up to Michelangelo.

Vasari was such a passionate admirer of Michelangelo Buonarroti that he finished his book with a biography of Michelangelo – the only story of the life of an artist who was still living – and called him 'the greatest of the sculptors, painters, and architects who have ever lived'

Undoubtedly, Michelangelo was an exceptional artist. We need only remember the Sistine Chapel in painting, the Dome of St Peter's in architecture, and the *Pietà* or *Moses* in sculpture, to agree that Michelangelo was truly a genius.

Michelangelo Buonarroti's life as written by Vasari tells us that the master gave great importance to techniques and processes in painting. For example, before beginning the frescoes of the Sistine Chapel, he recognized that he did not know about the technique of fresco painting and asked some fresco painters for help. From them he learned the job – although he later sent them packing, saying they were no use at all. (Buonarroti had a very bad temper.)

Concerning his oil paintings, all of which are on panels, Michelangelo began several and finished very few. One of the latter, which in itself qualifies him as an extraordinary painter, is *The Holy Family* (fig. 32). We can deduce its technique of execution from two other pictures which were not finished, *Madonna and Child with the Infant John the Baptist and Angels* (fig. 33) and *The Entombment* (fig. 34). The unfinished condition of these two paintings allows us to reconstruct, in effect, the techniques developed by Michelangelo in the painting of pictures in oil.

In the first place, our attention is drawn to the seeming disorder or lack of method: the two angels on the right of fig. 33 are only half painted, the Virgin's face is almost finished, but the two angels on the left are unfinished.

In *The Entombment* the surprising thing is that the clothing is all in different stages of execution, with one of the figures (kneeling on the right) not even started. The same can be said of the flesh. The face and body of Jesus Christ show the monochrome wash of the

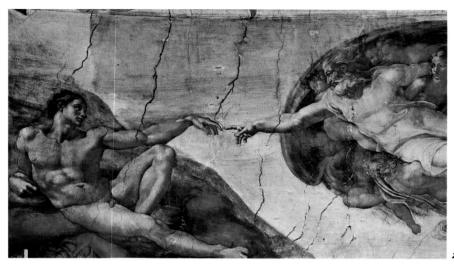

Fig. 28 Michelangelo, The Creation of Man, Sistine Chapel, The Vatican, Rome.

Fig. 29 Michelangelo, The Dome of St Peter's, The Vatican, Rome.

Fig. 30 Michelangelo, Pietà, Nicodemus self-portrait, Florence Cathedral.

Fig. 31 Michelangelo, Moses, San Pietro in Vincoli, Rome.

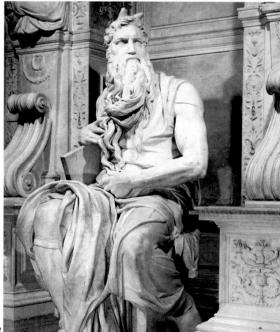

primitive construction. Saint John (dressed in red) already has the first glazes of colour, while Joseph of Arimathea's head, which appears behind Jesus, is so much more advanced in colour that it seems to be almost finished. It seems natural that Michelangelo should paint in this way, but it demonstrates that he did not faithfully follow the rules of the Flemish painters who, in an orderly way, would first paint the clothing, then the buildings, and lastly the flesh.

A further reference to the Flemish techniques can be seen in the picture Madonna and Child with the Infant John the Baptist and Angels. Michelangelo painted the faces, arms and legs of the two angels on the left in verdaccio leaving the clothing in white, which corresponds

to the technique of the van Eycks.

Perhaps the most interesting point of this picture is in the Virgin's clothes which are brown, almost black in the shadows, and white in the illuminated parts. The white was achieved by scraping with a scalpel. The Virgin's clothing, probably ultramarine blue, has been applied in glazes, thereby providing different tones. It is the same colour as that of the Virgin's mantle in The Holy Family (fig. 32). Now look at the two figures in The Entombment whose clothing Michelangelo painted with the same dark brown colour as the Madonna and Child. In both pictures, Michelangelo's idea was the same. When he wanted to paint with a luminous colour, he painted the clothing this almost black-brown and then 'opened' the white parts by scraping. Later he applied an intense and fairly uniform glaze whose transparency gave him the effect of volume in all the folds and creases of the clothing.

Fig. 32 Michelangelo. The Holy Family, Uffizi Gallery, Florence.

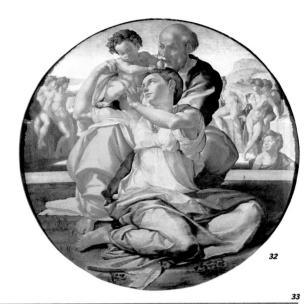

Fig. 33 Michelangelo, Madonna and Child with the Infant John the Baptist and Angels, National Gallery. London.

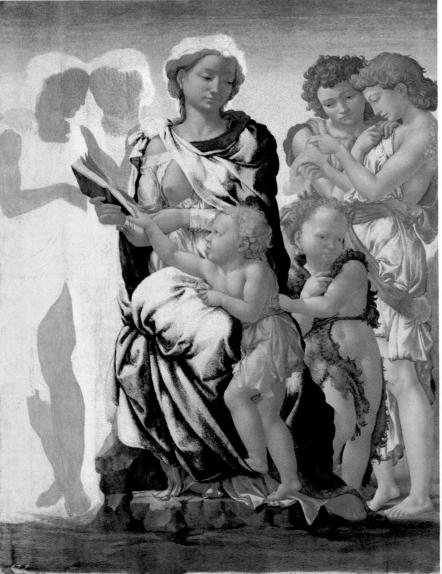

Michelangelo and Raphael

Here we pause to comment on the assumption that Raphael painted with the same or very similar techniques to those of Michelangelo. In fact, when Michelangelo painted the picture The Holy Family, Raphael was barely twenty-one. At this age, Raphael painted the famous picture The Marriage of the Virgin (fig. 36). Five years later he was called by Pope Julius II and was soon the first master to be employed in the Vatican, with the single exception of Michelangelo who was then working in the Sistine Chapel. Raphael then began one of his most famous works, the Stanze. He was twenty-six and was considered a front-rank painter, a genius comparable only to Leonardo da Vinci and Michelangelo.

When he was twenty, Raphael left Urbino where he was born, and moved to Florence. We know that there he worked very hard to learn all the processes and techniques of the Florentines. Five years later he was in Rome, associated with the best artists of the time, including Michelangelo. All these facts help us to confirm that Raphael – and the other artists of the time – did indeed paint with the same techniques as the master Michelangelo, who had, himself, followed in the steps of the Flemish artists.

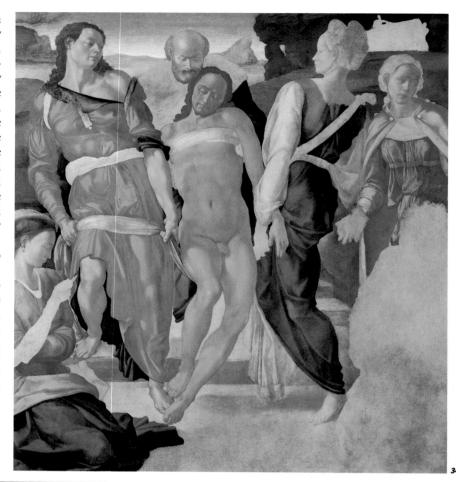

Artists who were contemporaries of Leonardo da Vinci, Michelangelo and Raphael

In 1510 Leonardo da Vinci was fifty-eight years old, Michelangelo thirty-five, and Raphael twenty-seven. As shown in this graph, in this same year of 1510 Bellini, Perugino, Dürer, Cranach, Jacopo Palma, and Titian (twenty-three years old) were living and painting with great success. Raphael died young, at thirty-seven, in 1520, one year before Leonardo died, at sixty-seven. But Michelangelo, who was eighty-nine when he died, shared his fame with artists such as Titian, Bronzino, Tintoretto, Veronese, Breugel and even El Greco, who was twenty-three when Michelangelo died.

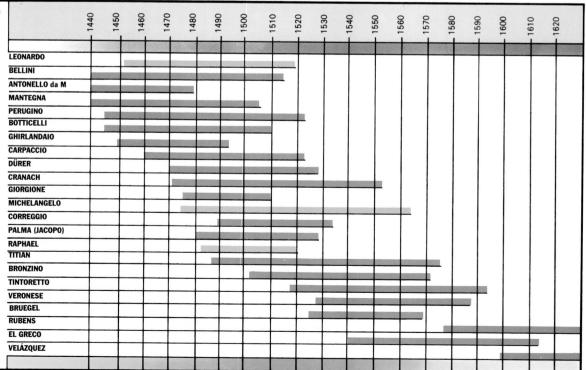

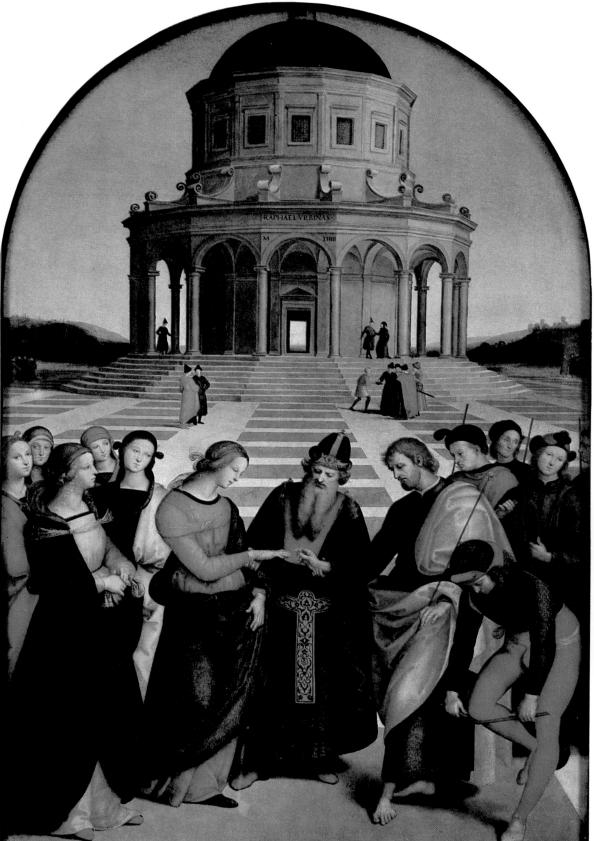

Fig. 34 Michelangelo, The Entombment, National Gallery, London.

Fig. 36 Raphael, The Marriage of the Virgin, Brera, Milan.

Fig. 37 Raphael, Virgin of the Grand Duke, Pitti Palace, Florence.

36

Titian, founder of modern painting

A few years after Jan van Eyck died, his successor as head of the Flemish School, Petrus Christus, was visited by Antonello da Messina, a young Italian painter who is said to have spent some time in Bruges, learning and practising the new technique of oil painting. Antonello da Messina went back to Venice and in a short time the Venetians had learned the techniques of the van Eycks. Among them was Giovanni Bellini, who, as time passed, became the most important master of his generation. Among others, Giorgione, Jacopo Palma, and Titian were his students. He learned the secrets of the van Eycks and adapted them to his personal way of seeing and doing things, creating a new way to paint oils, considered to be the basis of modern painting.

The year 1550 passed. The Renaissance was reaching its end to give way to Mannerism, an art of recherché themes, complicated composition, stylized forms (El Greco). For several vears it had been more and more common for artists to receive commissions for large pictures to decorate the walls and salons of the palaces of the time. In 1566, the Benedictines of Venice commissioned Paolo Caliari, known as 'Veronese', from Verona, the town of his birth, to paint the picture The Marriage at Cana on canvas. Its dimensions are 5.7 x 13 m. For this large a picture, a wooden panel was not profitable, and hardly practicable. Canvas for painting was acquiring more and more adherents. The desk or sloping table, on which small and large panels were painted, was changed for the workshop easel. Titian had been painting on canvas for some years already.

At this point, in this short history of oil painting, we must distinguish between 'before Titian' and 'after Titian', for it was Titian who revolutionized painting.

'Before Titian', artists painted in vivid, crude, exciting colours, as if, instead of painting pictures, they were colouring stained-glass windows. 'After Titian', the colours were less vivid. They contained grey, blue, or brown and were applied to the canvas to form a quietly harmonious whole.

'Before Titian', painters always worked with brushes with sharpened points and took pleasure in capturing details, endless minute details of jewels, curls, pearls, and eyelashes, as if the merit of the work lay just in each of these. 'After Titian', they painted with bristle brushes and ignored the details, devoting their attentions instead to the theme as a whole.

Fig. 38 Antonello da Messina, Self-Portrait, National Gallery, London

Fig. 39 Titian, Self-Portrait, Prado, Madrid.

Fig. 40 Veronese, The Marriage at Cana, Louvre, Paris.

Fig. 41 Titian, Danaë Receiving the Rain of Gold, Prado, Madrid Titian was the first who saw and painted with the 'optical grey' with which transitions from light to shadow acquire incomparable transparency and modelling.

Titian was the first who painted with a range of 'broken' colours, the mixture of complementary colours and white in unequal proportions. (In later pages we will talk about this special range.)

Titian painted with brushes and, especially in the last phases of the picture, with his fingers, something which other painters had already done, but not with Titian's perseverance.

Titian painted on coarse hemp canvas. Instead of drawing with attention to details like the

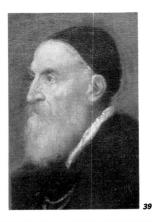

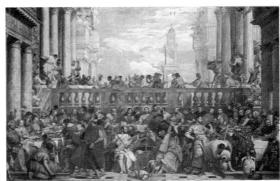

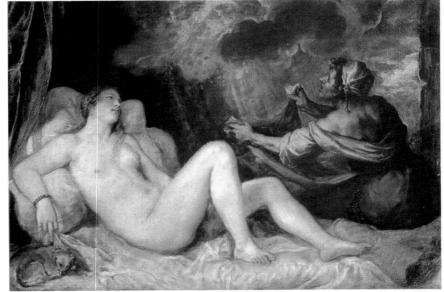

Flemish School (remember Saint Barbara, fig. 15), Titian sketched the construction with no more than a few lines and immediately began to paint. This procedure gave rise to comments of all kinds from the artists of the time, such as Michelangelo's ironical phrase, quoted by Vasari: 'It's a pity that in Venice they don't start off by learning to draw pro-perly.' For his part, Titian had said: 'I don't want to construct too much. It disturbs my fantasy and doesn't let me paint.'

Fig. 44 Titian, Christ Crowned with Thorns, Pinakothek, Munich. An example of the use of 'broken' or 'dirty' colours, as Titian called them.

'Dirty your colours'

Titian was the first painter to discover the value of dull, broken colours, which he applied to his pictures, rejecting 'the beautiful colouring' of the Flemish School. But the phrase Titian gave his followers, 'dirty your colours', should not be interpreted literally, but rather with the idea of eliminating stridencies and achieving harmonies of more realistic colours, taking into account the fact that in real life colours are not pure, they are not clean like those in a stained-glass window. In these colour mixtures you can see an example of what we understand by 'dirty colours'.

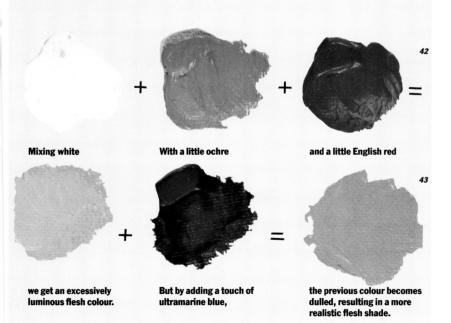

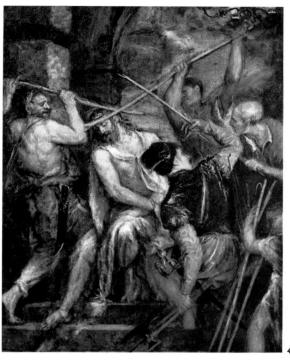

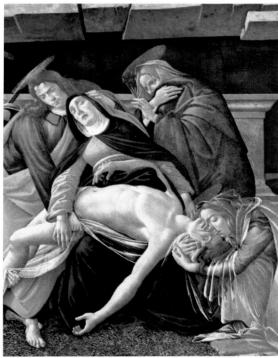

Fig. 45 Botticelli, Pietà, Pinakothek, Munich. Like all the artists who followed the style of the Flemish School, Botticelli painted with clear, clean colours in a manner that was more decorative and less real than the way in which Titian's followers painted.

A revolutionary technique

Once he was ready to paint, seeing how Titian began the picture must have been a fascinating spectacle. Jacopo Palma, Titian's young pupil, describes it like this: 'He spread over the canvas a layer of a certain colour which served as a basis for what he wanted to express. I myself have seen this intense background, all the same, painted only with *terra rosse* ['red earth', probably Venetian red]. Afterwards, with the same brush, loaded first with red, then black, then yellow paint, he painted the dark, medium and light parts; in four brushstrokes he had achieved extraordinarily welldone figures.'

Fantastic! Do you realize, Titian painted with half-impasto, using dense covering paint with the vision and spontaneity of an artist of today? Titian called this initial sketch, painted in half-impasto with a hog's-hair brush, 'the

base of the painting'.

After this first stage, it was Titian's habit to place the picture face to the wall and leave it for weeks, even months, 'until one day he took it up again', explains Jacopo Palma, 'and looked at it critically, as if it were a mortal enemy ... if he found something that he didn't like he set to work like a surgeon. Thus, by means of repeated revisions, he perfected his pictures, and while one was drying he began to work on another.'

In the following phases, Titian worked on the modelling by means of a series of glazes ('Thirty or forty!' Titian used to say when people asked him if they were many or a few) with which he returned to the classical method, but with certain variations. On top of the former 'base of the painting', the artist applied glazes of bright colours in the illuminated parts, and the same glazes made more liquid in the medium lights. The darker parts were not treated with glazes, they were left as they were. The bright colours of the glazes were, in each case, similar to the underlying colour. Thus, on red clothing the glaze was a pink colour, on flesh it was yellow ochre, and so forth.

The effect of these bright glazes on a dark background is comparable to a drawing done on a black slate with chalk rubbed in with the fingers, so that the dark colour of the slate is visible through the bright colour of the chalk. This promotes a series of grey gradations that later, when local colours are applied, will show through, forming the classical 'optical greys'. On this monochrome painting, some parts of which were already definitive, Titian applied a

series of glazes, all at once painting, highlight-

ing, and at the same time accentuating.

The picture was finished with sessions of direct painting, when half-impasto and full impasto were painted on top of the lights and bright parts and rubbed with the brush, a process called 'frottage'.

Titian, master of the frottage technique

The word 'frottage' derives from the French verb *frotter* (to rub). This technique consists of lightly loading the brush with thick paint which is rubbed on top of an area already painted and dry. Frottage, or rubbing, is generally applied by painting bright colours over dark ones, to complete areas from light to dark, shining parts, highlights, or middle tones.

In fig. 46 we can see the three phases of frottage. The area to be treated is a dark green spherical form on a dark crimson background. In the second box, yellow paint was scrubbed on top of the already dry green colour. By pressing from the outline into the inner part of the sphere, the change in value is completed. On the following page (fig. 48), in the *Portrait of Pietro Aretino*, the technique of frottage was applied by Titian in a masterly way, first concentrating on the face, and then with yellow scrubbings, the reddish clothes of the model.

Fig. 47 Background of priming colour used by Titian. On top of this he began what he called 'the base of the painting'.

Fig. 48 Titian, Portrait of Pietro Aretino, Pitti Palace, Florence.

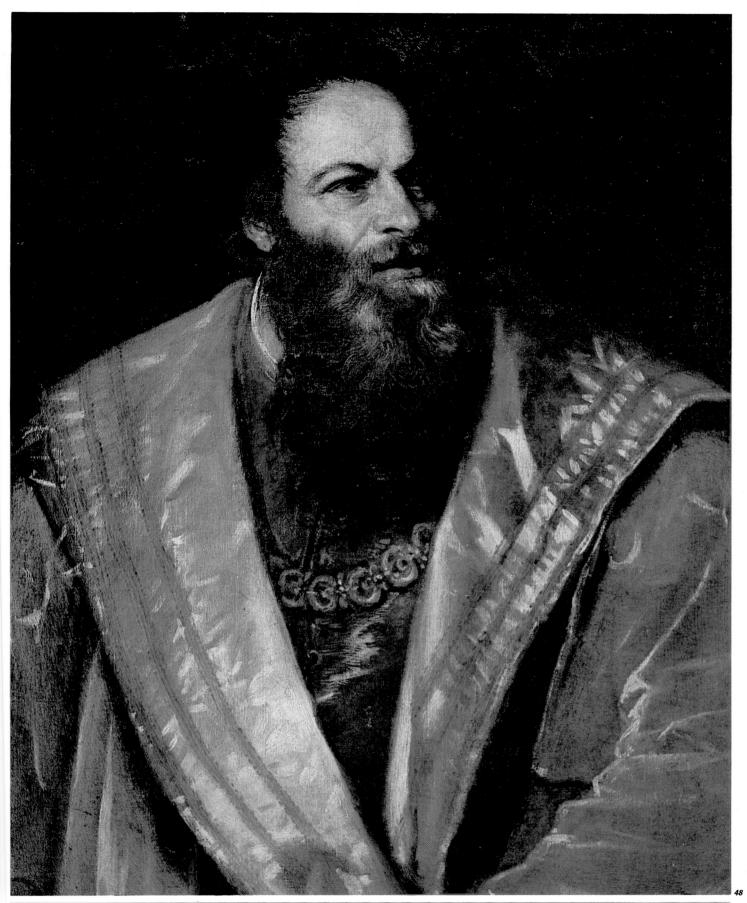

Rubens: half-impasto and direct painting

In 1650, two hundred years after the van Evcks, Rubens, as if he wanted to go back to sources, painted with a technique that still had something to do with the Flemish painters. By the year 1650 the habit of abandoning the wooden panel and painting on a background previously primed in brown or Venetian red was already common, and was followed by all the Italian artists. However, except in large sizes, Rubens went on painting on panels, assuring others that 'wood is the best support for small pictures'. Rubens did not accept the idea of a background of Venetian red; before beginning the picture, he applied a layer of silvered grey to his panels and canvases. But his main contribution to the technique of oil painting was painting not only with glazes, but also with half-impastos, that is, with covering

Rubens mixed his colours directly on the canvas itself; without waiting for drying periods, he began and finished a picture in a continuous session as do many painters today. This discovery of formulas and processes for painting faster, together with an extraordinary skill for drawing and painting, made him famous, painting pictures and portraits for all the nobles and kings of Europe. During his life he painted more than two thousand five hundred pictures, some of them of enormous dimensions, like the series of twenty-one paintings on the *Histories of Marie de Médicis*, each measuring 4 × 3 m.

Fig. 49 Rubens, Rubens and Isabella Brandt (detail), Pinakothek, Munich. Painted a few months after Rubens married Isabella, when he was thirty-two.

Figs. 50 and 52 Rubens, Hélène Fourment, Historical Museum of Vienna. (Right-hand page shows detail.)

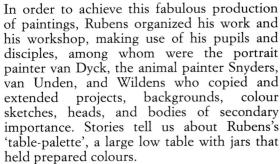

The workshop was large, with two floors. The second floor was in the form of a gallery encircling the room. On easels, or on wooden scaffolding for the large pictures, they all worked together on different pictures with Rubens, himself, there to initiate, rectify and construct.

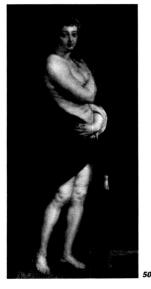

Fig. 51 Rubens, La Kermesse, Louvre, Paris.

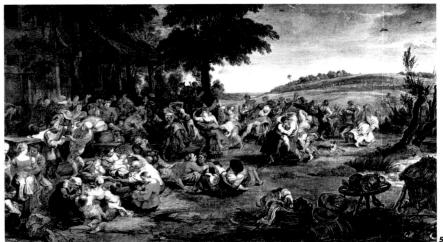

Hélène Fourment, Rubens's model and wife

Rubens's first marriage was to Isabella Brandt in 1609. She died in 1626. Four years later Rubens married the very young Hélène Fourment. Hélène was sixteen and Rubens fifty-three. He had ten years to live, during which time Hélène was the inspiring muse of all his pictures on mythological themes, as well as his favourite model for figure studies and portraits. When Rubens died, his widow wanted to destroy some of these studies, including figs. 50 and 52, reproduced here. In this magnificent work, the techniques of glazes and half-impasto in direct painting are obvious. Observe the thin dark backgrounds; the forms on top of dark areas (hair, ribbon, veil on the upper part of the head) all defined with glazes; the flesh, made first with wet glazes, then with half-impastos, resulting in brighter flesh colours on the forehead, right side of the face, upper part of the forearm, breasts, collarbone, and so forth.

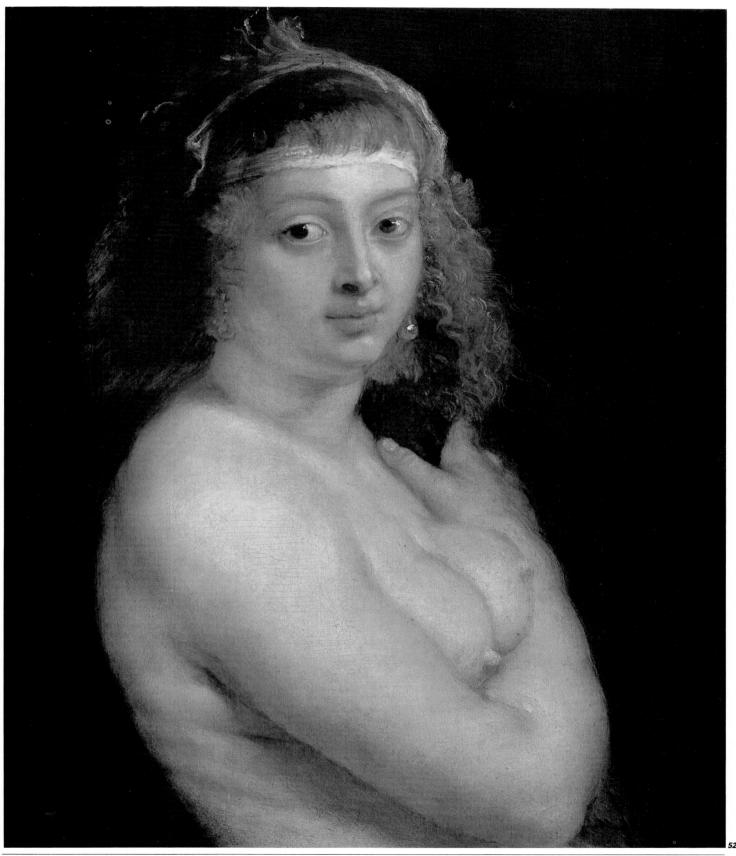

How Rubens painted

Here we have Rubens's technique explained. On a wooden surface or a canvas he first painted a layer of rather dark silver grey. On top of this he drew, and then painted, the theme of the picture in a brown wash. He went on accentuating lights and halftones with glazes of light colours. Here Rubens recommended not 'dirtying' the tenuous and transparent shadows with light glazes: 'Paint the shadows carefully, but don't put white on top of them! It's poison for the picture!' And he further insisted: 'If you paint with glazes on top of the transparent and golden qualities of your picture, your colours won't be luminous any more, but rather flat and grey.'

Up to this point, Rubens's procedure was not very different from the one developed by Titian, but from this phase on, Rubens painted the shadows with glazes or half-impastos that hardly covered anything. He painted with half- and up to full impasto in the light areas, especially the flesh, which he worked on with complete freedom, as Delacroix and Daumier would do two hundred years later. Note the head on the right, a detail from Rubens's picture *Saint Francis's Last Communion*, in which his techniques of half-impasto and direct painting are graphically demonstrated.

Fig. 53 Rubens, Saint Francis's Last Communion, Museum of Fine Arts, Antwerp. One of his most important works on a religious theme, due to its artistic composition. Observe the play of forms and colours provoked by the canopy, and the window-picture behind. As for the expressiveness of the figures, test this by looking at the enlarged head of Saint Francis in fig. 55.

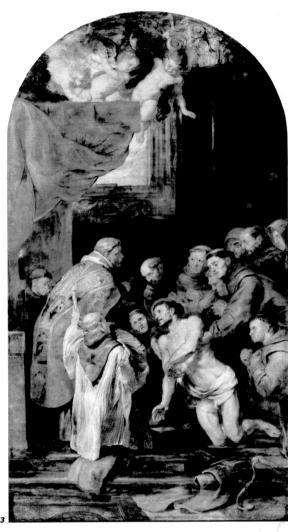

5

Rubens's technique

A) In the lower background, on the upper and lower left, we see the thin layer of paint which hardly covers the grey priming of the panel.

B) On the head, above the ear, we see the thinness of the dark, almost black, layer.

C) The flesh colour on face, ear and neck was first stained with a glaze of clear ochre. This glaze can be distinguished in many parts of the face, especially on the ear.

D) There is a general modelling, slightly darkening effect, on top of the eyelid, under the nose, and on the left side, the chin.

E) Rubens used a series of flesh-coloured glazes. This work of glazing in superimposed layers can be clearly seen in the profile of the forehead, above the right eyebrow.

F) Rubens achieved bright impastos, with thick opaque paint.

G) He has clarified, with fine sable brushstrokes, the eyes, eyebrows, moustache, and beard. Finally, he accentuated the lights and shadows, painting the shining parts and details like the tear, the highlights of the eye, the red touch in the same eye – a true Impressionist detail.

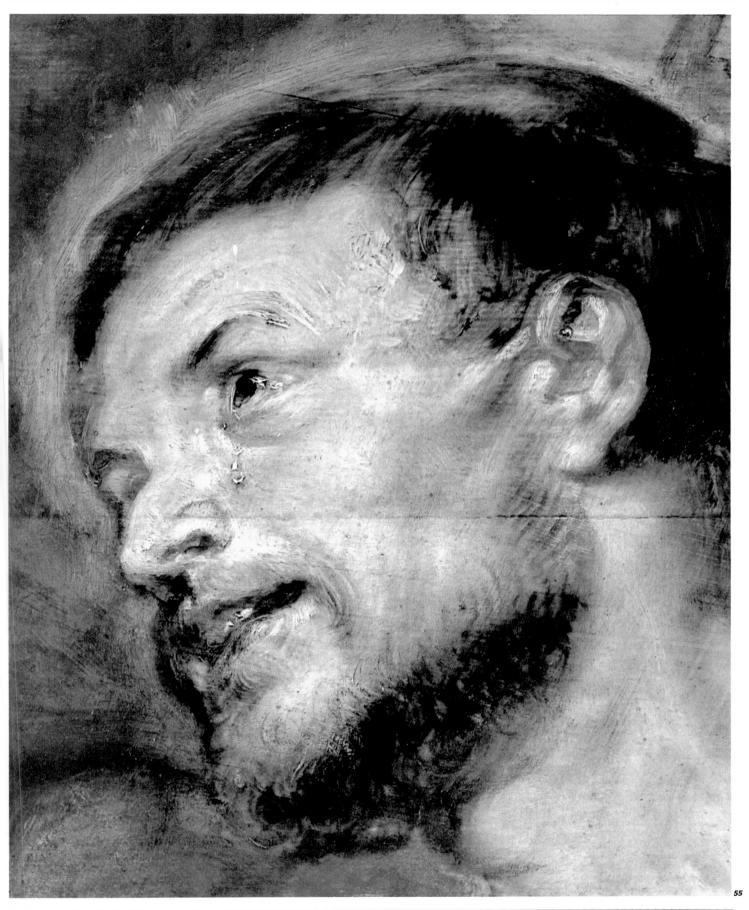

Rembrandt: chiaroscuros and full impastos

Rembrandt van Riin was a self-taught man. He never left Holland, yet he learned chiaroscuro from Leonardo da Vinci, and from Titian he learned to capture the lights and the shining areas with thick, opaque paint. 'Why to go Italy?' he answered when questioned by a friend. 'Why go to see them on their own ground, if here in the Low Countries we have their pictures and can study them all the time?' To those who went very near the canvas to look at his pictures and were astonished to see the 'careless' finish and the thickness of the paint, Rembrandt said that the pictures weren't for smelling, but for looking at. And, in this connection, the impasto on some faces was so thick, it became a popular joke in Amsterdam that Rembrandt's pictures could be hung up 'by the nose'.

Some say that, influenced by Caravaggio's tenebrism, Rembrandt felt inclined to compose his pictures with special light and shadow effects, called *chiaroscuro*. In this respect, most of Rembrandt's pictures offer a type of composition in which the centre of interest the figure in the group that forms the theme is illuminated by direct light, while the rest of the picture remains in partial shadow, with only enough light to distinguish the forms and bodies in the shade. You see on this page and the following, two magnificent examples of this artistic conception. In fig. 57, The Holy Family, one of Rembrandt's most famous works, the light focuses interest on the Virgin and Child and the angels coming down from heaven. But behind the Virgin, Saint Joseph is wrapped in chiaroscuro.

On the following page, *The Adulterous Woman* (fig. 59) is a masterly lesson in the art of *chiaroscuro*. Attention is focused on the group made up by the woman – dressed in white to increase the effect – Jesus, who stands out because of his height, and the surrounding priests. At the same time, in the upper part of the picture, profane worship goes on. The material richness is highlighted by the flashiness of the altar, and the throne and clothing of the officiating priest.

The dark areas in both pictures are defined with a thin layer of paint, while, in the illuminated parts, Rembrandt painted with full impastos, applying thicknesses of paint that differ little from those used by some artists today. But let's leave this interesting theme for a full discussion on the next page.

Rembrandt's 'chiaroscuro'

Fourteen years after Caravaggio's death, Rembrandt was still only eighteen years old. Caravaggio's style, with its strong contrasts between light and shadow so-called tenebrism - was the prevailing method, influencing all the themes and palettes of the time. But Rembrandt was already an artist with his own personality. According to a 17th-century art historian, Rembrandt repudiated most norms and rules from official centres and institutions. For him, intense light was not only produced through contrasts, and intense colours did not help to create intense lights. The solution consisted in clarifying the colours by illuminating them proportionally to the light received. With these ideas, and with a constant study of nature, Rembrandt managed to dominate the art of chiaroscuro like no other artist. This technique could be summarized as being light in shadow.

Figs. 56 and 57 (Left) Caravaggio, The Virgin of the Grooms, Borghese Gallery, Rome. (Right) Rembrandt, The Holy Family, Hermitage Museum, Leningrad.

Fig. 58 Light scheme of Rembrandt's picture The Holy Family. Here we can see Rembrandt's way of composing to emphasize the main point.

Fig. 59 Rembrandt, The Adulterous Woman, National Gallery, London. Here, in one of Rembrandt's most famous pictures, the chiaroscuro effect and the meaning of this term are so obvious that further explanations are hardly necessary. *Chiaroscuro* is the same as painting 'light in the shadow', illuminating with tenuous colours and lights the forms in the penumbra, so that they are in the picture. Study these forms in this marvellous work by Rembrandt, and note the subjects that have been 'abbreviated'. See, as Rembrandt knew how to see, that the intense luminosity of the main subject exaggerates the religious import of this beautiful composition.

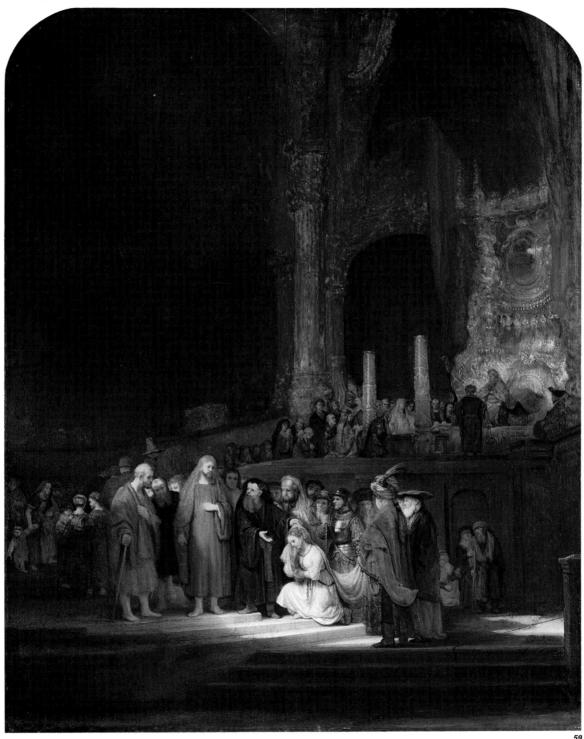

Rembrandt, master of 'frottage'

In 1642, Saskia died.

Saskia van Uylenburgh had married Rembrandt eight years before, bringing him a good dowry and many friendships. Among these friends was Captain Frans Banning Cocq who placed a special commission with Rembrandt to paint a large portrait of twenty men, the officers and soldiers of his company. The condition was that they should all look good, and some would pay more, others less, according to their position in the picture.

The picture measures 3.59 × 4.38 m. *The Company of Captain Frans Banning Cocq* soon lost its name to become *The Night Watch*.

Rembrandt filled the order. The picture is one of the most famous of all Dutch paintings – but it was also the cause of disagreements and enmities, as Rembrandt did not respect the positions selected by his customers. Rembrandt had given up the idea of placing all the heads face forward. Taking into account only his own artistic criteria, he arranged the models according to his creative sense, highlighting some heads and subduing others.

Because of this, Rembrandt did not receive more commissions for a long time. His acquaintances withdrew their friendship and finally, alone and almost ruined, he shut himself in, physically and spiritually. He ended up painting a fascinating and varied series of self-

portraits, a total of sixty in all.

The self-portrait reproduced on the following page, his last but one, was painted by the artist when he was sixty-three years old, and is a good example for studying Rembrandt's technique. First, note that the background paint does not show any relief, while in the beret and the neck of the jacket, even though they are dark, the thickness and the brush-strokes are visible. Second, notice that on top of a face colour of medium intensity but rather dark. Rembrandt has applied a small amount of thick paint on an almost dry brush. Moving over the composition, Rembrandt went scrubbing with the brush: applying here some white, as to the shining areas of the nose and forehead, adding a stroke on the right eyelid, dirtying the right cheek with a little sienna and blue. Painting with the technique of scrubbing, the brush, loaded with thick paint, modelled the face, creating superb solidity and

Don't think that Rembrandt always painted with the same technique, with an established formula. No, Rembrandt was an eclectic, a painter of endless resources and improvizations, who made use of any means available to

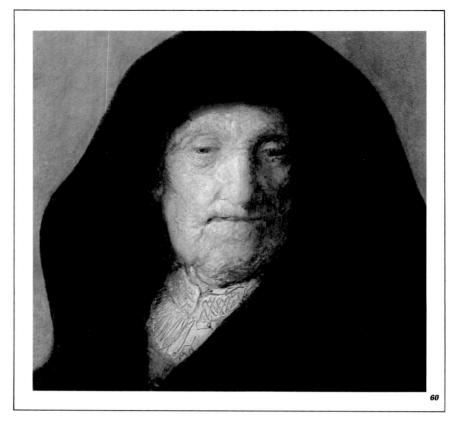

achieve his goal. Hence, in the portrait of his mother (fig. 60), the lines in the embroidery of her underbodice were done by drawing with the tip of the paintbrush handle. The paint in the forehead and nose is of an extraordinary thickness, while on the chin and jaw Rembrandt engraved with the brush, following absolutely no rules at all. But always, he was himself.

Rembrandt van Rijn was truly a self-taught man.

Fig. 60 Rembrandt, Rembrandt's Mother, Van Bohlen Collection, Essen.

Fig. 61 Rembrandt, Self-Portrait, National Gallery, London.

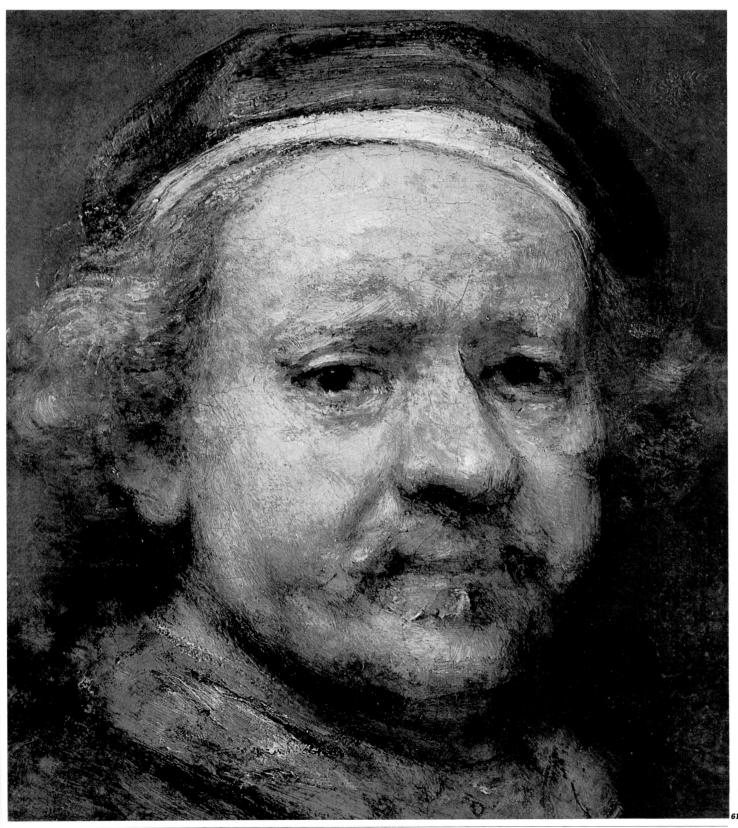

The Complete Book of Oil Painting 37

Velázquez

'It's as if he had invented oil painting all by himself.'

This sentence is from the writer and art critic Raffaelli, and is quoted by Léon-Paul Fargue, who says of Velázquez: 'He's modern, he foretells the future. There is a primitive van Eyck in the portrait of the *Old Woman Cooking Eggs* and there's a Courbet in *The Maids of Honour*, a Delacroix and a Degas in *The Spinners*.'

Diego Rodriguez de Silva y Velázquez was born in Seville in 1599. At the age of twelve he became a pupil in Francisco Pacheco's drawing and painting academy, in Seville. Pacheco was a painter and a writer of a book on painting technique entitled *The Art of Painting*. His familiarity with El Greco, from whom he had first-hand news about Titian's artistry, made him a good teacher for Velázquez.

When he was eighteen years old, Velázquez was already one of the best painters in Spain. At this age he painted *The Adoration of the Magi*, the most important of his first pictures, in which, apart from its Caravaggian style, we must stress the beautiful studied composition based on 'the Golden Section', formulated in the Renaissance (see adjoining box). The Virgin painted in *The Adoration* is the daughter of Professor Pacheco, the woman Velázquez married the following year.

Other pictures that Velázquez had already painted before the age of twenty include the well-known Old Woman Cooking Eggs, The Immaculate Conception, The Water-Carrier of Seville and Christ in the House of Martha and Mary. These carried his fame to Madrid, so that King Philip IV called him to paint a portrait. Velázquez was twenty-three when he painted the King for the first time. Philip IV was well pleased and named Velázquez painter of the royal house. Very soon Velázquez had his workshop and his house in the palace. This appointment gave Velázquez the chance to see

important works by the Flemish School, Titian, Rubens, Rembrandt, and many others. For Velázquez, the best and most important painter was Titian, who, at one time, he said he liked even more than Raphael.

When Velázquez was twenty-eight, Rubens

and study, in depth, the collection of paintings in the palace. Among these were numerous

came to Madrid and made friends with the Spanish painter; undoubtedly, they exchanged ideas about techniques and processes in oil painting. The year after he met Rubens, Velázquez made his first trip to Italy, and in 1648 he travelled there for the second time.

The Law of the Golden Section

In ancient Rome, in the time of Augustus, there was a famous architect called Vitruvius, who established the 'Law of the Golden Section', which says:

'For an area divided into unequal sections to be agreeable and aesthetic, there should be the same relationship between the larger section and the whole as between the smaller and larger sections.'

The arithmetical expression of the Golden Section is 1.618. To find this ideal division, you need only put the following formula into practice: multiply the width of the canvas by the factor 0.618, and you will automatically obtain the division of the Golden Section. By repeating the operation for the height of the canvas, you will obtain a point which is considered ideal for placing the main element of the picture. The painter Velázquez, in his picture The Adoration of the Magi, placed the head of the baby Jesus right on this point of the Golden Section. Velázquez's picture measures 200 × 125 cm. Multiplying 200 by 0.618 we get a number of about 123; and multiplying 123 by 0.618, we get about 76. Where these two lines cross we find the point of the Golden Section. The same point may be right or left, above or below.

Fig. 62 Velázquez, The Adoration of the Magi (detail), Prado, Madrid.

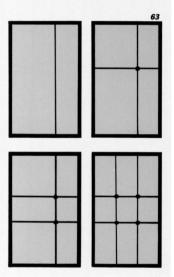

During this second stay in Rome, he painted the famous portrait of Pope Innocent X and the only nude that survives, *The Venus in the Mirror*. Back in Spain, he painted his most famous painting, *The Maids of Honour*.

Velázquez, realized his pictures largely by

Velázquez realized his pictures largely by applying Titian's techniques, as he was one of the greatest admirers of Titian's work.

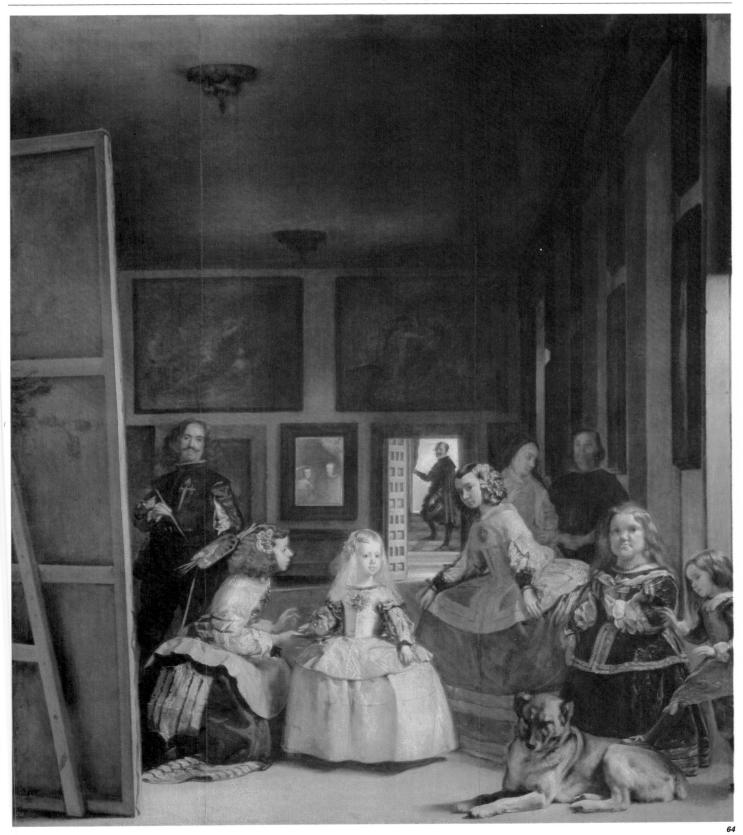

Fig. 64 Velázquez, The Maids of Honour, Prado, Madrid. This is considered to be the painter's most important work – the only work which allows us to learn what his physical appearance was like, as the figure of the artist looking at us with his palette in his hand is really Velázquez. The Infanta, Margarita, surrounded by her ladies in waiting, is the centre of the composition. The group of people in the foreground are looking at the King and Queen,

whose images are reflected in the mirror in the background. We still don't know if Velázquez is painting the portrait of the King and Queen, or if he is contemplating the Infanta and her ladies.

Velázquez

Velázquez discovered, with the help of his master Pacheco, and later with Rubens's confidences, the possibility of painting more directly – without so much glazing – by means of half- and full impastos. From this to painting with full impastos, mixing and composing the colours on the palette, and taking them from the palette to the picture, like we do today, took only a few years during which Velázquez experimented alone in his workshop in the Palace.

From the extensive information and documents that I have been able to gather, I believe it's possible that Velázquez always painted on a coarse canvas which he first covered with a uniform layer of Venetian red, exactly the same colour with which Titian sized his canvases before beginning to paint. Velázquez, like Titian, wasn't in favour of a previous drawing made in detail, like other famous painters of the time. He began, like Titian, with a brush loaded with colour, painting and drawing at the same time. He worked over the whole picture first with a half-impasto, in the style of the 'base of the painting' advocated by Titian. Velázquez did not plan or anticipate later highlighting with the traditional glazes and the typical three colours of the Flemish painters. For Velázquez, this technique was out of date. He painted directly, but with an overall first stage of colour in which there was a predominance of grey. On top of these direct grevs he then applied the definitive colours. This grisaille effect furthered the optical grey discovered by Titian.

On the other hand, Velázquez's way of making impastos, which contributes so much to seeing in the Spanish painter the workmanship of a modern painter, was the result of the application of Titian's and Rembrandt's techniques, combined with those of Rubens. Note that Titian - Velázquez's model - was the first to paint with what I venture to call 'thick glazes', or, in the painter's technical vocabulary, frottage (rubbing). But Titian applied these frottages with moderation. Rembrandt made use of frottage for creating volume, applying it decisively. Don't forget that both Titian and Rembrandt painted directly, as corresponds to the frottage technique. Meanwhile, Rubens softened his way of doing it, inventing the half-impasto, which, in the way that Rubens manipulated it, was nothing more than a series of 'less thick glazes'. These pastel-like layers he applied one on top of the other, mixing the shades on the canvas first, some on top of others.

Velázquez knew the advantages and disadvantages of both systems, and knew how to combine the two. It was a process that was to some extent logical, and was reached at the same time by Velázquez in Spain, Poussin and de la Tour in France, Franz Hals and Vermeer in Holland, and Reynolds and Gainsborough in England.

Fig. 65 Velázquez, Prado, Madrid.

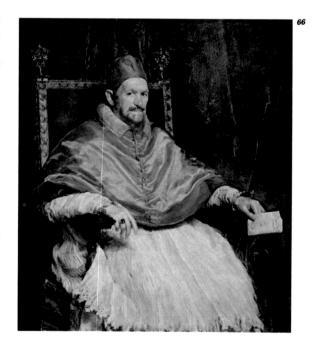

Figs. 66 and 68 Velázquez, Pope Innocent X, Doria Gallery, Rome. The friendship between Rubens and Velázquez meant that the latter travelled to Rome, the first time in 1629 and for the second time in 1648. This second trip was really advantageous. He painted the magnificent and only surviving nude, The Venus in the Mirror, and the portrait of Pope Innocent X, considered by many the best of all those he painted. Before creating this famous portrait, he painted the portrait of his servant Pareja, showing his technique of painting 'in blotches', as people used to say, or 'with separate stains' in 'his abbreviated way', meaning, as we now understand it, 'like an Impressionist'.

Velázquez was daring enough to paint with this free, loose style for the Pope himself. Note, in the detail of the head of the Pope, the relaxed but still certain workmanship of this incredible portrait.

Fig. 67 Velázquez, detail from The Maids of Honour, Prado, Madrid. Velázquez painted with wide, sure brushstrokes - look at the eyes, the nostrils, the lips - with an extraordinary synthesis more appropriate to a master of Impressionism. Notice the way the hair is painted with 'stains' which close up don't look like anything, yet represent flowers or ornaments. Observe the texture of the canvas, the weight of the paint, the direction of the brushstroke. What enviable facility!

The Complete Book of Oil Painting 41

Velázquez's best portrait

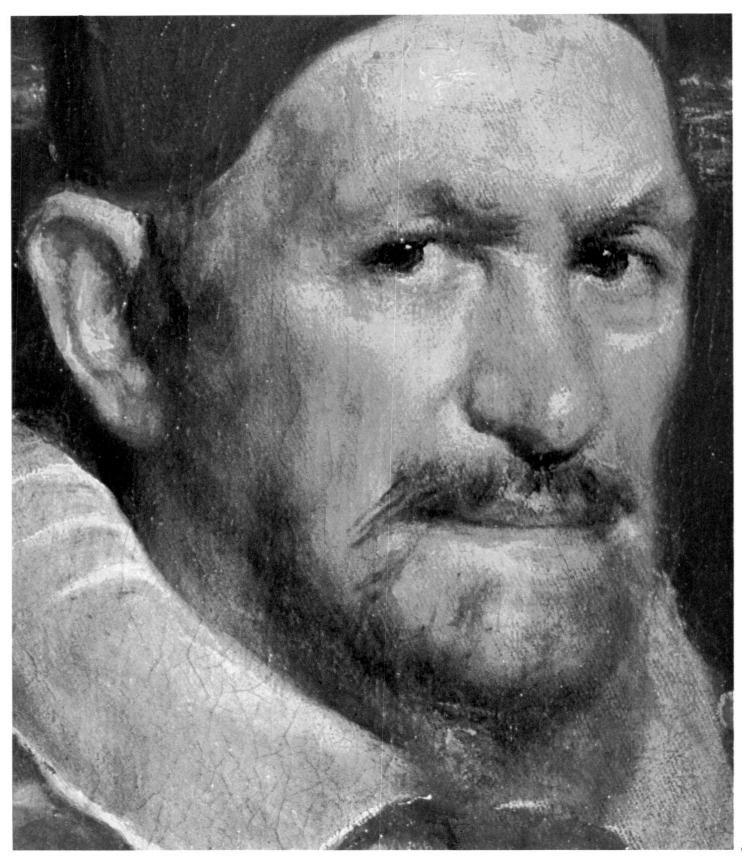

From Velázquez to Picasso

From Velázquez until the early 18th century, it can be said that there was no real change in oil painting worth taking into account. We can note, however, some variations; for example, in the Rococo period, when the painting of Boucher and Fragonard offered a decorative and frivolous concept. The fashion was to paint with vegetable mediums, that is, instead of adding thick, slow-drying oils to the already mixed colours, turpentine was used, which meant that the colours dried quicker and produced a matt surface without gloss. This is a procedure which is valid today and which ensures that a picture will have a long life.

In the second half of the 18th century, the Neoclassical style made its appearance in Europe, and the standard-bearer of this movement was the French painter Jacques-Louis David. David and his school, in which we find, among others, Gros and Ingres, went back to Rubens's technique of transparent glazes combined with half-impastos. This technique the Neoclassicists carried to its greatest height, reaching a perfection that was ultimately comparable to the paintings of van Eyck and his followers.

The portraits of Ingres, which the philosopher Ortega y Gasset compared to the figures in a wax museum, are a good example of the adoption of this technique, then called 'classical'.

Romanticism lasted until the middle of the 19th century. There was also the addition to the palette of the colours bitumen of Judea and mummy, both comparable to today's Cassel earth, with the difference that they took a long time to dry. When the pictures were new, the colours appeared brilliant, with magnificent hues and contrast, but after a few years they turned almost black, and deteriorated without any possibility of restoration.

Fortunately, there then appeared the luminous pictures and bright palette of the Impressionists, who reached their zenith between 1850 and 1870, with the pictures of Manet, Monet, Pissarro, Degas, Renoir, Sisley, and Cézanne.

Fig. 69 Boucher, Reclining Girl, Pinakothek, Munich. In the French Rococo it was the fashion to paint with solvents instead of oils. Rectified turpentine was one of these, and is still used today to achieve lean paint.

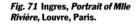

Fig. 72 David, The Consecration of Napoleon I, Louvre, Paris.

Oil painting today

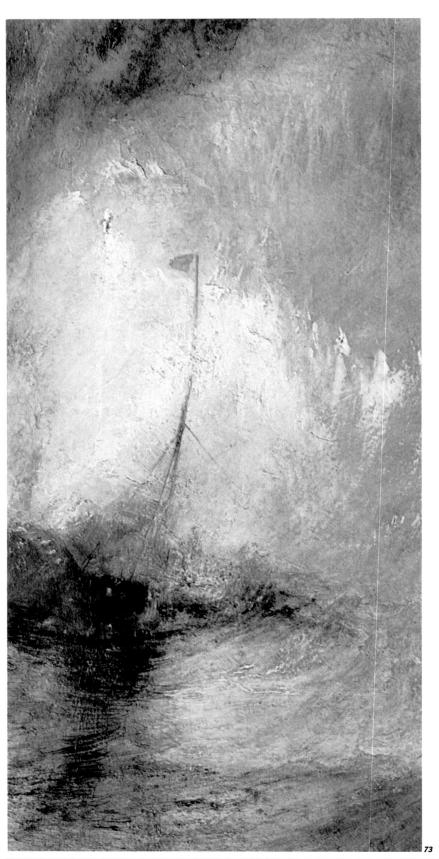

Up until the last third of the 18th century, oil colours were made by the artist himself or by his helpers, according to methods which we will study later. At the end of the 18th century, colours were already prepared and sold in small skin bladders. The performance of these colours was very uncertain, as the preparation was done in a very empirical way, without any guarantee that a certain colour - ultramarine blue, for example - would always have the same hue, intensity, and consistency. From 1850 to 1860, the first oil colours packaged in collapsible metal tubes appeared on the market. There was considerable trial and error as regards the quality of the paints, but finally the manufacturers achieved oil colours of a consistent quality. Also, the new manufacturers offered a much wider range of colours, with a gloss and richness that the masters of ancient times could never have imagined. Renoir said, in his later years: 'Tube colours allowed us to paint in the open air, from natural models.' Without these colours in tubes neither Cézanne, nor Monet, nor Sisley, nor Pissarro's paintings would have existed, nor would there have been what journalists called 'Impressionism'.

The quality of the materials, especially that of oil colours since the beginning of the present century, has opened up many possibilities to the artist: any kind of surface can be used, from paper to a brick wall; painting with a brush, a knife, in squirts from the tube, and in layers so liquid or thin that the canvas becomes a texture instead of just a support, are among other possibilities. Anything can be done, and the material always responds, provided a few basic rules are respected, which we are going to talk about in this book.

Fig. 73 Turner, Storm at Sea,
Tate Gallery, London. Turner
already painted like an
Impressionist at the beginning
of the last century. His
technique was completely
personal, and he often applied
the technique of rubbing.

Fig. 74 Cézanne, Self-Portrait in a Cap, Hermitage Museum, Leningrad. Of almost actual size, this reproduction shows us the free, confident, and completely spontaneous way in which Cézanne painted, in a style that goes beyond Impressionism.

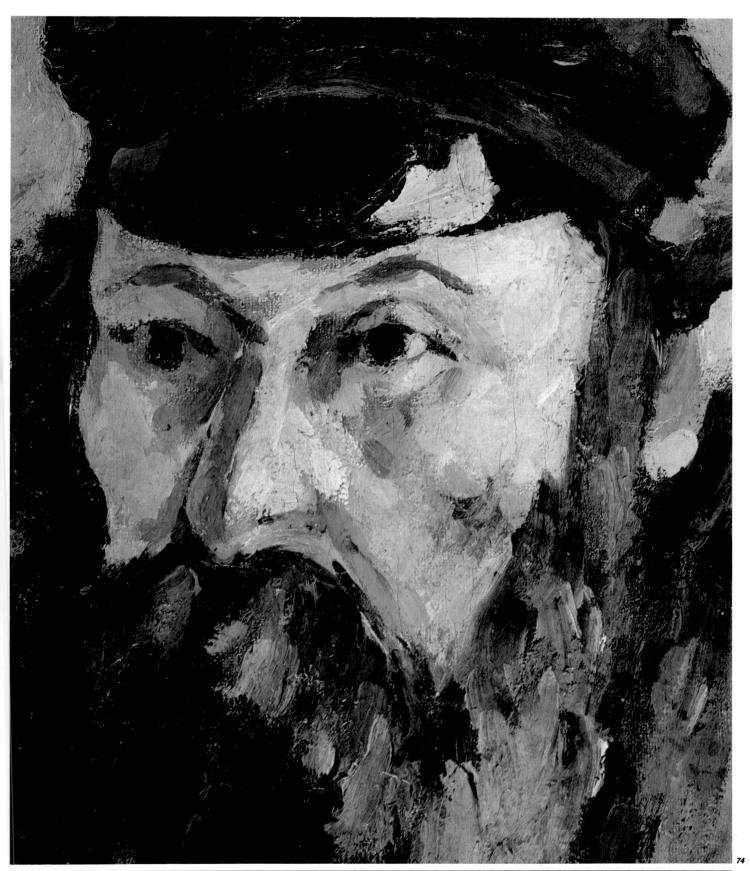

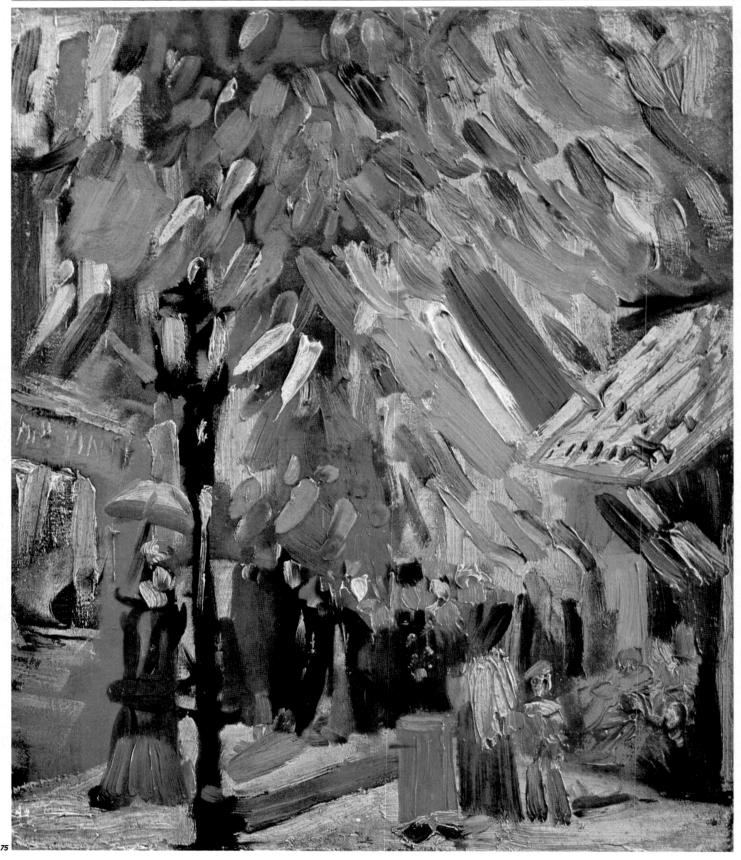

Fig. 75 Van Gogh, 14th of July in Paris, Collection Jaggli Hahnloser, Winterthur. Before the height of Fauvism, van Gogh had already developed a technique of thick impastos with paint directly from the tube, completing his pictures

in a single afternoon.

Fig. 76 (Facing) Vermeer, The Artist's Studio, Vienna.

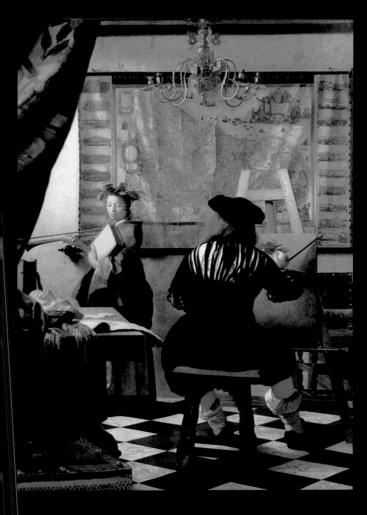

The painter's studio

'You will have your workshop where nobody will disturb you, and which has a single window. Near this window you will place your desk as if you were going to write.'

Cennino Cennini (c. 1370-1440)

History of the painter's studio

Have you ever asked yourself what the studios of the great maestros of the 16th and 17th centuries, Rubens, Rembrandt and Velázquez, were like?

Of course, they all worked in large rooms, large areas which were in no way different from those occupied by other artisans, like the tailor, the carpenter, the boilermaker. The studio was the workroom.

Velázquez's workroom measured approximately six metres high by five wide and was about ten metres long. The painter Juan Bautista del Mazo, a disciple of Velázquez, painted a picture entitled Velázquez's Family, set in the maestro's studio (fig. 78). We also know that the picture *The Spinners* (fig. 77) was painted by Velázquez in his own studio, although he modified the structure slightly, especially the recess in the background which he painted in a somewhat more stylized way. Lastly, the picture The Maids of Honour was also painted by Velázquez in his own studio, placing the figures in the foreground and using the same illumination as that he gave the spinners and Velázquez's family. In the studios of the time, there was, next to the large chamber, a small room, where there was running water and a stove, as well as a table or bench for grinding colours. In this room, as well as different tools, there were small bags of coloured pigments, bottles of oils, resins and solvents, and small containers holding colours that had already been made. These were all stored on shelves and in cupboards, the whole rather like a rudimentary kitchen, in which, we must remember, the painter's apprentices 'spent six years', according to Cennini, 'grinding colours, cooking the glues, and mixing the plasters'. This kind of kitchen still existed in studios until no more than about fifty years ago, and even now, when we see a painting or a picture that has been heavily manipulated, with special textures or finish, we may hear a comment something like 'there's a lot of kitchen work here'.

At the end of the last century, the studio of famous painters became a small museum and reception salon. The painter's tools were accessories and most important was the decoration, with old furniture, tapestries, copper vessels, oriental hangings, and fabrics. In Paris, the painter Gérôme a small palace in front of the Moulin Rouge, in which there was a series of luxurious salons, and sculpture and painting workshops, full of objets d'art and oriental curios. This was a kind of museum in which the artist used to hold receptions and,

at the same time, sell his pictures. The Realists first, and later the *Impressionists*, began the use of halls or galleries for exhibiting pictures in studio-museums in the style of Gérôme, establishing a normal workshop-studio on a scale we now consider excessive. The two pictures reproduced on the following page illustrate something of this studio of the end of the last century and the beginning of the present one in the workshops of Courbet (fig. 79) and Bazille (fig. 80).

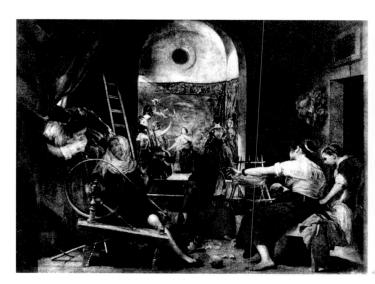

Fig. 77 Velázquez, The Spinners, Prado, Madrid.

Fig. 78 Del Mazo, Velázquez's Family, Kunsthistorisches, Vienna. The historical value of this picture is not so much in seeing and meeting Velázquez's family, as that the group is situated in the painter's studio. In the background you can see Velázquez himself, painting. Observe the similarities between this room and the one in the picture The Spinners.

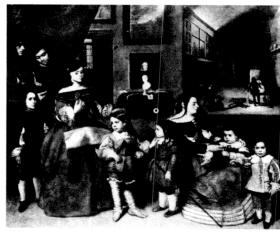

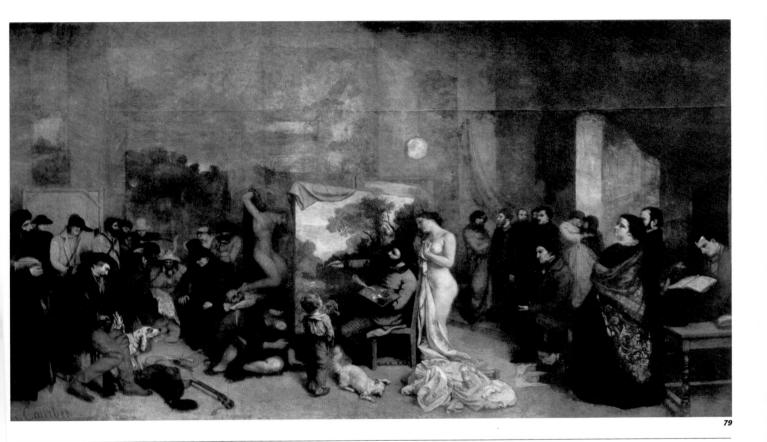

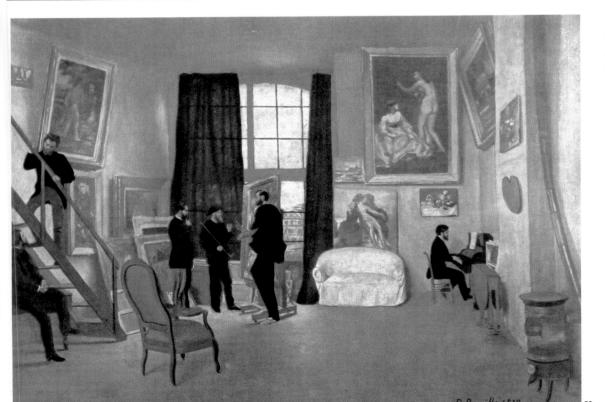

Fig. 79 Courbet, The Artist's Studio, Louvre, Paris. The picture shows us Courbet's studio at a time when the artist still painted on its practically naked walls. Courbet wanted to present his workshop, his models, and people with whom he had worked within these four walls.

Fig. 80 Bazille, Bazille's Workshop, Louvre, Paris. A painter's studio, typical of the end of the last century, with piano, wide window, black curtains for controlling the light, stove, and attic room for spending the night (here, upstairs).

The painter's studio today

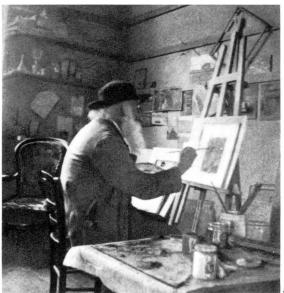

Fig. 81 A corner of Pissarro's studio, with the artist painting. The type of easel is still made today and is common in fine-art schools.

Fig. 82 A view of part of Cézanne's studio in Aix-en-Provence, where we can see a type of easel suitable for large pictures. Strangely enough, Cézanne had no pictures on the walls of his workshop.

Fig. 83 Picasso, The Blue Room, The Phillips Collection, Washington, D.C. A picture in which Picasso reproduced his own room, which also served as a studio, in Paris in the boulevard Clichy.

About 1890, Camille Pissarro and Paul Cézanne lived in the country and had their studios in their country houses, on the ground floor, with one or two normal windows, and walls hung with pictures – a normal room but still spacious, as befitted the rooms of old country houses.

In 1901, Pablo Picasso travelled for the first time to Paris and stayed in a room on the boulevard Clichy that did not measure more than 4 x 5 metres. In this room Picasso lived and painted. He made it his studio. This is proved by the picture *The Blue Room* in which Picasso reproduced his own room (fig. 83). Picasso went back to Spain and returned to Paris in 1904. The sculptor, Paco Durio, wrote to him a month before he set out, offering the studio he had in Paris, a room on one side of Montmartre, at number 13 rue de Ravignan (today, Place Emile Goudeau). 'Simple, cheap and in a beautiful quarter,' Picasso's friend, Paco Durio, told him.

Picasso's new studio was an old ramshackle wooden building, which, as he used to say with a laugh when the wind and rain grew strong, 'swayed like a yacht'. Max Jacob, the poet, called it 'bateau-lavoir', remembering the old floating wooden launches anchored in the Seine. The famous bateau-lavoir must have been really large, bearing in mind that up to fifteen people used to meet there. From what has been said, we can deduce that the dimensions and the location of the studio do not have a decisive influence when it comes to creating and painting. However, there are minimum conditions regarding the place, the space, the light, and the materials. We will begin by specifying the minimum dimensions of an artist's studio:

A minimum space of about 4 x 3.5 m is adequate but a larger room is preferable.

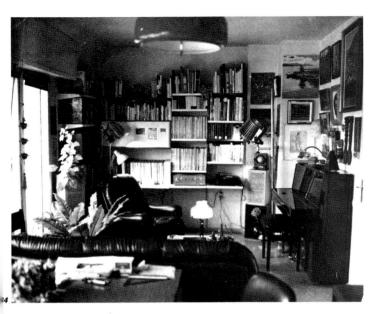

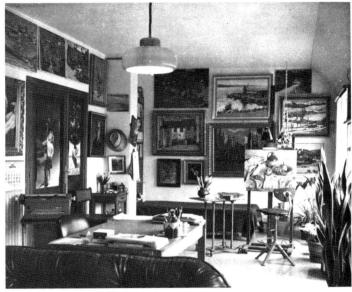

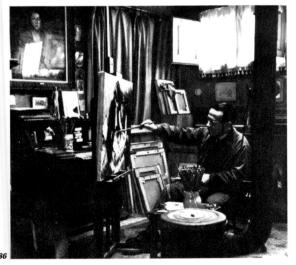

Figs. 84 and 85 A painter's studio, in a city flat, just as it might be nowadays, made up of one room (9 x 3.5 m), half of which is used for painting and half for reading, listening to music, and chatting with friends.

Fig. 86 Here we have Francesc Serra's studio in a garret in the old part of Barcelona, in a building with seven floors, with the artist himself, painting. It is a room of 4 x 5 m lit by three windows up above.

Fig. 87 Corner of my own studio in a country house. It measures 6×5 m and has a large picture window 1.70 m from the floor (see fig. 88).

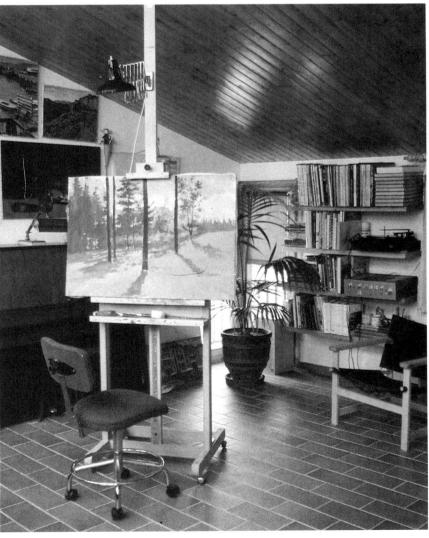

Lighting the studio

On one occasion, while I was in Francesc Serra's studio watching him paint a figure, I noted that the light came from a picture window placed about two metres from the floor, giving a quality and direction that we could call *central-lateral*.

Then I remembered Velázquez and his studio with a large open picture-window in the upper part of one of the side walls, and I thought of the possibility of building a modern studio having this kind of natural illumination. This studio, in which I now work with very good results, can be seen in fig. 88. The lighting is diffuse but gives pleasant contrast for painting in general and especially for painting figures and portraits. The direction of the light, and the above-mentioned diffused quality, eliminate any reflection or shine. The sloping roof of varnished wood (a warm colour) compensates for the intensity reflected from the white walls (a cold tendency) and balances the colour of the light and the intensity in the room as a whole.

Most painters work and paint by day with natural light, which does not mean that if one wants to one cannot paint with artificial light. There are many professionals who 'carry' two paintings at a time, one in the morning, painted by daylight, and another in the evening or night, painted by the light of one or more electric lamps.

To paint with natural light, the studio should have at least one large window which allows daylight to light the model in a frontal-lateral or lateral direction. Painting by artificial light one needs two lamps, one to light the model and another to light the picture one is painting. Also it is a good idea to have an additional light for general illumination.

To illuminate the model, whether it is a figure or a still life, we only need a single 100-watt lamp set in a large white reflector in order to avoid the effect of focus or directed light and the excessive contrast it would produce. To paint a still life of a portrait the lamp should be placed at about a metre from the model. The illumination of the picture should be projected from above with a swan-neck lamp, or extending arm, set up on the workshop easel (see fig. 95), with a 100-watt lamp. To avoid imbalances between the light on the model and that on the picture, it is important to work with two lamps of the same power. Lastly, the auxiliary light should be installed quite high, near the roof, with at least a 100-watt bulb (depending on the dimensions of the room).

Fig. 88 Lighting from above, through picture windows situated 1.70 m from the floor.

Figs. 89, 90 Artificial light can give rise to reflections (fig. 89), which can be eliminated by sloping the canvas and painting diagonally or vertically (fig. 90).

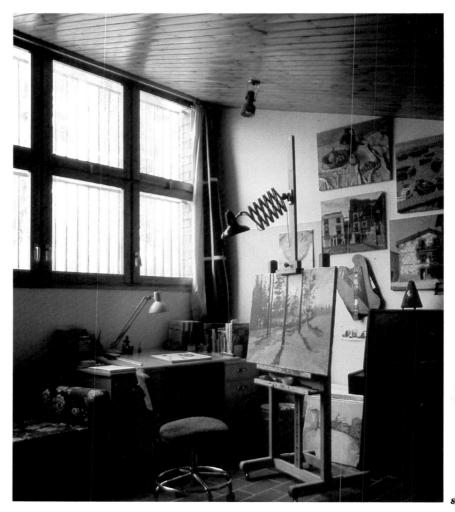

Fig. 91 Illumination with natural light coming from a wide window. In the photograph of the model we can see that

the shadows are soft, without clear-cut edges. The colour of the light is neutral or with a tendency to blue.

Fig. 92 Artificial light coming from a table lamp with 100watt bulb. The contrasts are accentuated, the shadows seem cut out, clearly defined and darker. With a tungsten

lamp, the colour tends towards yellow. This is not really important, as you only have to change it when painting or accentuate it deliberately.

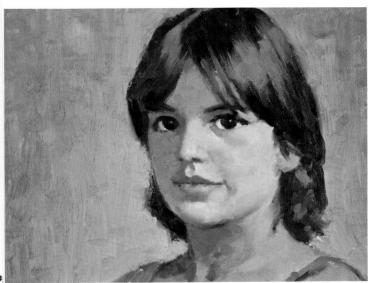

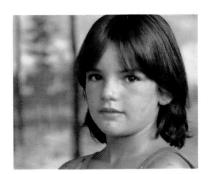

Fig. 93 I painted this sketch in the studio reproduced in fig. 88, with a high light source, capable, as you can see, of providing soft illumination. To

accentuate the contrasts, it's only necessary to draw the curtains and you are left with the more direct light of the small lamp.

Contents and illumination of the studio

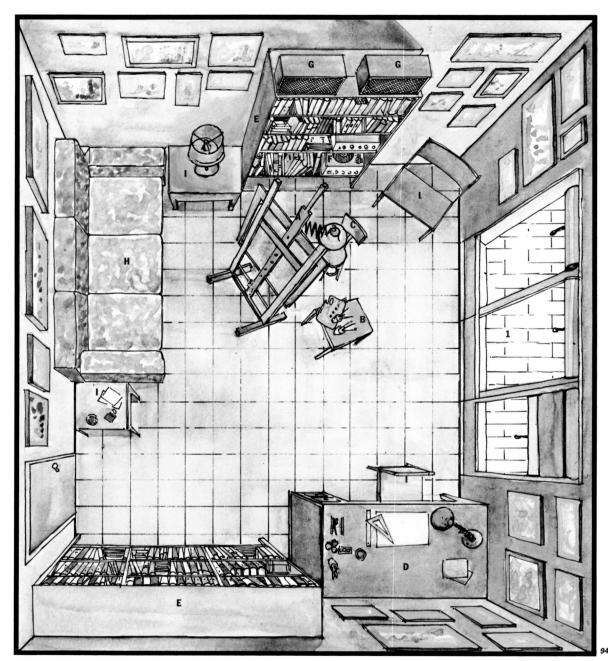

Fig. 94 Here we have a painter's studio 3.5 m wide by 4 m long, drawn to scale, as are the dimensions of the furniture. Included is everything needed to work comfortably.

Illumination

- 1. Windows.
- 2. Table lamp.
- 3. Extending light on the easel.
- 4. Extra lamp for special effects.
- 5. General light (in the ceiling, not shown in the drawing).

Furniture and tools

A. Painter's easel.

- B. Small table or extra piece of furniture for paints and palette.
- C. Stool.
- D. Auxiliary rectangular table.
- E. Bookshelves.
- F. Stereo.
- G. Loudspeakers.
- H. Sofa bed.
- I. Auxiliary table, chair, armchair.

Here we have a drawing of the studio seen from above, showing the furniture and tools, and the sources of light and their positions. Note that apart from the equipment and tools for painting there are items of furniture such as a sofa bed, bookshelves with musical equip-

Dimensions

- 4 metres long
- 3.5 metres wide
- Take these dimensions as minimums.

ment, and an extra table which can be used either for placing a still life or for writing, drawing, and making sketches and plans. The distribution of the light sources is functional. The general light of the studio, hanging from the ceiling, is not shown here.

The furniture and tools that are essential for painting are limited to an easel, a seat, and a table for tubes of paint, rags, bottles of oil and turpentine, and a container for brushes (see fig. 95).

You will find a more complete discussion on the basic outdoor and workshop easels a few pages hence. The painting table can be found in shops selling drawing and painting equipment, along with other furniture designed for the artist. The piece of furniture shown in fig. 96 has wheels which allow it to be moved around the studio.

As a substitute, you can use any normal table. Some time ago, I adapted an old typewriter trolley for this job by adding a drawer at the bottom (fig. 97). On the other hand, I recommend buying a folder stand like that shown in fig. 98. It is very desirable for storing drawing paper or finished work.

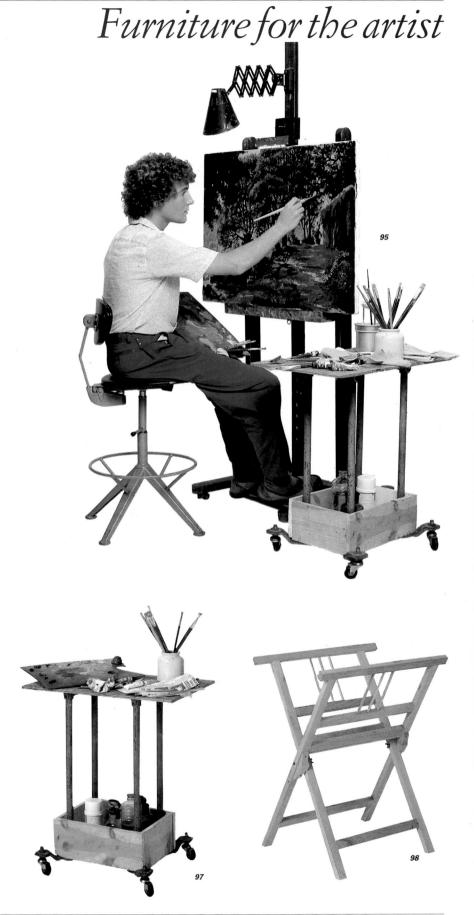

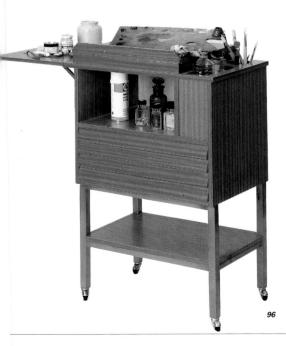

Auxiliary furniture

Some people paint standing up, but generally speaking, most artists paint 'half sitting', that is to say, on a seat or stool that is higher than normal on which one can half sit down and can stand up with almost no effort. There are two typical models. The chair with wheels has a slightly flexible back, a covered seat that you can raise or lower, and a bar at the bottom to rest your feet on (fig. 99). Another type is a wooden stool with three legs and an adjustable seat, as shown in fig. 100.

The studio table has to provide a place to write, plan and draw. I recommend a model like the one in fig. 101 made up of two independent stacks of drawers and a sloping tabletop placed on top without being fixed, so that it can be separated as desired.

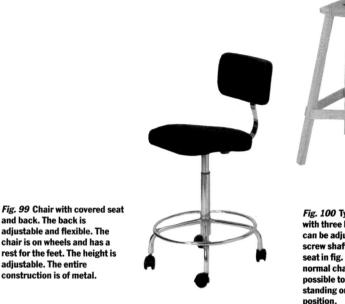

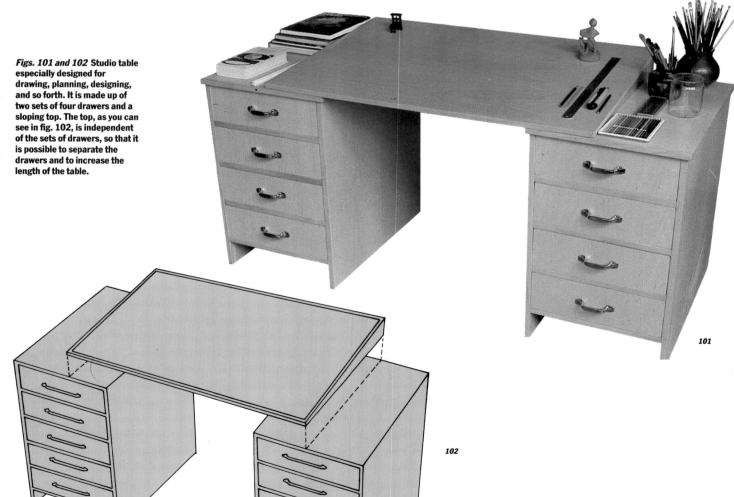

and back. The back is

adjustable. The entire

construction is of metal.

Paintboxes

The oil-painting paintbox, a vital part of the artist's equipment, is used for painting in the open air – country landscapes, urban landscapes, seascapes. The paintbox can also be used in the studio as an auxiliary piece of equipment while painting, to hold and leave brushes, tubes and rags.

The most common and well-known paintbox is the same as the type shown in figs. 115 and 116. Its special advantages are that you can carry the palette without cleaning it, with the remains of the paint left on at the end of the painting session and, thanks to the movable strips of wood with clips, you can transport both the wet palette and a number 5 canvas that has just been painted, without any risk of marks. The arrangement of these strips of wood and the calculated slope of the lid allow us to paint without an easel.

The model shown in fig. 114 is made completely of plastic, so you can pack tubes, dippers, bottles, even brushes into it. Personally, I think the model in fig. 115 is better and much

Fig. 115 Wooden paintbox, smaller size, solidly constructed, very nice and functional.

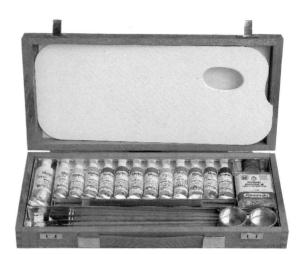

115

Fig. 114 Plastic paintbox with built-in moulded shapes which accommodate tubes, brushes, and solvent neatly.

more pleasant. It is made of good wood and beautifully finished. The smaller size of this box -34 cm long \times 16.5 cm wide and 5 cm deep - makes it a really functional paintbox.

Canvases, cardboard, surfaces

The best canvases for painting in oils are made of linen or cotton. There are still some who paint on hemp, but this is an exception. Linen canvas is undoubtedly the best and can be distinguished by its stiffness and somewhat dark greyish ochre colour. Cotton is softer to the touch and is light grey in colour. Some manufacturers dye the cotton so that it looks like linen.

Within these groups, the artist can choose between canvases with fine, medium or coarse weave, with more or less *priming*. Priming is a layer of rabbit or carpenter's glue mixed with plaster (Spanish white) and zinc oxide, which prepares the canvas – wood, cardboard, any surface at all – for better adhesion of the paint and future preservation of the painting. This priming formula provides a white layer, but you only have to add a grey or siennacoloured powder to get a coloured priming, such as Rubens (grey) or Titian and Velázquez (Venetian red) used to do.

The priming of canvases or any other surface may be done with acrylic paint, or with paint that has been especially prepared for this function – 'priming white' from Winsor and Newton, for example.

The canvas can be bought already mounted on a stretcher, or in a piece, sold by the metre. Rolls of canvas measure from 0.70 to 2 m in width. A stretcher is a wooden frame which has small wooden wedges in the corners allowing you to tighten or slacken the canvas. The old wooden support has today become a thin sheet of plywood or pressed wood that is flat, light and rigid. A sheet of wood can be prepared with a layer of thin carpenter's glue. To paint sketches, notes, and small pictures it is common to use prepared cardboard primed with a smooth, white matt surface. In the same way as wood, cardboard can be prepared by the artist, priming both sides to avoid deformations caused by moisture.

There is also canvas-covered cardboard which does not need any preparation at all. It is worth remembering that for plans and small sketches high-quality drawing paper (Canson, Caballo, Schoeller, etc.) serve perfectly well.

Priming a surface for painting

Taking into account the fact that in shops selling drawing and painting materials there is a wide assortment of canvases and stretchers, sheets of cardboard and wood, all perfectly prepared, in all sizes and kinds, of medium or high quality, it might seem absurd to want to prepare the canvas oneself, to make the stretcher and to put it together, wasting precious time and running unnecessary risks. But, so that it cannot be said we have ignored this point, and in case you do have to do it one day, here is a priming formula and instructions for using it.

Sizing

Ingredients:

70 g of carpenter's glue (Cologne or rabbit glue) and a litre of water.

Leave the glue soaking in water for twenty-four

hours so that it softens and swells. Then heat it in a water bath and apply it to the canvas with a brush while still warm. Use, allowing each coat to dry before applying the next.

Priming

Ingredients:
One part natural plaster or chalk (Spanish white).

One part zinc white. Two parts water.

One part tepid glue water.

First mix the plaster with the zinc white and the water until you get a creamy but liquid paste. Heat in a water bath and add the glue water. Apply to the canvas while warm, and put on three layers, each in a different direction. Again, let each coat dry before applying another.

Fig. 117 Priming a canvas. Apply a layer of rabbit glue, made up of 70 g of glue per litre of water, while still warm, going over it three of four times.

Fig. 118 Mix one part of plaster (Spanish white) with another part of zinc oxide. Add from one to three parts water and one part of slightly warm, liquid-glue water.

Fig. 119 Heat the previous mixture in a water bath.

Fig. 120 Finally apply to the canvas while still warm, spreading the paste over the canvas with a brush or spatula. Apply three layers in different directions.

Fig. 121 Supports for oil painting. 1. Sample of cotton cloth that can be identified by the evenness of the weave. 2. Linen cloth, darker than the cotton and showing some slubbing, is the best surface for oil painting. One of the European manufacturers who gives a guarantee with regard to this is Cassens from Belgium, an old traditional company of high reputation. 3. Sacking or hessian. There are a few painters who use it but they are becoming less numerous because of the difficulties presented by the coarse texture of the cloth. 4. Cotton cloth of a very simple type, already primed. 5. Standard-quality linen cloth, primed. 6. Cassens brand linen cloth. Cloth for painting is available in different thicknesses of weave, more or less closely woven. The best quality is the densest one. 7. Canvas-covered cardboard. 8. Back of a panel of wood of the Tablex type. 9. Plywood. 10. Oak panel (it can be other kinds of wood). 11. Cardboard or wood with white priming. 12. Canvas-covered cardboard with acrylic priming. 13. Thick grey cardboard (can be prepared with a simple layer of glue or by rubbing with a clove of garlic). 14. Coloured drawing paper, Canson type.

International stretcher measurements

Stretchers with the canvas already mounted and cardboard and wooden sheets are classified according to size; a number indicates the measurements of the picture. Different themes demand different proportions: figure, landscape, seascape. The proportions of the stretchers for pictures of figures are squarer than those for landscapes, and the seascape stretcher is the most oblong (see figs. 122, 123, and 124). Note, however, that in practice the artist does not have to stick to this kind of principle. People do paint landscapes on 'figure' stretchers with the canvas already mounted, so that the artist can choose one of the sizes from the table, go to the shop and simply ask for 'a figure (or landscape, or seascape) stretcher number x'.

The table of international measurements for stretchers was probably worked out by one of the first canvas manufacturers. This happened approximately one hundred and thirty years ago. The size of many pictures from the middle of the last century is already in keeping with the measurements of the table

INTERNATIONAL MEASUREMENTS FOR STRETCHERS IN CENTIMETRES

No.	FIGURE	LANDSCAPE	SEASCAPE
1	22/16	22 x 14	22 x 12
2	22/19	24 x 16	24 x 14
3	27/22	27 x 19	27 x 16
4	33/24	33 x 22	33 x 19
5	35/27	35 x 24	35 x 22
6	41/33	41 x 2	41 x 24
8	46/38	46 x 33	46 x 27
10	55/46	55 x 38	55 x 33
12	61/50	61 x 46	61 x 38
15	65/54	65 x 50	65 x 46
20	73/60	73 x 54	73 x 50
25	81/65	81 x 60	81 x 54
30	92/73	92 x 65	92 x 60
40	100/81	100 x 81	100 x 65
50	116/89	116 x 81	116 x 73
60	130/97	130 x 89	130 x 81
80	146/114	146 x 97	146 x 90
100	162/30	162 x 114	162 x 97
120	195/30	195 x 114	195 x 97

122

shown here. But there were then, and there are now, artists who do without the standard measurements and paint with stretchers that are made to measure, with special dimensions which correspond, according to them, to a frame especially planned for the main theme

Fig. 125 Here is a canvas for painting, mounted on a wooden stretcher. Note that on the stretcher we can see the designation 12F, which means number 12 canvas, for figures.

125

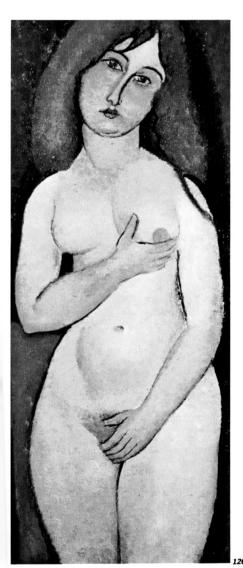

Fig. 126 Modigliani, Venus, private collection, Paris. Modigliani painted this nude on a canvas measuring 160 x 60 cm. Special proportions have nothing to do with the international measurements for stretchers.

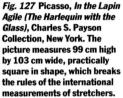

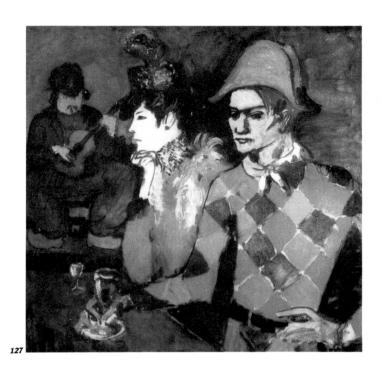

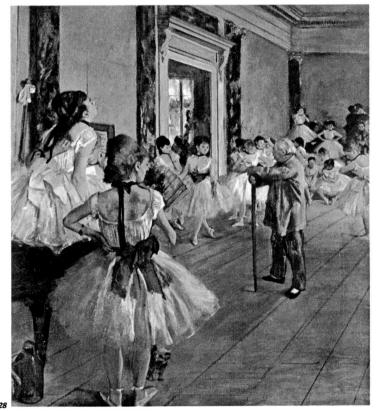

of the picture. On this page you can see some examples of unusual sizes in pictures painted by Modigliani, Picasso, and Degas. Therefore, remember that nothing compels you to paint on prefabricated sizes, although they tend to be used by artists 90 per cent of the time.

Fig. 128 Degas, The Dancing Class, Louvre, Paris. It seems as though the measurements of the picture correspond to the proportions of a 'figure' canvas,

but this is not so. Degas too chose a stretcher with special measurements for this picture: 85 x 75 cm.

How to construct a stretcher with canvas

I said, and I repeat, that it is more convenient and safer to buy a ready-made stretcher than to make it yourself, but there are cases where one lives a long way from where they are sold, or one throws away a canvas and the stretcher is left empty. In any case, it may be useful to know how to make a stretcher and how to mount the canvas.

As you can see in fig. 129, as well as the canvas, four strips of wood to form the frame, a hammer and saw, you will need some small wooden wedges, some special pliers with wide jaws to stretch the canvas, and a pistol-type stapler like decorators use. We are going to see what you can do and how to do it looking at the series of pictures figs. 130 to 141.

Construction of the stretcher and mounting the canvas

Figs. 130, 131, and 132
The system for assembling a stretcher has two special features. The first is that the strips are thicker at the outer edge than at the inner edge (fig. 131, A and B). This difference occurs on the upper face of the strips, the side which will be covered by the canvas. This keeps the canvas 2 or 3 m away from angle C (figs. 131, 132) so that the angle cannot spoil the picture.

Fig. 133 Secondly, the strips are not glued. The corners fit snugly into each other, and the strips are tightly held in place by the joints, the mounted canvas nailed onto the stretcher, and by wedges hammered into the corners which very slightly displace the strips, stretching the canvas and forming a rigid whole.

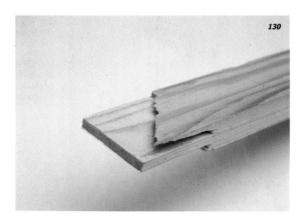

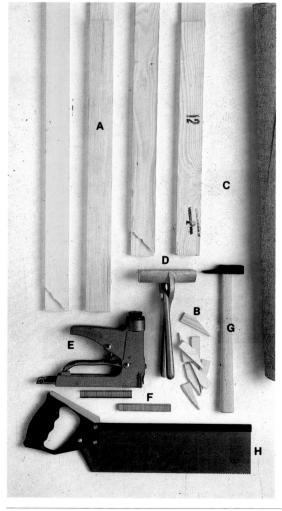

Fig. 129 Materials for constructing a stretcher with canvas: Al strips of wood for the stretcher. B) wooden wedges for stretching the canvas. C) canvas. D) special pliers, with wide jaws, for mounting and stretching the canvas. E) pistol-type stapler. F) staples. G) hammer. H) saw.

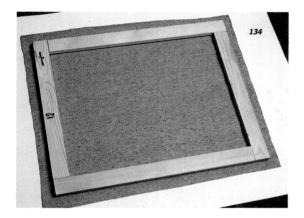

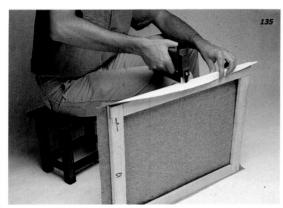

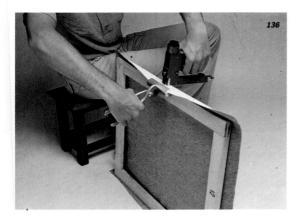

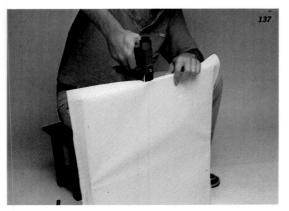

Fig. 134 After the stretcher is made (before the wedges are inserted) we cut the canvas, making it about 4 cm bigger than the stretcher on all sides.

Fig. 135 With the stretcher standing on edge, put the first staple in the centre of one of the longer sides.

Fig. 136 Turn the stretcher over and use the pliers to pull and stretch the canvas while you put the second staple in.

Fig. 137 Now place the stretcher in a vertical position, and put the third staple in the centre of one of the shorter sides. Repeat the operation on the opposite side, stretching the canvas with the help of the pliers. At this point, the stapling and stretching of the canvas form a slight wrinkle, which is characteristic of good mounting.

Fig. 138 With the help of the pliers, go on putting in staples until you reach the stage that can be seen in the following figure.

Fig. 139 The canvas is now attached to the stretcher and we only have to finish it off at the corners.

Figs. 140 and 141 The canvas has been folded at the corners and the excess cloth stapled, to finish the mounting. Place the wedges and the job is finished.

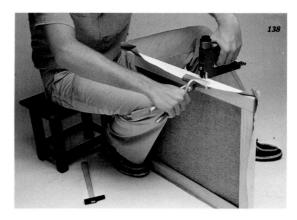

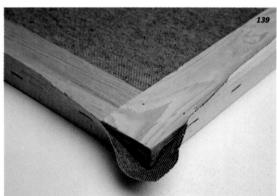

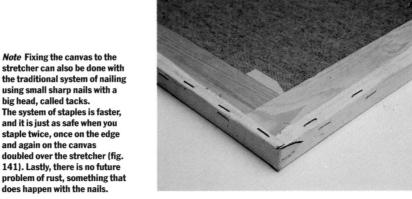

Brushes for oil painting

Bristle brushes, normally used for oil painting, are made of *hog's hair*. But for certain areas, people also use brushes made of sable or *squirrel hair*. Not long ago brushes made of *synthetic hair* appeared on the market, but I honestly believe they do not better the hog's-hair brush. This is harder and stiffer; it can be scrubbed, rubbed and washed with no danger of the hairs sticking together. The sable or squirrel brush is more suitable for a soft style of painting, with regular layers, without ups and downs. They are also used to deal with the drawing and colouring of small forms, details, and fine lines. Brushes for oil painting are made with three types of points.

- 1 round-pointed brushes
- 2 brushes with a 'cat's tongue' point (filbert)
- **3** flat-pointed brushes (fig. 143)

A brush is made up of handle, metal ferrule, and hair. The ferrule is the part which holds the hairs. The handles of brushes for oil painting are long and allow us to hold the brush further up, and paint further away from the picture, with the arm extended, thus extending the angle of vision.

The thickness of the hair and, in general, of the whole brush is identified by a number printed on the handle which goes from 0 to 24, going up in twos (0, 2, 4, 6, 8, 10, etc.). Below, you can see an assortment of brushes listed which would be considered normal.

Assortment of brushes used by the professional

A round brush, sable hair, no. 4.
A flat brush, hog's hair, no. 4.
A round brush, squirrel hair, no. 6.
Two flat brushes, hog's hair, no. 6.
A 'cat's tongue' brush, hog's hair, no. 6.
Three flat brushes, hog's hair, no. 8.
One 'cat's tongue' brush, hog's hair, no. 12.
One flat brushes, hog's hair, no. 12.
One flat brush, hog's hair, no. 20.

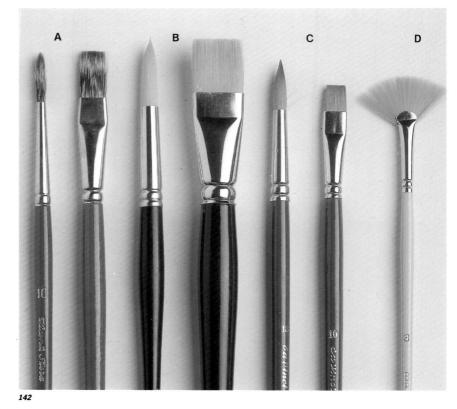

Fig. 142 Brushes for oil painting from left to right: A) squirrel-hair brushes. B) synthetic-hair brushes. C) sable-hair brush, fan-shaped, used specially for blending and very gentle softening of edges.

Fig. 143 Three bristle brushes, the kind of hair currently used by the professional painter, in its three characteristic forms: A) with rounded end, B) with 'cat's tongue' end (filbert) and C) with flat end.

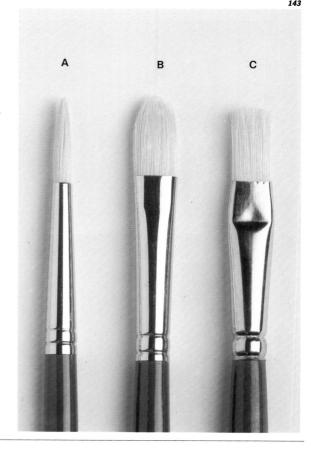

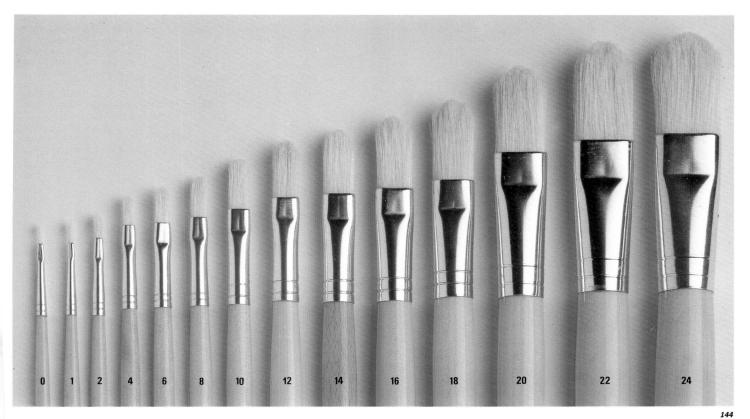

Fig. 144 Complete assortment of bristle brushes, from number 0 to number 24. The brushes are reproduced here in a slightly reduced size compared to the actual size. In this connection consider that the brush that here appears as number 24 corresponds to the actual size of a number 16 brush.

Figs. 145, 146, and 147 The two usual ways of holding the brush for oil painting. In the first place, note that the brush is held further up than a pencil or a brush for painting with watercolours. This meets the

need to paint a certain distance from the picture, with the arm almost extended, thereby increasing the angle of vision. On the other hand, note that as well as the usual way of holding the brush as if it were a long pencil (figs. 145 and 147), there is the way with the handle inside your palm, which facilitates drawing with the arm extended (fig. 146).

Taking care of brushes

When a brush is old but is in good condition, it paints better than a new one. For this reason, and because brushes are expensive, we have to look after them. When one is painting there are no problems. It is even possible to suspend the session for two or three hours without affecting the brushes. But from one day to another, and especially when the picture is finished and you don't intend to go on painting, you have to clean the brushes to keep them as good as new. In this connection, the most practical formula seems to be washing them in turps then rubbing them with soap and water. In the pictures on this page, figs. 148 to 153, you can see the procedure for the maintenance and care of brushes.

Figs. 148 and 149 This container for cleaning brushes is a double-bottomed pot. The top layer is full of holes so that when the container is filled with turpentine, the paint that comes off the brushes will fall into the real bottom and the next round of brushes can be washed with relatively clean turpentine. A spring on the upper part of the pot lets the brushes stay submerged in a vertical position without hurting the bristles.

148

150

151

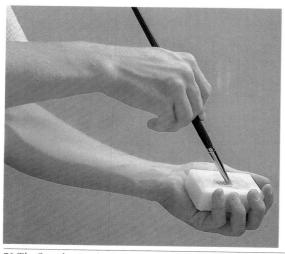

Figs. 150, 151, 152, and 153 One of the most mechanical and tedious jobs a painter has is washing brushes after finishing a session of painting. To put off this job, the professional sometimes resorts to the method of drying the brushes, first with a piece of newspaper and then with a cloth, and leaving them in a pan of water until the next session, the following day and the day after. But both are only temporary solutions. In the end you have to clean the brushes really well, first with turpentine, then with water and common soap, twirling the hairs in the palm of your hand, pressing and squeezing them with your fingers, running them under water. Then scrub them again on the cake of soap, until the foam is white and the brush is really clean. Smooth out the hairs once they are clean and put the brushes to dry in a pot or jar with the bristles upwards.

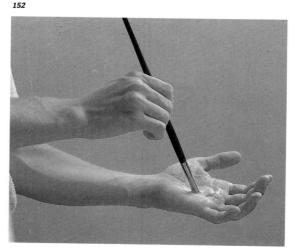

153

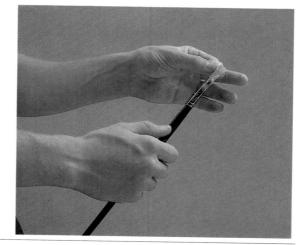

70 The Complete Book of Oil Painting

Palette knife, painting knives, mahl stick

As you know, a palette or painting knife has a wooden handle and a metal blade; it is flexible and ends in a rounded point without an edge. The most characteristic painting knife has the shape of a trowel. It is used both to erase, scraping the picture and taking the paint off, and to paint by using the knife instead of the brush. Only the stiffer palette knife should be used for removing hardening paint from the palette.

The mahl stick is a long stick topped with a small ball, which is used to rest your hand on when painting small areas, so as not to mark

the rest of the painting.

Additional items you will need are: charcoal for the initial drawing of the picture, spray fixer for fixing the drawing, pieces of newspaper, rags for wiping and cleaning brushes, and a stretcher-carrier for painting out of doors.

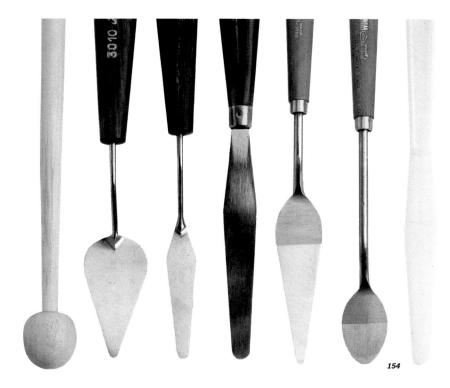

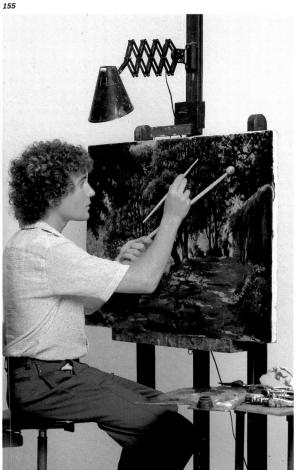

Solvents and varnishes

Oil colours, as they come out of the tube, are sometimes too thick. To dilute the colour and make it more fluid to paint backgrounds, touch up, repair glazes, and the like, the artist uses oils, solvents, mediums and varnishes. Here are the most important ones.

Oils

Among others, we can list linseed oil, poppy oil and walnut oil.

Linseed oil is the best known and most widely used of the drying oils for oil painting. It is extracted from the seeds of flax, a plant which also gives us the fibres to manufacture linen canvas for painting. It is light yellow, dries in three or four days, livens up the colours and dilutes the paint well. It is not usually used by itself, but rather mixed with turpentine as we shall see below.

Poppy oil is extracted from a variety of the poppy plant. It is a refined oil, practically colourless, used in the manufacture of oil colours. It is very stable, with less tendency to wrinkle than linseed oil, but it dries more slowly. It is the perfect oil for painting glazes.

Walnut oil is obtained by pressing ripe walnuts. It is very fluid, especially for completing painting that requires fine lines and detailed outlines and finishes. It is similar to poppy oil and, like it, is slow to dry.

Rectified turpentine is a non-fatty, ethereal,

volatile liquid, commonly known as turpentine, obtained from distilling resinous balsams that come from a certain variety of pine (coniferous). It is used especially when beginning to paint a picture, when one draws and colours the canvas with very thin paint. Using rectified turpentine as the only solvent, the paint appears matt, with no gloss. In any case, rectified turpentine has to be used in minimum amounts to avoid the paint losing the body needed to adhere to and stay on the canvas. Turpentine is also used to erase painted areas and to clean paint stains on clothes which should be done before they dry. It is used to clean brushes, knives, and palette, and for cleaning your hands, although turps substitute or white spirit can be used for these jobs. It is advisable not to expose turpentine to the sun or it will thicken or become resinous. It is inflammable.

Mediums and thinners

The medium is an oil-paint solvent made up of a mixture of synthetic or natural resins, drying oils, and solvents that evaporate slowly or quickly. Mediums can be bought already prepared in bottles in guaranteed brands such as Talens. But the classic prepared by the artist is based on linseed oil and rectified turpentine mixed in equal parts. Apart from this medium, which can always be recommended, we list the following brands as suitable for use:

Fig. 157 On the market, you will find more than twenty solvents, oils, essences, and varnishes for oil painting. Apart from the fact that you will want to experiment with some of them, I think that the only essential products are linseed oil, rectified turpentine, a touching-up varnish and the final protective varnish. It is also worth getting used to using a ready-prepared medium instead of the medium prepared by the artist himself of linseed oil and turpentine in equal parts.

137

Normal Rembrandt medium, made up of resins, drying vegetable oils, and slowly evaporating solvent. This can be used at all stages of the work, from beginning to end. It does not present any difficulties or future problems because it is not too fat or lean.

Fast-drying Rembrandt medium, similar to the normal one but faster drying thanks to the addition of drying agents and a more volatile solvent. It can also be used at all stages of painting.

Varnishes

We have to distinguish between retouching varnishes and protective varnishes.

Retouch varnish, made up of natural or synthetic resin and volatile solvents, dries fast and keeps the gloss of the picture uniform. It is used for retouching areas that are 'soaked in', matt, without gloss, or dull in colour due to absorption of the oil by the lower layer. After repainting these areas with retouch varnish the normal shine returns and the colours revert to their original intensity.

Protective varnish is the varnish applied to the picture when it is finished and has completely dried. The guarantee of complete and perfect drying presupposes a non-humid time of year, favourable atmospheric conditions in the studio, and depends on the thickness of the paint. There are glossy and matt varnishes found in bottles or in aerosol sprays.

Fat over lean

So that a painting does not crack with time, we have to paint the first layers with more turpentine than linseed oil. Oil paint – and even more so if diluted with linseed oil – is fat. Diluted with turpentine it is lean. A layer of fat paint takes longer to dry than a layer of lean paint. When, by mistake, lean is painted over fat, the lean layer dries more quickly than the fat layer, and when the latter dries, the lean layer on top contracts and cracks, and the picture appears broken up. Paint fat over lean.

Oil colours

There are still people who say that a good painter should make his own oil colours, following the example of the Old Masters, and reject buying them ready-made. The latter, they say, do not offer an absolute guarantee of quality and within a few years the colours may turn yellow, the paint may crack and deteriorate. If you want to verify this, ask experts and famous artists; but you will find that few modern artists make their own oil colours. Almost without exception, they buy them ready-made in art shops. This is no obstacle to knowing how and with what one makes oil colours. Oil colours are made up of two basic ingredients:

A) Colours or pigments are solids, generally found in the form of powders, known as earths; classified as organic when they come from the vegetable or animal kingdom and inorganic when from mineral origins.

These earths are mixed with liquids forming the thick paste characteristic of oil paints. These liquid substances are the

B) Binders, made up of fatty and drying oils, as well as resins, balsams, and waxes.

In the adjoining illustrations you can see a demonstration of this short explanation. The manufacture, at home, of oil colours is not advisable nowadays.

We are going to talk about colours (following page) and we are going to study the differences between one white and another white, between colours which dry fast and those which dry slowly and about their differing covering powers; all things you need to know to be able to paint with more understanding.

Fig. 158 Based on a picture by Rickaert, drawn by Maurice Bousset. The character in this illustration, a 17th-century artist, is grinding and making his colours for oil painting, as all artists did in olden times. Rickaert's composition lets us see the small room next to the studio, a kind of kitchen or rudimentary laboratory where the artist carried out all kinds of experiments. This kind of kitchen no longer has any reason for existing, although one still talks of 'pictures with a lot of kitchen work', referring to painting which by its texture, subject or treatment shows the use of materials, preparation or manipulation out of the ordinary.

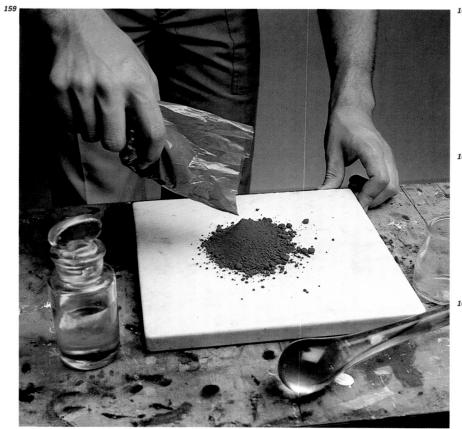

Figs. 159 to 162 Home preparation of oil colours. The materials required are coloured pigment in powder form, linseed oil, a slab of glass or marble, a pestle, a palette knife, and a container for storing the prepared colour.

Tip the coloured powered pigment onto the marble slab and pour linseed oil very slowly on top of it while grinding and mixing the colour with your palette knife and pestle until it takes on the consistency and fluidity of oil paint. You have to grind the colour very carefully, eliminating lumps and trying to obtain a homogeneous paste, which may need to be ground for ten minutes or a quarter of an hour and left to be taken up again later, until you have a perfect compound of pigment and linseed oil.

74 The Complete Book of Oil Painting

Oil colours are divided into whites, yellows, reds, greens, blues, browns and blacks.

1. White colours The most commonly known are lead white (also known as silver white), zinc white, and titanium white.

Lead or silver white has extraordinary opacity and covering power, and its speed of drying is also notable. These qualities can be useful for a style of painting based on thick pastes, being equally suitable for backgrounds or first states. It is very poisonous, something which you must constantly remember, especially the artist who wants to make his own colours. Simply inhaling the powder may have

serious consequences.

Zinc white has a colder tone than lead white, is less compact, covers less, and dries more slowly. This last quality becomes an advantage when the artist prefers to work on a layer which has not dried completely. It is not poisonous.

Titanium white is a modern pigment compared to the two mentioned. It has great covering power, normal opacity, speedy drying power, and no serious limitations, making it highly considered by most artists. In oil painting, white is one of the most used colours, which is the reason why tubes of white oil paint are usually large.

Figs. 163, 164, and 165 From left to right: lead or silver white, zinc white and titanium white. The latter is the most commonly used by artists.

2. Yellow colours The most common are Naples yellow, chrome yellow, cadmium yellow, yellow ochre, and raw sienna.

Naples yellow comes from lead antimoniate and is one of the oldest colours. It is opaque and dries well. Poisonous, like all lead colours, it can be mixed with any other colour without

undergoing alteration, as long as it is pure and of good quality. Rubens used it by preference, especially for flesh colours.

Chrome yellow, derived from lead and therefore poisonous, is supplied in various shades from very light, tending to lemon, to very dark, almost orange. It is opaque and dries

Figs. 166 to 169 From left to right: Naples yellow, cadmium yellow, medium yellow ochre and raw sienna.

Oil colours

well, but offers very little resistance to light, tending to become darker over the years, especially the lighter shades.

Cadmium yellow. A good colour, powerful, bright, rather slow drying; it can be mixed with all other colours, except those made of copper.

Yellow ochre is an earthy colour, classic and ancient, with great colouring and covering power and permanence. It can be mixed with any other colour without presenting any

difficulties as long as it is pure. It is also made artificially without any loss of the above-mentioned qualities.

Raw sienna is an earthy colour made of earths from Siena, Italy. It is a beautiful, bright colour, but as an oil colour there is a danger of it turning black because it has to be mixed with a large amount of oil. When painting in oils, therefore, it is better not to use raw sienna on large underlayers or on large areas where the colour will play an important part.

3. Red colours The most used reds are burnt sienna, cadmium red, alizarin crimson, and vermilion.

Burnt sienna has similar characteristics to the above-mentioned raw sienna. Darker, with a reddish tendency, it can be used in all techniques without limitations, that is to say, with less risk of later turning black. It was very much used by the old masters, mainly the Venetians. Some authors maintain that it was the colour used by Rubens to paint the bright reds of flesh.

Cadmium red substitutes advantageously for vermilion, as it does not blacken when exposed to sunlight. It is a bright, powerful colour, which can be mixed with all colours, except copper colours, such as opaque green. It covers well but dries with some difficulty. It is not advisable to mix it with copper colours or with lead white.

Alizarin crimson madder is a very potent colour supplying a rich range of pinkish, purple, and crimson tones. It is rather fluid and dries slowly.

4. Greens and blues The following are currently used: permanent green, terre verte, emerald green, cobalt blue, ultramarine blue, and

Prussian blue.

Permanent green. A pale, luminous green colour, produced by a mixture of chromium oxide (viridian or emerald green) and cadmium lemon yellow. It is a safe colour, without limitations.

Terre verte (earth green) is a brownish, khaki green derived from ochre. A very old colour which can be used in all techniques, dries relatively well, and has good covering power.

Emerald green. Also known as viridian green, it must not be confused with Schweinfurt green or opaque green, which it is called on some colour charts. The latter offers many inconveniences and limitations. This is not so with the emerald green we are referring to which is considered the best of the greens for its tonal capacity, richness, stability and safety. Cobalt blue is a metallic colour, it is non-poisonous, and may be used in all techniques without limitations. It covers well and dries fast, the latter a quality which may be a disadvantage when it is applied on top of layers of paint that are not quite dry, thereby causing cracking. In oil paint, due to the amount of oil it needs, it may take on a slightly greenish tone with time. The colour cobalt blue is obtainable both in pale and in dark shades.

Figs. 170 to 173 From left to right: burnt sienna, cinnabar vermilion, cadmium red, and alizarin crimson.

Figs. 174 to 178 From left to right: permanent green, emerald green, dark cobalt blue, dark ultramarine blue, and Prussian blue.

Ultramarine blue. Like the previous one, this is a colour used since ancient times. It was derived from lapis lazuli, a semi-precious stone, and for this reason it used to be the most expensive colour. At present, it is made artificially, and is stable with normal opacity and drying. It is also available in pale and dark shades and shows a more reddish tendency than cobalt blue.

Prussian blue, also called Paris blue, is a colour of great staining power. It is transparent, dries well, and has the important defect of being so affected by light that it may fade (with the peculiarity that the colour regenerates when it is left in darkness for some time). It is not advisable to mix it with vermilion or with zinc white.

vermilion or with zinc white.

5. Browns The most often used are raw and burnt umber, and Cassel earth, also called Van Dyck brown.

Raw and burnt umber. Both colours are natural earths, the second being the product of

calcination. They are both very dark; in the raw umber there is a slight greenish tint, while in the burnt umber the tone is slightly more reddish. They can be used in all techniques, but it is inevitable that they will blacken with time. They dry very fast, making it advisable not to apply these colours in thick layers, in order to avoid cracks.

Cassel earth or Van Dyck brown. Of dark tonality, similar to the previous browns, but with a rather greyish tendency. It is not recommended for painting backgrounds in oils because it cracks easily. It can be used in glazes, retouching, and in mixtures for rather limited areas.

6. Blacks The most well-known are lamp black and ivory black.

Lamp black, a rather cold shade, is stable and can be used in all techniques.

Ivory black, a slightly warm shade, gives perhaps a deeper black than lamp black, and is equally useful for all painting techniques.

Figs. 179 to 182 From left to right: raw umber, burnt umber, Van Dyck brown, and ivory black.

Oil colours in tubes

Oil colours are sold in squeezable metal tubes with screw caps in four or five different capacities, and basically, in two qualities, the 'student's' and the 'artist's' colours.

The table on this page indicates the sizes and capacities of tubes of oil paints found in art material shops.

Choose an average size and capacity for all the colours, except for white, which we always need to buy in a bigger tube. On this subject, and in accordance with my experience, I recommend:

tubes of 20 or 30 cc for all the colours, tubes of 60 cc for white

The tubes shown on this page in actual sizes are bright red (21 cc), Winsor green (30 cc), and titanium white (60 cc), and represent this relationship.

At the foot of this page are reproductions of six tubes of colours, the three on the left corresponding to student's quality and the three on the right to artist's quality. The latter are undoubtedly better - and more expensive but the quality of the student types is perfectly good, especially if you know how to choose the brands.

Fig. 183 Three sizes of tubes of oil paint, reproduced in actual size commonly used by professionals. Note that the tube of white, because it is the one used most, has to be a bigger size.

tubes of oil paints. The classes called 'student's' are on the left, artist's tubes are on the right.

Tubes

6

10

13

TABLE OF SIZES AND CAPACITY OF TUBES OF OIL PAINT

Length

105mm

150mm

200mm

Capacity

20cm³

60cm³

200cm³

Liquid oil colours

85

Not very long ago, *liquid oil colour* appeared on the market. This is a viscous, semi-liquid paint, and its characteristics can be summarized as follows: it is fast to light, dries to touch in a few hours, gives a bright film, can be painted over after about six hours, and after a few weeks it can be considered completely dry. With fluid oil colours one can paint on any surface whatsoever: canvas, wood, paper, plastic, glass, and others.

It is recommended to dilute it with white spirit. With this solvent, watercolour effects can be obtained, and it is possible to apply it with an airbrush. Adding a solidifying agent, you obtain a thick colour that can be applied with a knife. By spraying a freshly painted surface with water, you can create special effects.

Fluid oil paint is appropriate for painting any theme, either as an opaque, or, diluted with a

Fig. 185 With a collection of 23 colours in small tins, fluid oil colours allow us to paint on any surface, and are especially suited for painting large areas of an even colour or tone. Diluted with white spirit (a solvent similar to turpentine), fluid oil colours may be applied with an airbrush, or used to create special effects.

solvent, like a watercolour. There are, however, some tasks especially suited for this type of paint, for instance, abstract and mural painting, where there is a need to paint large surfaces with nearly uniform colour.

Fig. 186 Luis Feito, Number 935, oils, 1972 $(1.60 \times 1.30 \text{ m})$.

Fig. 187 Joan Ponc, Red

Character, oils on canvas, 1967-8 (1.25 \times 1.25 m). The workmanship and theme of both pictures are appropriate for fluid oil colours.

The Complete Book of Oil Painting 79

3*

3*

1***

Oil colour chart

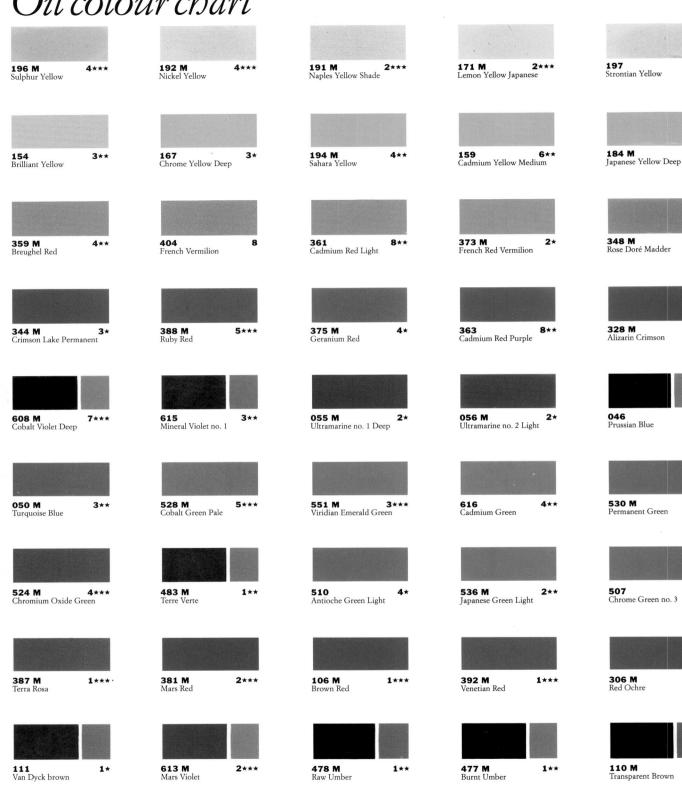

008 M

Titanium White

009 M

Zinc White

002 M

Silver White

217 M Mars Black

Theory and use of colours

'I am really enthralled by these laws and theories of colours. Ah, if only they had taught us about them when we were young!'

Vincent van Gogh (1853-90)

Colours of light

Light is colour.

Any textbook on elementary physics says that light is colour and proves it by explaining the phenomenon of the rainbow. 'The rainbow is the product of millions of drops of rain which, when they receive the rays of the sun, act like millions of small prisms and break the light down into six colours.' This textbook on elementary physics also explains that two hundred years ago, the physicist, Isaac Newton, reproduced the phenomenon of the rainbow in his home: 'he shut himself in a dark room. allowing a pencil of light to come in, similar to a ray of sunlight, and he intercepted this ray with a triangular prism, managing to disperse the white light into the colours of the spectrum'. The textbook goes on to say that years later another famous physicist, Thomas Young, did the opposite of Newton: 'researching with coloured lamps, he determined, by elimination, that the six colours of the spectrum could be reduced to three basic colours: green, red, and blue. Then he took three lamps and, projecting three beams of light through the filters of the said colours, he managed to reconstruct light, obtaining white

But for most people, all this belongs to the world of theory. You and I, are we really conscious of the fact that the light that surrounds us is made up of colours, 'travels in a straight line', at a speed of 300,000 kilometres per second to reach an object, when it will be partially absorbed, partially reflected, thus producing colour?

Not me. I have to make an effort to understand it. While considering and analysing these ideas one day, I decided that the best thing would be to put the theory into practice.

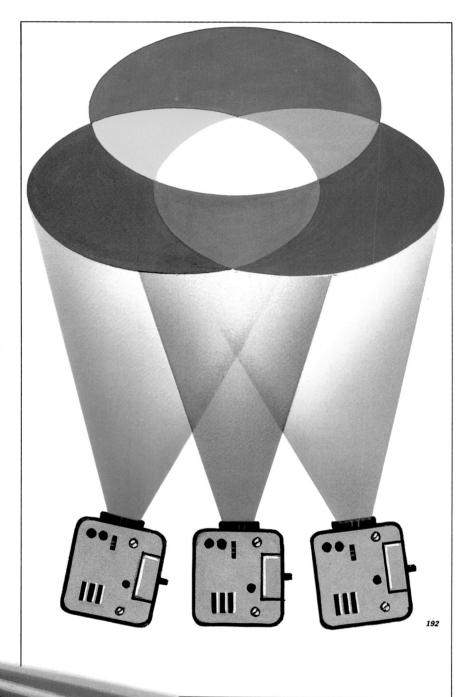

Fig. 192 Reconstruction of light. By projecting three beams of light through three filters with the primary light colours, green, red and blue, white light is reconstructed. When they are projected in

pairs, we obtain the three secondary light colours, yellow, cyan blue, and magenta. First, as Newton did, I broke down light. I bought a prism, I went home, I shut myself up in the dark, I projected the little pencil of light, and marvellous - do the same and you'll see it - the colours of the rainbow were projected onto the wall with a luminosity and clarity that I had never seen! I carried on with my practical experiments. I got together three slide projectors to project three beams of light, green, red, and blue. And then I did what Young did: I recon-

structed light.

I would need several pages of this book to describe the feelings I lived through that day. For example: to see with my own eyes that by projecting a beam of green light on the screen and projecting a beam of red light on top I saw the colour yellow! Imagine - for me, a painter who all his life had painted brown by mixing red and green! Since that day I have begun to understand what light is, which colours make up light, why we see a tomato as red and a plant as green, why red and green placed side by side offer such violence that van Gogh said, 'human eyes can hardly bear the sight of this contrast'. In other words, from then onward I understood the true extent of the concept: light is colour, and I developed my own textbook. By understanding that all the things you and I can see are, at this very moment, receiving the three primary light colours, we can establish the physical law

Fig. 193 When a body is illuminated it reflects all or part of the light it receives. A white cube or the page of this book are like all bodies - both receive the three light colours: red, green, and blue. But, just as the light rays arrive, the white surface returns them. reflects them, providing, with the sum of the three, the white colour we see on this page. When a black body receives the three colours, they are completely absorbed, leaving the surface without light, in the dark; hence, the reason why we see it as black. A red tomato absorbs the green and the blue and reflects the red. A vellow banana absorbs the colour blue and reflects the red and green which together allow us to see vellow.

Newton broke down the colours of light and determined the six colours of the spectrum. Young reconstructed light and classified the six colours of the spectrum as primary and secondary:

Primary light colours: red. green, blue Secondary light colours (mixtures in pairs, of the previous primary colours): blue light + green light = cyan red light + blue light = magenta green light + red light = yellow

From the previous classification we can deduce that a complementary colour is a secondary colour which only needs a primary colour in order to complement it and make up white light (or vice versa). Complementary light colours: Blue, complement of yellow Red, complement of cyan

Green, complement of magenta

of absorption and reflection of light colours, which says:

All opaque bodies, when they are illuminated, have the property of reflecting all or part of the light they receive.

Pigment colours

Pigment colours are our painting colours, made with colouring materials, oils, and varnishes. With these, the artist tries to imitate the phenomena of light and colour we saw on the previous page. In connection with these explanations, remember that light, in order to 'colour' bodies, uses *three intense light colours*; when they are mixed in pairs they provide *three lighter colours*; and when they are all mixed together, they make *the colour white*.

But we cannot 'colour' with light. In painting we cannot obtain lighter colours from mixtures of dark colours. Taking as a basis the six colours of the spectrum, we change the nature of some colours with respect to others, saying that:

Our primary colours are the light secondary colours, and vice versa, our secondary colours are the light primary ones.

Complicated? No. Let me explain. Our mixtures of colours always suppose *taking away light*, that is, passing from light colours to dark colours. If we mix red and green, we get

Fig. 194 The primary pigment colours, cyan, magenta, and yellow, mixed in pairs, supply the secondary colours; green, red, and blue. Mixing the three primary colours produces black.

a darker colour – brown; if we mix our pigment primaries together we get black.

Summarizing what I have explained and looking at the pictures at the foot of this page: light 'colours' by adding colours. To get the secondary light colour, yellow, light adds red and green, and when their rays are mixed they give a lighter colour. Physicists call this additive synthesis.

Pigments 'colour' by taking away colours. To obtain the secondary pigment green, we mix cyan and yellow. In respect to the light colours, cyan absorbs the red, and the yellow absorbs the blue. The only one both reflect is green. This phenomenon is called subtractive synthesis.

Primary pigment colours
Cyan, magenta, yellow
Secondary pigment colours (by mixtures of the previous primary
colours in pairs):

Magenta pigment + yellow pigment = red Yellow pigment + cyan pigment = green Cyan pigment + magenta pigment = blue.

Fig. 195 How light 'colours': additive synthesis. In order to 'colour' the secondary light, yellow light adds red and green and takes away (absorbs) the blue.

Fig. 196 How pigments 'colour': subtractive synthesis. In order to paint the secondary pigment green, we mix yellow and cyan. The yellow absorbs (takes away) the intense blue and the cyan absorbs (takes away) the red. The only colour reflected by both is green.

130

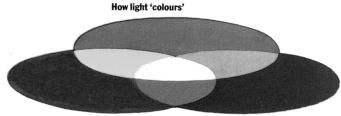

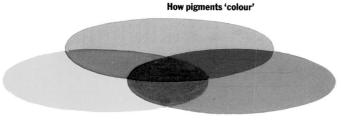

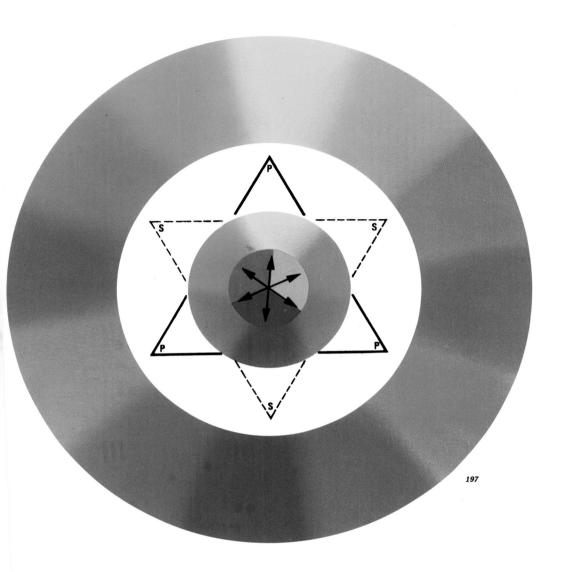

Fig. 197 Chromatic circle or table of pigment colours. The primary colours are each indicated with a P in the heavily marked triangles. When mixed in pairs, they make the three secondary colours, each indicated with an S in the broken-line triangles. These, mixed in pairs with the primary colours, give us six more colours, the tertiary colours. Below is a list and classification of these colours.

Pigment colours

Primary:

Yellow Cyan (*) Magenta

Secondary:

Green Red Blue

Tertiary:

Orange Crimson Violet Ultramarine blue Emerald green Light green

The chromatic circle, or table, of pigment colours – our colours – starts with the three primary colours, indicated with **P**s in the points of the heavily marked triangles. By mixing these in pairs, we obtain the three secondary colours (**S**s), which, when mixed with the primaries, create six more colours, called tertiary colours.

What we have studied up to now may be summarized in a series of practical conclusions which justify the study of colour theory:

1 Light and the artist both 'colour' with the same colours – the colours of the spectrum.

2 The perfect coincidence between light colours and pigment colours allows the artist to imitate the effects of light when it illuminates bodies,

(*) the colour *cyan* does not exist on oil colour charts. It is proper to the graphic arts and colour photography, and has been adopted by the modern treatises of colour theory. It corresponds to a blue-green or turquoise.

and thus to reproduce, with considerable faithfulness, all the colours of nature.

3 In accordance with the theories of light and colour, the artist can paint all the colours of nature, using only the three primary colours.

4 The study and use of complementary colours allows us to achieve effects of great value and a better resolution of the picture.

We are going to talk about this last and very important conclusion on the following page.

Complementary colours

The chromatic circle on the previous page shows us which colours complement each other. Thus, we see that:

Yellow complements blue
Cyan complements red
Magenta complements green
(and vice versa)

Following the same rule of some colours opposing others, we can deduce the complementary colours of the tertiary colours.

Orange complements ultramarine blue Light green complements violet Crimson complements emerald green (and vice versa)

But what's the real use of the complementary colours at the moment of painting?

In the first place, to create colour contrasts. If you paint a yellow and right beside it you paint an intense blue you will obtain one of the biggest colour contrasts imaginable in painting. The Post-Impressionist artists like van Gogh and Gauguin, but especially those who came later – Derain, Matisse, Vlaminck – made of this rule a style of painting called Fauvism. André Derain's painting Westminster Bridge, reproduced on the following page, is an excellent example of the possibilities complementary colours offer to the artist who understands their theory and practical application

Moreover, knowledge of the complementary colours is basic for painting the colour of shadows, for the shadow of any subject will contain the complementary colour of the subject in question. For example, in the real shadow of a green melon – dark green like the tertiary emerald green – it is certain that crimson, its complementary, plays a part.

Fig. 198 Complementary colours

The secondary colour blue, a mixture of the primary colours cyan and magenta, is the complement of the primary yellow, and vice versa.

The secondary colour red, a mixture of the primary colours yellow and magenta, is the complement of the primary colour cyan, and vice versa.

The secondary colour green, a mixture of the primary colours cyan and yellow, complements the primary colour magenta, and vice versa.

198

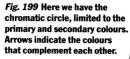

Fig. 200 The juxtaposition of two complementary colours provides a maximum contrast, which is used by many artists.

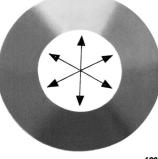

Fig. 201 An example of the use of maximum contrasts created by juxtaposing complementary colours. André Derain, Westminster Bridge, private collection, Paris.

199

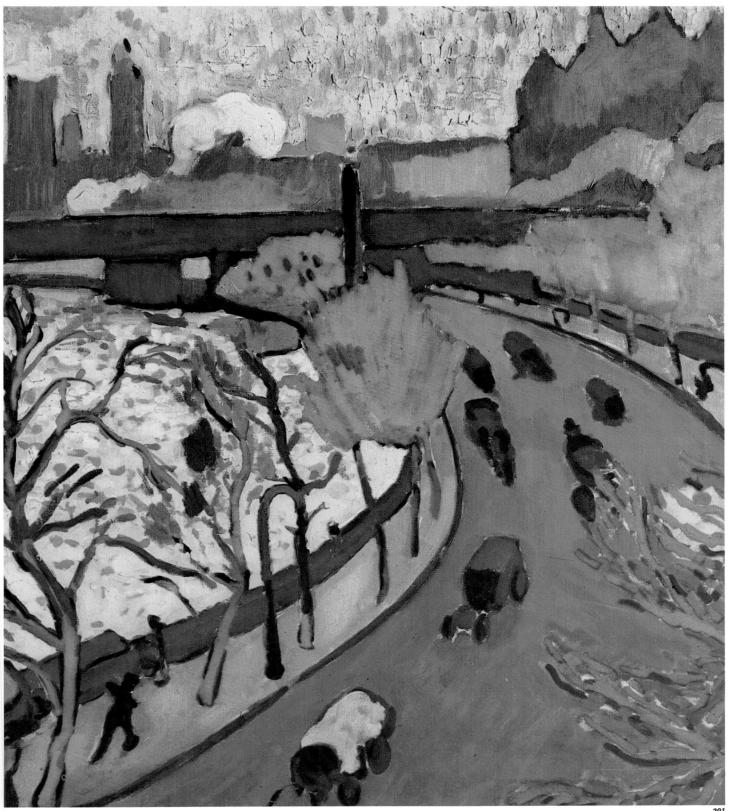

Colour of the subject

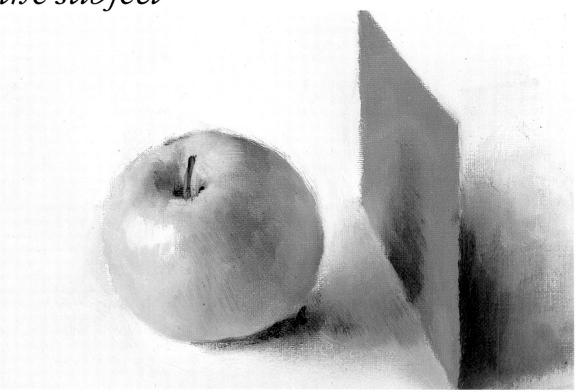

Fig. 202 In this apple we see the factors that determine the colour of bodies, that is, the local colour, the tonal colour, and the environmental or reflected colour.

We speak of a blue flower, a red house, a yellow field, and we say it truthfully, but when we are painting not all of the flower is blue, nor all of the house red, nor all of the field yellow. There are shades, penumbras, reflections. There are, in the end, factors which intervene and condition the colour of bodies. They are:

- a) The local colour, the subject's own colour.
- **b)** The tonal colour, produced by lights and shadows.
- **c)** The colour of the environment: reflections from other bodies.

These factors are in turn conditioned by:

- **d)** The colour of the light.
- e) The intensity of the light.
- f) The interposed atmosphere.

The local colour is the real colour of the objects, not modified by the effects of light and shade or by reflected colours. In fig. 202 we see a yellow apple illuminated by lateral light, located on a green surface. This green surface has no variations and no volume, it's flat, its *local colour* is green, there is no other. On the other hand, the apple, even though it is yellow, is lighter on the lit side and darker on the shadowed side. It reflects the

green of the surface on the side nearest to it. However, there is a yellow which is not modified by the lights, nor by the shadows, nor the reflections. This is the real yellow of the apple, the local colour.

The tonal colour is a larger or smaller variation of the local colour, generally influenced by the reflection of other colours. Therefore it is a complex colour with many variations within itself. It is the lightest colour of the illuminated parts, and the darkest colour of the shadowed parts – with an infinity of shades in between – complicated, moreover, by the colours reflected by other bodies. In the apple in the above-mentioned figure, we can note the variety of shades of the tonal colour.

The reflected colour is a constant factor, the product of the colour of the environment and the reflection of other objects. In spite of the fact that some artists have made of this factor auxiliary forms, and sometimes even the basic source of illumination, it is not advisable to accentuate the effects of reflected lights and colours because, in general, they prejudice the volume and the realism of the subject, offering a spurious resolution that somehow looks as if it is affected.

Problems of construction and perspective

The laws of perspective must not be overlooked. On these depend whether the picture is constructed well or poorly, especially in cases including geometrical forms. Luckily, in this case, the problem comes down to placing a series of circles in perspective, and looking at them from above or below. The so-called parallel, or one-point perspective, is the least complicated form of perspective, as you can see in the short explanation given in the adjoining box. Also, in the illustrations and texts at the foot of the page, read the rules to be taken into account when constructing circles and cylinders in perspective. Remember that we are learning through practice, and it would be a good idea to follow these explanations with a pencil in hand, and draw.

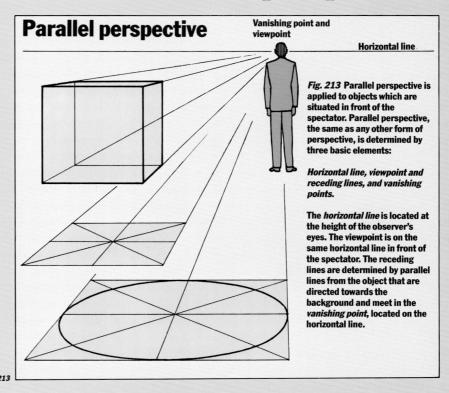

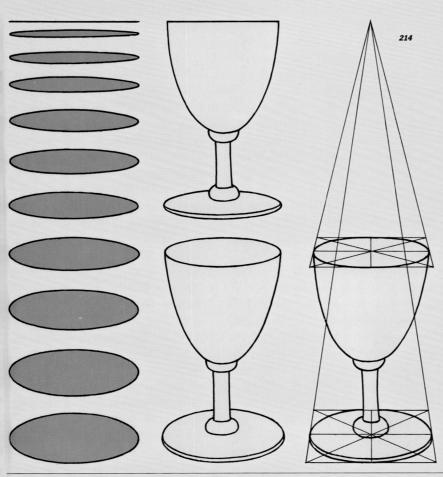

Fig. 214 In order to paint a tumbler, a wine glass, or a coffee cup, you do not need to draw such a laborious perspective scheme as illustrated in this figure. It is useful to know, however, that this scheme exists, to learn, for example, that a circle located at the height or level of the horizontal line appears as a horizontal line, while, as the circle moves lower in comparison to the horizontal line, it becomes an oval that gradually opens up.

Fig. 215 When you draw the top or base of a cylinder, remember that the vertices should not end in an angle, but rather in a more or less tight curve, depending on the level from which you see it, above or below, but always in the form of a curve.

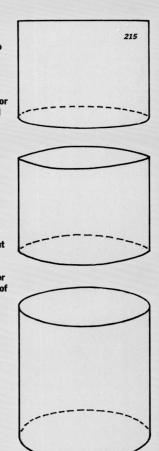

Previous study in lead pencil

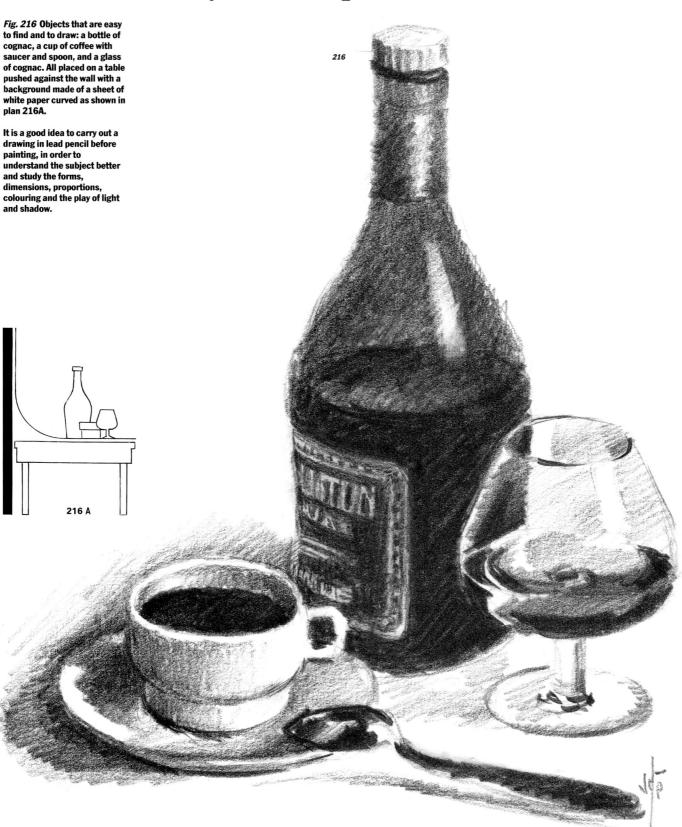

First stage

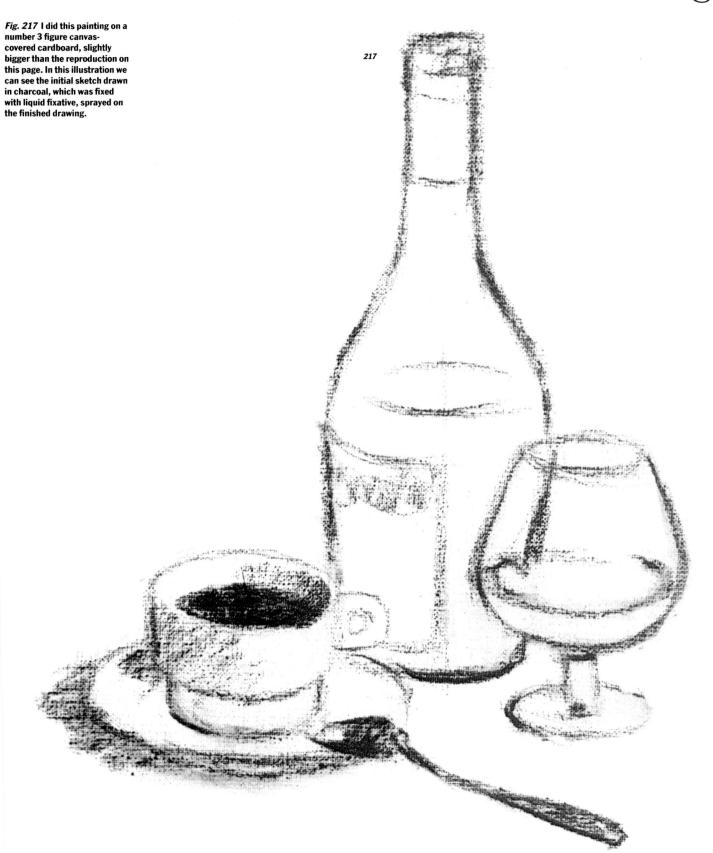

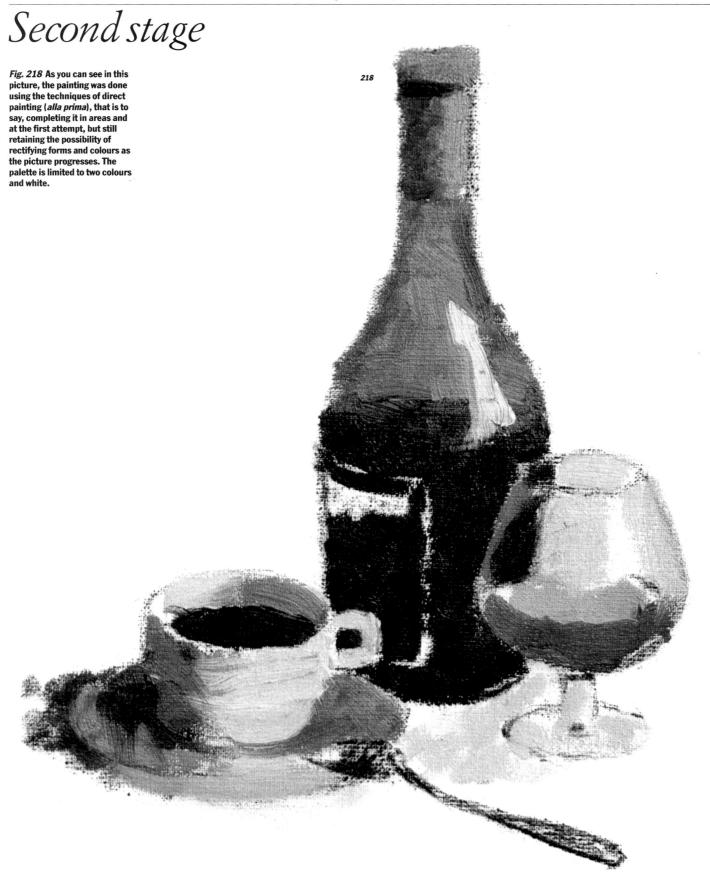

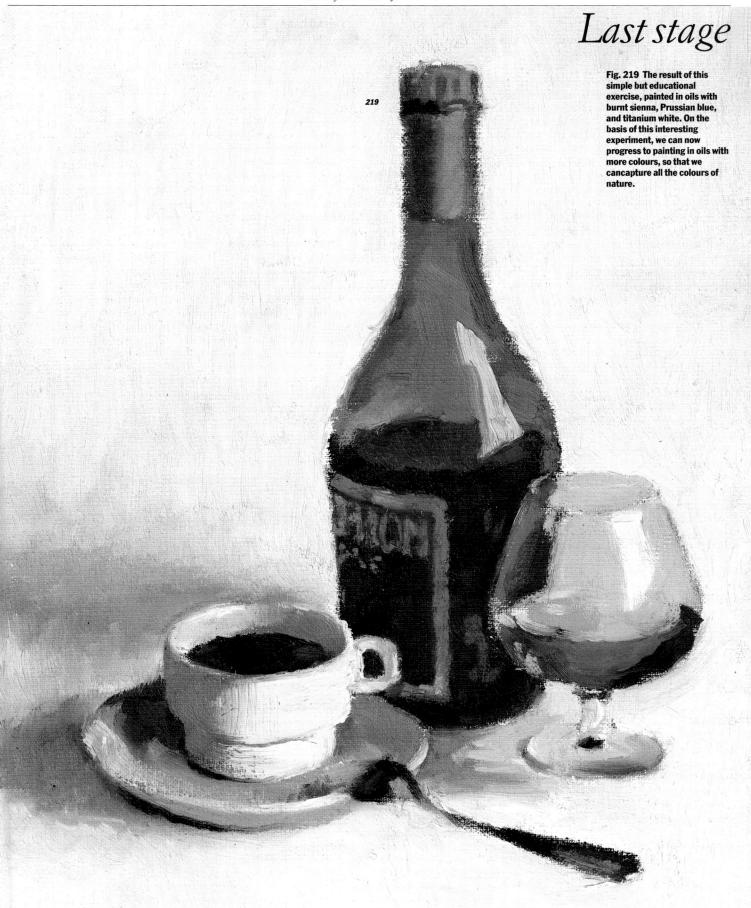

Use and abuse of white

In some of my books, but mainly in the one called *This is How To Paint*, I have discussed pictures that are sadly grey, without contrasts, dull, having monotonous colours, with no appeal. In the same book I said that one of the main reasons why the amateur falls into what I call 'the trap of the greys' is the use and abuse of white and black mixed with other colours. He believes that to lighten a colour you only have to add white, and to darken it to add black, without taking into account that with black and white you are really painting grey.

This does not happen only with the inexperienced amateur. On a lesser scale, I have seen the effects of the 'grey trap' in more than one exhibition of pictures. Mental laziness on the part of the artist? Perhaps, but in any case, let me remind you of the following facts.

Painting in watercolours, white does not exist. Watercolours are transparent. To paint sky blue you only have to add more water to the blue, so that the white of the paper shows through, making the blue lighter. Painting in oils, white is a 'colour', and, of course, oils are opaque. To paint the sky blue you have to mix blue paint with white paint. White paint is a basic component – 50 per cent together with black – in getting a grey.

Adding white to a colour involves (in theory, and unfortunately, in practice) moving the colour in the direction of grey.

Do you know the experiment with white coffee? If you take two identical white cups with the same amount of coffee in both and add water to one of them and milk to the other, you will see the water lighten the colour of the coffee, turning it red, orange, gold – reacting in a similar way as when you mix a transparent colour or a watercolour with water. In the other cup the milk transforms the colour of the coffee into a dirty sienna, a dirty ochre, a grey cream, behaving in the same way as when you mix the opaque colour white with another equally opaque colour.

This experiment enables us to understand and remember a highly important rule, that is:

White is not the only way to obtain a lighter colour.

In this, too, we have to imitate nature. Observe how the colour red behaves in the spectrum (fig. 224C). Note that when it gets dark it turns violet and blue, and when it gets lighter it turns orange and then yellow. Thus, in order to lighten a red, you first have to mix

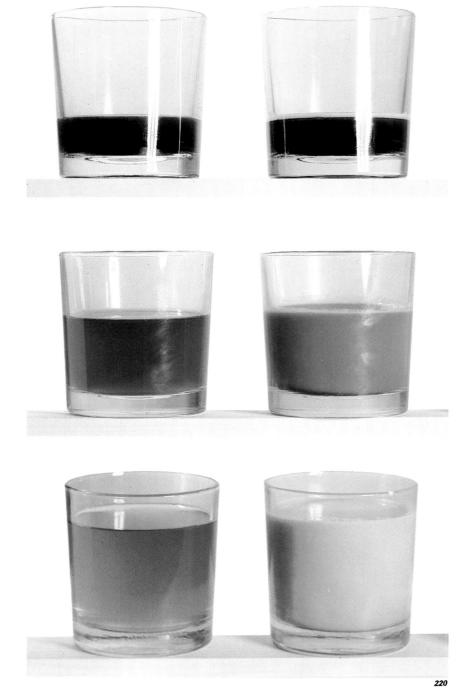

Fig. 220 Two glasses with the same amount of coffee, one lightened with water and the other lightened with milk, produce results that can be compared to painting in watercolours and oils. The watercolour, on being lightened with water, keeps its original tone. However, opaque oil colour, when lightened with the colour white, has its original tone adulterated and

it with yellow, and then with yellow and white. Try it. Paint something red – a tomato or a pepper – and try to lighten it 'whisking the white out of sight', as my old art teacher used to say.

As for black, the problem is the same but

221

more dramatic. The Impressionists reached the point of excluding black from their palettes because they considered it the enemy of colour.

But we are going on to talk about black in much more detail on the next page.

made grey.
Fig. 221 The illuminated parts
of a red pepper or tomato
should not be lightened with
just white, pinkish colours, or
mixtures of white and red. The
light parts of red bodies have
to be obtained by following the
scheme of the spectrum using

oranges and yellows. These, in some areas, may be mixed with white. But try, as far as possible, to 'whisk the white out of sight', knowing that, in a fatal way, white alters the saturation and makes the colours grey.

Use and abuse of black

Yes, Manet excluded black from his palette. So did Monet, Degas, Sisley and Cézanne. Years later, once the fever of Chevreul, the colour theoretician, had passed, van Gogh and Gauguin and Bonnard used black. But they did it with insight, they used black as *local colour*, a proper colour, not as a *tonal colour* – are you following me? They did not use black as a 'colour' to darken shadows, because in this they already had the experience of their predecessors, Monet, Manet, Degas, and others. They all knew perfectly well that:

In nature black does not exist.

In fact, black is the negation of light. A black surface absorbs all the light colours and does not reflect any. The colour black in oils – ivory black, lamp black or jet black – mixed with any other colour to darken and paint in shadows, becomes a germ of dirtiness which contaminates all the colours, taking life away from them, transforming them automatically into a horrible grey range.

Do the test yourself. Take yellow oil paint – cadmium yellow, for example – and paint a strip. Then try to darken the yellow with black, painting a breakdown like the one in fig. 224A. Do you see what happens? The black does not darken the yellow, it dirties it. It turns it green, a strange green which in no way represents the good shadow of the colour yellow.

Let's go back to nature and try to imitate the behaviour of the spectrum. We see that darkness comes from the side of the reds, that these become oranges, which lighten until they are yellow. So then, the perfect range of a broken-down yellow should begin with black, followed by purplish red, sienna, orangeish sienna, chrome yellow, cadmium yellow, lemon yellow (a mixture of yellow, green, and white), and finally white. Compare the schemes of the spectrum in figs. 224A 'bad' and 224B 'good'. Here the colour yellow is broken down first with just black ('bad') and then, with the above-mentioned colours of the spectrum ('good').

To confirm this theory, observe what I have painted, and you will forget black as the colour of shadows. Here, in fig. 222, a yellow jar and a yellow banana have been painted exclusively with cadmium yellow medium, black and white, and the results are completely unpleasant – cold colourless, monotonous, and dirty. But in fig. 223, the same subject is painted with a palette of reds, siennas, ochres, crimsons, blues, and a little white with very pleasing results.

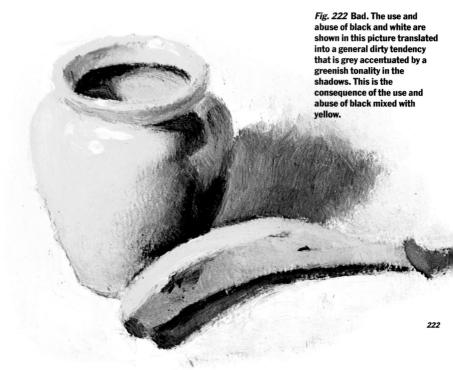

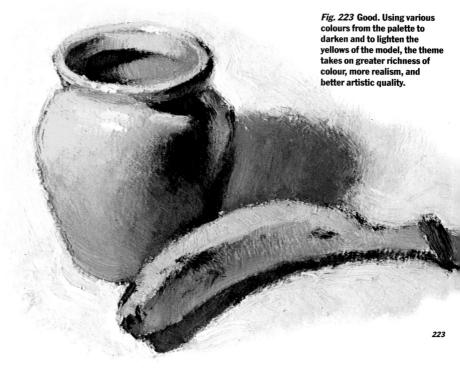

Fig. 225 Here we have three formulas which show us how to make a neutral black, a warm black, and a cold black, by mixing burnt umber, emerald green, deep madder, and Prussian blue.

Look at the schemes of the spectrum. Besides the yellow and the red that we have already studied, we offer one corresponding to the colour blue. On the side of clarity, blue meets with green, while on the dark side, the blue spectrum ends in an intense, dark blue with a violet tendency, represented in the colour chart by ultramarine blue. Therefore, in a breakdown of the colour blue, there should be a blueish-green tendency in the light parts, neutral blues in the centre, and violet in the

At the foot of this page, we see the three classical mixture formulas for making the colour

black without black.

Formula A): neutral black: 1 part burnt umber 1 part emerald green 1 part deep madder

Formula B): warm black 1 part deep madder 1 part burnt umber 1/2 part emerald green

Formula C): cold black 1 part burnt umber 1 part Prussian blue 1/2 part emerald green

A

What do 'warm black' and 'cold black' mean? Well ... a black with a tendency towards crimson would be suitable for painting the black of a doorway or a window of a building in full sunlight, while a black with a blueish tendency might be used to paint the black of an intensely dark area in the middle of a forest.

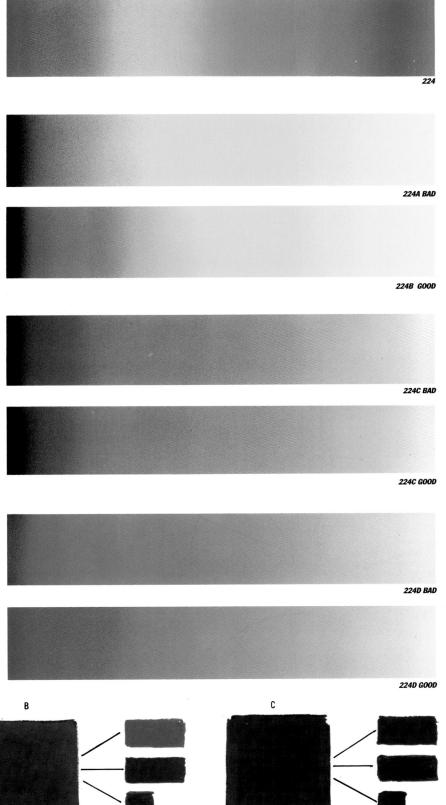

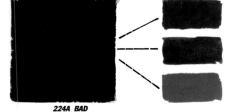

The colours of the shadows

Each artist has his own palette, for no two people see colour in the same way. But where there is no variation, and where painting must submit to a perfect *colouring relationship*, is in the shadows. With reason, Rubens said: 'It doesn't matter what colour you give the lights, if you paint the shadows with the colour corresponding to each light.' But what are the colours of shadows?

Some time ago, when I was holding classes in painting and drawing in the Escuela Massana in Barcelona, I found a formula which since then I have recommended to hundreds of pupils. It is based on generalizing the colours which play a part in any shadow colour. These are the three colours:

- **1.** The original colour in a darker tone.
- 2. The complement of the colour itself.
- **3.** The colour blue, present in every darkness.

Let's use some examples. On this page and on the page on the right, there are various schemes painted with the three colours which play a part in the colour of shadows. Look at the still life in fig. 229 – a dish, four apples, and two bananas – reproduced three times on a smaller scale in figs. 229A, B and C. Now, look at what the pictures 'say'.

Fig. 229A: The original colour in a darker tone is the tonal colour: ochre in the shadow of the dish, dark yellow in the shadows of the bananas, dark red for the apples. These colours are mixed with

Fig. 229B: the complement of the original colour. For the yellow dish and bananas, the complementary colour is intense blue; for the red apples, the complementary colour is green. These colours are mixed with

Fig. 229C: blue to provide the colour of the shadows. Keep in mind that blue is the basic colour of the shadows. Decide yourself, looking at the subject, whether this blue has to be clean, neutral like cobalt blue, greenish like Titian blue, or purpleish blue like ultramarine blue.

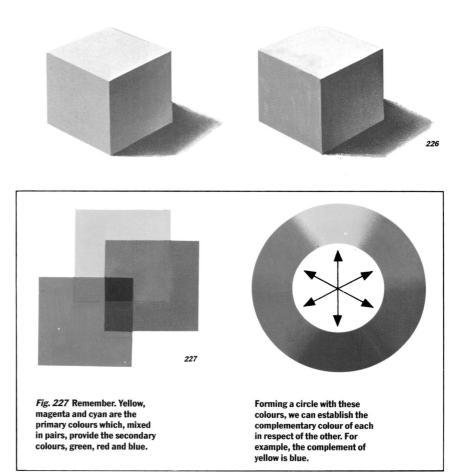

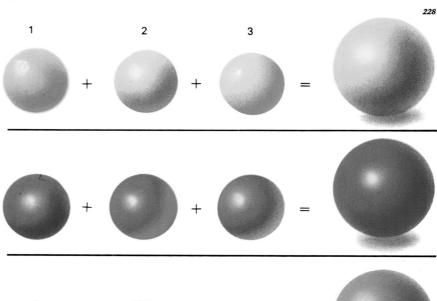

Fig. 228 The original colour is shown in a darker tone, mixed with the complementary colour, and mixed with blue, to provide the colour of the shadow. Here, this formula is applied to a yellow object, a red object, and a blue object.

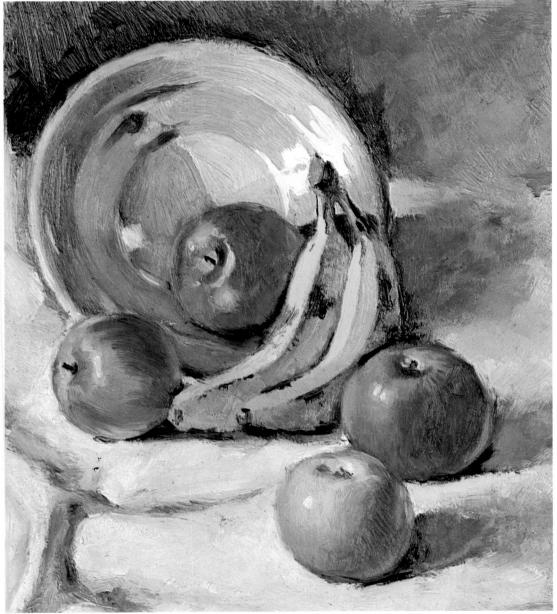

Fig. 229 Here we have a still life where the basic colours are the yellow of the bananas and the dish, and the red of the apples. In pictures 229A, B and C, we see the theoretical-practical separation of the colours that make up the shadow. In fig. 229B, I have painted the shadows the complementary colours of the original colour. In fig. 229C, we see the blue which plays a part in the colour of the shadows. In connection with the blue, it is worth quoting Monet's phrase when he was talking with his friends about the colour of shadows: 'When it gets dark the whole country turns blue.' When the light diminishes the influence of the colour blue increases, becoming particularly evident in the shadows.

Harmonizing colours

In all the pictures of the great masters there is always a colour plan suggested, on the one hand, by the subject itself and, on the other, by the artist - a harmonization of tones and colours that is calculated and organized. It is not by chance that Rubens painted the flesh, faces and bodies of his models with a range of warm colours - pinks, yellows, ochres, oranges and reds - while his friend Velázquez painted the flesh, faces and bodies with greys, blueish pinks, 'dirty' yellows and greenish ochres, in a range of less warm, almost cold colours.

Harmonizing colours is an art and is an important part in the art of painting. A picture may be pitched with colours of a reddish tendency. answering to a range of warm or hot colours. Or it may be painted with blueish colours, answering to a range of cold colours. It might also be a series of greyish tones and colours, answering to a range of broken colours. It is even possible to paint with a melodic range of colours, understanding that such a range is made up of a dominating colour broken down in different tones, just as Picasso did in the pictures of his Blue Period or his Pink Period (fig. 230).

The range of colours is dictated by the subject itself, thanks to the fact that in nature there is always, whatever the theme, a luminous tendency which causes the colours to relate to each other. Figs. 231, 232 and 233 are three examples of luminous tendencies offered by nature. In fig. 232 we see a seascape of a fishermen's wharf in Barcelona painted in a range of cold colours. It was ten in the morning on a winter's day, with the sun half covered by the clouds, lighting against light colours, so that the seawater, with hardly any waves, was like a white mirror in which appeared the grey and blue reflections of the ships and boats tied to the wharf. Everything was grey and blue. There was nothing else to do but see and take in. I became almost obsessed with the idea of blue as I worked to get this result.

At the other extreme (fig. 233), we have a street in a village, painted at five o'clock in the afternoon on a warm summer's day, with a range of warm colours. The sun at this time 'colours' with warm colours – yellows, ochres, siennas, reds. This wide range of yellows and ochres is reflected by the walls of the houses. where even the blue shadows offer a reddish. purpleish tendency.

Last of all, in fig. 231, we see a still life painted in the studio in daylight, using a range of broken colours of a neutral colour tendency,

Fig. 230 Picasso, The Meeting, Picasso Museum, Barcelona. The nicture belongs to Picasso's famous Blue Period, when the artist enjoyed himself painting with a melodic range of colours, based on the colour

neither warm nor cold. They were produced by mixing complementary colours and white, a very interesting formula which we are going to talk about in the following pages.

Artificial light also offers a definite chromatic tendency. The light of a normal electric lamp is yellowish. Fluorescent light is blueish or

pink.

Now that we are in the field of practice, the artist should first study, before painting, the luminous tendency presented by the subject. In the second place, once the range of colours he is going to use has been decided on, he has to enjoy the luminous tendency, accentuate it if it is suitable, for with this he will be on the way to interpreting the colour and painting a good picture.

Fig. 231 J. M. Parramón, Still Life with Lemonade, private collection. Here we have an example of harmonizing colour by means of a range of broken colours suggested by the hues and tones of the model itself.

Fig. 232 J. M. Parramón,
The Fishermen's Wharf in
the Port of Barcelona, private
collection. The harmonization
of the colour is generally
suggested by nature itself. At
the time and season of the year
when I painted this picture, at
ten in the morning on a winter's
day with the sun almost hidden
by clouds, the scene offered
this range of cold, perfectly
harmonized colours.

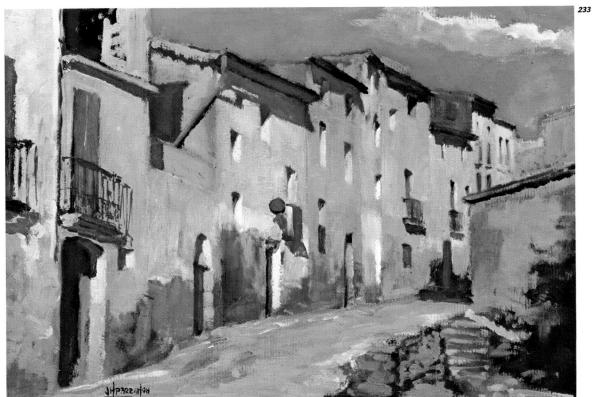

Fig. 233 J. M. Parramón, La Torra, private collection. Five o'clock in the afternoon on a summer's day with bright sun and a clear sky. At this time of the day and year the light is rather orange, yellow with a red tendency. Nature herself harmonized the colours, 'tinting' the forms and bodies with a golden colour. Harmonizing, in short, is the same as knowing how to see, interpret, and highlight the effects of light and colour, even when they are not as obvious as in this case.

Range of warm colours

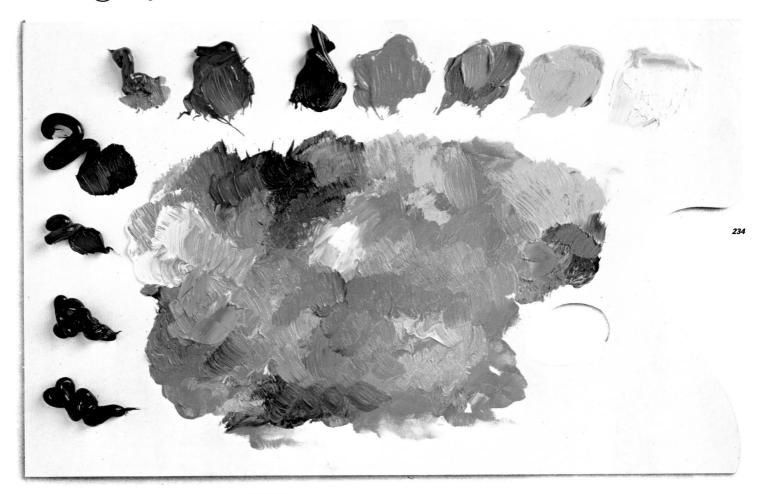

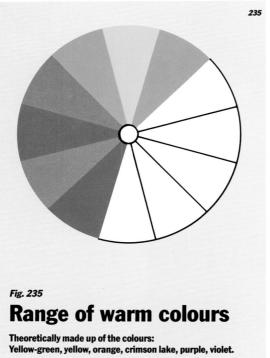

From a theoretical point of view, the range of warm colours is made up of the colours shown in the chart in fig. 235. In practice, thinking of the colours that are close to, or related to red, and taking into account the colours currently used by professionals, we have to choose the colours reproduced on the palette shown in fig. 234:

Yellow, ochre, red, burnt umber, deep madder, permanent green, emerald green, and ultra-marine.

But be careful! The fact that we have excluded cobalt blue and Prussian blue does not mean that these colours – and all colours – cannot play a part in a range of warm colours. Range of warm colours means a chromatic tendency towards red, yellow, orange, ochre or sienna, but still being able to mix these and other warm colours with blues, greens, or purples, to make them greyer, 'to dirty them', as Titian said, in order to paint shadows and penumbras.

Fig. 234 This palette shows the range of warm colours. The dominating colour is red, and the related colours are greenyellow, yellow, ochre, crimson, purple, and violet.

Fig. 236 Cézanne, Still Life with Curtain (detail), Hermitage Museum, St Petersburg. Here we have a superb example of how Cézanne applied a range of warm colours. Study this colouring to see how, by means of yellows, reds, and siennas, Cézanne achieves an extraordinary harmonization of colour.

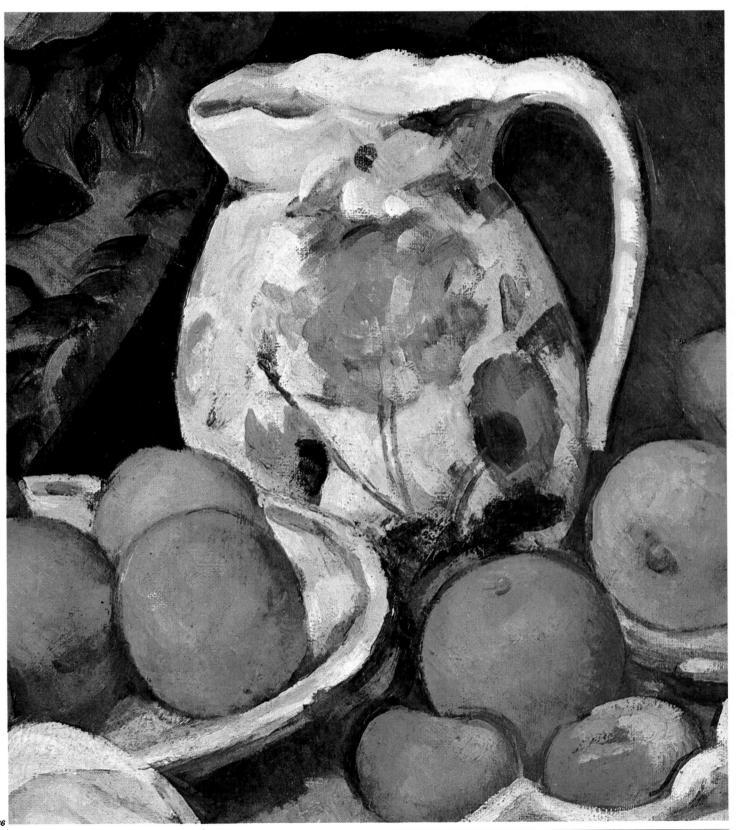

The Complete Book of Oil Painting 111

ige of cold colours

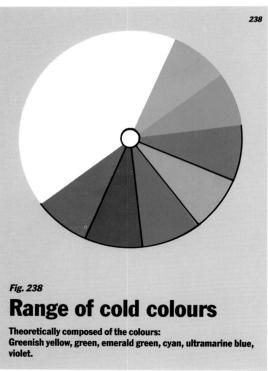

The colours set out in this chart are the ones that, in theory, make up the range of cold colours. But in practice, the colours in this range are conditioned by those which the artist normally uses and which appear on the palette in fig. 237. Following the order of the palette from bottom to top and from left to right:

Prussian blue, dark ultramarine blue, dark cobalt blue, emerald green, permanent green, deep madder, through to raw umber, yellow ochre.

Study this magnificent portrait by Degas (fig. 239), so that you understand that a range called *cold* does not necessarily have to be blue, even when the flesh colours, themselves, include the tendency towards blue.

Fig. 237 Symbolic palette showing the range of cold colours, which, as you can see, offer a dominating blue, harmonized with bright green, neutral green, emerald green, cobalt blue, ultramarine blue and violet. Painting with a range of cold colours does not mean excluding reds, yellow and ochre from your palette: these can participate in harmonizing the picture as long as the piece preserves a blueish tinge.

Fig. 239 Degas, Portrait of a Young Woman, Louvre, Paris. This is a good example of what was said at the end of the caption for fig. 237. This excellent portrait by Degas uses harmonization of cold colours, not simply because of the background blue and the blueish black of the dress, but because there is blue in the hair, in the shadows of the face; even in the flesh colour a hint of blue appears.

Range of broken colours

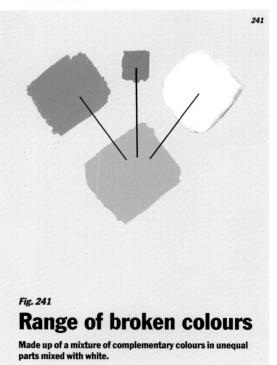

Take two colours that complement each other, for example, green and intense red. Mix one part green with a quarter of intense red and add as much white as you like. You will get a brown, khaki, ochre, or green colour which, in any case, will be greyish or 'dirty'. The more equal the amounts of the two colours, the darker this colour will be. Its greyness will depend on how much white is added.

Fig. 242 is a clear example of a picture resolved with a *range of broken colours*. You can see the range of neutral, grey, 'dirty' colours, dictated by the scene itself of a cloudy day in an industrial area with tenements, houses and buildings tainted by the soot from the engines.

Observe, moreover, that within this beautiful range of broken colours, you can choose a cold or warm tendency, and that the range of such colours does not exclude any colour from the palette.

Fig. 240 All the colours of the palette may play a part in a range of broken colours, as long as they are not lively or raw, but are broken, dirty colours.

Fig. 242 J. M. Parramón, The Bridge in Marina Street, private collection. A grey day and a grey theme, carriages and engines, smoke, soot, undefined colours, broken

colours. A theme which nature set out like this and which I had the luck to see and paint. Observe that there are many different colours and tones, but that none stands out except the crimson red in the centre of the train. However, the admixture of other tones converts it into a broken crimson, so that it harmonizes with the whole. Choose a grey model on a grey

day and try painting with a range of broken colours. It is, I believe, sheer poetry.

The colour of flesh

range of colour the painter prefers. Francesc Serra, an excellent figure and female nude painter, once explained to me the composition of flesh colour: 'Let me assure you that it is the same as, or very similar to, that used by Dutch artists in the eighteenth century,' he

said. Here you may observe

this in fig. 245.

Fig. 243 Francesc Serra, Nude, private collection.

Fig. 244 Velázquez, The Venus in the Mirror, National Gallery, London.

Fig. 245 The colour of flesh depends on many factors. This is the formula used by Francesc Serra, a specialist in nudes.

The famous painter Eugène Delacroix said on one occasion, 'Give me mud and I will paint the skin of a Venus on condition that I can paint around her, as the background, the colours that I want to.'

Delacroix's statement confirms the idea that there is no determinate flesh colour, that flesh colour depends on the background and the form of lighting, that is, the colour of the light, its intensity and quality, and the atmospheric reflections. Lastly, flesh colour depends on the

116 The Complete Book of Oil Painting

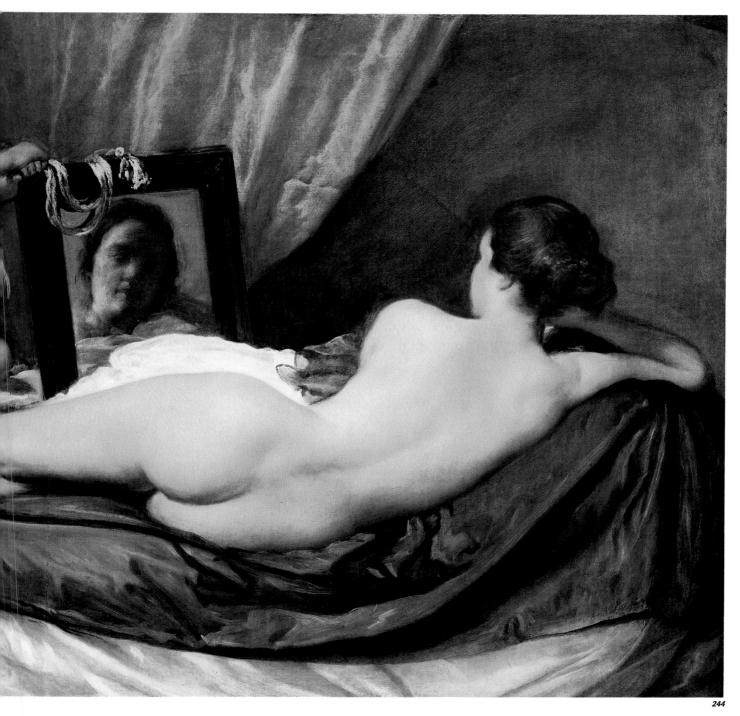

White mixed with ochre and with English red gives a light flesh colour. Adding ultramarine blue gives a dark flesh colour.

Contrast of tone and colour

Curious, educational, and practical is this question of contrasts.

The most well-known effect is the one in fig. 247 called *simultaneous contrast*. The rule about this says: a colour appears darker when the colour around it is lighter and conversely, a colour appears lighter when the colour around it is darker. Another well-known rule within the field of *simultaneous contrasts* is: the juxtaposition of the same colour in different tones causes a change to appear in all tones, with the light one becoming lighter and the dark one becoming darker (fig. 246).

And we also have the effect of *maximum* contrast, caused by the juxtaposition of two colours that are complementary to each other (figs. 248A, B, C, D, E and F).

Serving for some cases, but not all, is the so-called *induction of complementary colours*, which can be explained by saying: *in order to modify a certain colour it is enough to change the colour of the background surrounding it*. In fig. 249, the green square looks blue against a yellow background, and yellow on a blue background.

Lastly, let's play with the *phenomenon of successive images*. Look steadily at the three coloured balloons on a white background in fig. 250. Concentrating your eyes on the centre of the picture, watch the red balloon for about thirty seconds in a very well-lit room. Then lift your eyes a little higher, to

Fig. 246 The juxtaposition of two different shades causes the enhancement of both, lightening the light one and darkening the dark one. Looked at separately, each of these strips is regular in tone and without variation, but looked at one above the other, we observe a considerable variation in the tones; each strip appears lighter at the top edge and darker at the lower edge.

246

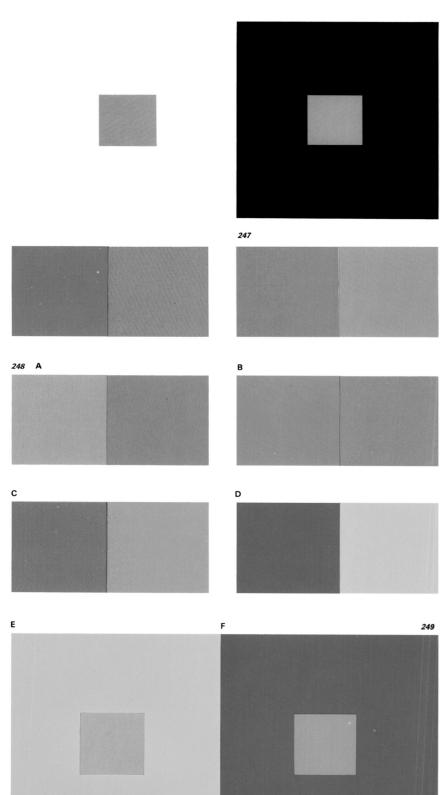

Fig. 247 (Left) Because of the law of simultaneous contrasts, the pink square printed on a white background seems darker than the same pink square on a black background.

Fig. 248 The juxtaposition of two complementary colours produces maximum contrast (independent of tone). The use of these juxtapositions may produce powerful artistic effects in compositions. It can also be the cause of unpleasant dissonances, as occurs, for example, in pictures 248A

Fig. 249 The 'sympathy' of complementary colours, Chevreul's law, according to which a colour casts over its neighbouring shade its own complementary colour, is obvious in this illustration, in which the green square in a yellow background had a slight blueish tendency, while the green square on a blue background shows a slight yellowish tendency.

Fig. 250 The physicist Chevreul established that 'the vision of any colour creates, by "sympathy", the appearance of the complementary one'. You may test this law by looking steadily for half a minute, and in good light, at the balloons printed on the w..te background. After thirty seconds, move your eyes a little higher up the page and you will see the same forms, the balloons, but in their complementary colours.

the centre of the white space. You will see on the white paper, relatively clearly, the three balloons in their complementary colours; the yellow balloon will be blue, the red one cyan, and the blue one yellow. The colours of such after-images are very pale.

The induction of complementary colours and the phenomenon of successive images lead us to the evidence that the vision of any colour whatsoever creates, by 'sympathy', the appearance of the complementary colour. The physicist, Chevreul, classified these phenomena with this rule:

A colour will cast its own complementary colour (its contrasting colour) and tones thereof, over neighbouring colours and shades.

Contrast of tone and colour

Fig. 251 Francesc Serra, Reading, private collection. In this picture the artist took into account the induction of complementary colours, painting a grey, greenish, yellowish face, but on a blue background, which by induction adds red (the complement of blue) to the colour painted on the face.

Simultaneous contrasts, maximum contrasts, induction of complementary colours, successive images. What's the use of all this? Let's look at it from a practical point of view.

If you want to modernize your themes and your palette, remember the colour contrast provoked by two juxtaposed complementary hues, one touching the other. Try to find this effect even before painting, when you analyse or compose the subject. Think of the possibility of changing colours.

If you want an object to stand out from the background and take on relief, use simultaneous contrast; exaggerate the difference between the outline and the background, the brightness of the object and the darker tone of the background, or vice versa. In this connection, look at what Cézanne used to do in *The Card Players* (fig. 252). Observe the colours, false and dark, painted in the background, the heads, the arms, to give emphasis to the figures.

Bear in mind the *induction of complementary colours* and the phenomenon of *successive images*, always painting the background first and then the subject, placed in front. This will allow you to adjust and harmonize colours. Try to paint *at the same time*, *all at the same time*, filling the whole canvas, leaving no white areas, remembering Chevreul's definitive statement:

Putting a brushstroke of colour on a canvas is not just staining the canvas with the colour on the brush, but also colouring the space around the stain with its complementary colour.

Fig. 252 Paul Cézanne,
The Card Players, Musée
d'Orsay, Paris. Observe the
simultaneous contrasts
provoked by Cézanne in this
work, by analysing the
background and the
surroundings in which the
artist darkened or lightened
as necessary, giving the forms
greater relief, visibility and
delineation.

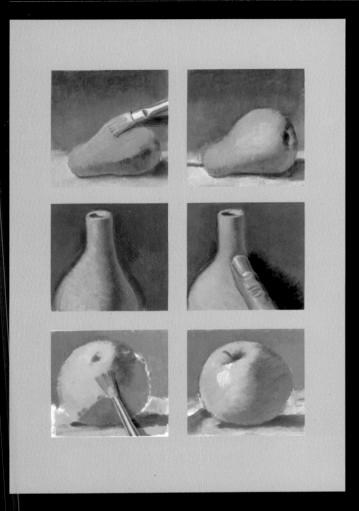

Technique and sk.ill in oil painting

Learn to see and mix colours

Technique and skill – both can be learned. By knowing how to see and mix colours, for example. Painting is something that one learns by observing, imagining, trying, and finally doing. Let us try out this process now. Look at fig. 253. This range of colours, ochre, red, purples, violets, and mulberries, was printed with only three colours - yellow, magenta, and cvan - as you can see in the three colour samples below. Do you see how it works? Well, it's a question of covering the three samples at the bottom with a piece of paper, and then, choosing any colour at all from fig. 253, imagine how much yellow, magenta and cyan are needed to make it up. For example, the colour F (the mulberry in the middle), what colour is it? Imagine the colour and then look at the solution: 0% yellow, 90% magenta, and 20% cyan. What colour is it? Ask yourself this question at any time looking at an orange: cadmium red, cadmium yellow, and a little crimson; looking at an unvarnished piece of furniture: ochre, white, and maybe a little ultramarine blue. Look at the sky and ask yourself what colour it is. Is it blue? White? More white than blue? Is there a touch of crimson?

Then, when you have the model in front of you and you do these exercises, there'll be a lot more possibility of your being right.

Fig. 253 Look at the colours that appear in this figure.
Select one and try to analyse the colours you would have to mix and in what proportion, to make up that colour.

Fig. 254 (Above right). Mixing the three primary colours in pairs, we obtain the secondary colours green, red and blue. Mixing all three at once, we get black

Figs. 255, 256, and 257 Look at the three ranges of colours in these illustrations: yellowish green, reddish ochre, and purpleish blue. They show that with only three colours (and white), it is possible to obtain all the colours of nature.

Fig. 258 J. M. Parramón, Landscape of the Catalan Pyrenees, private collection. Painted with three colours and white.

Mixing with three colours and white

The first practical exercise for anyone who wants to learn to make hundreds of different colours by mixing a few is to paint with only three colours and white.

The basic colours that cannot be made with any mixing formula are yellow, magenta and cyan. As you will have guessed, these are the three primary colours from which (with the help of white whenever necessary) you can make all the colours of nature.

When painting in oils the three above-mentioned colours are:

- **1.** Medium cadmium yellow.
- 2. Alizarin crimson madder.
- 3. Prussian blue.

Figs. 254A and 254B show how to obtain the three *secondary colours*, green, red and blue, by mixing the primary colours in pairs. Observe that mixing the three primary colours together produces black.

Study the ranges of colour reproduced in figs. 255, 256 and 257 achieved by using the three primary oil colours. Even this landscape (fig. 258) was painted with only the three colours mentioned and white. Incredible? We are going to do it together, starting on the following page.

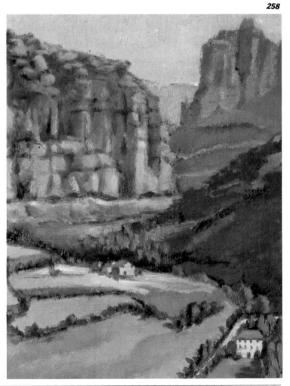

The Complete Book of Oil Painting 123

Composition of warm colours

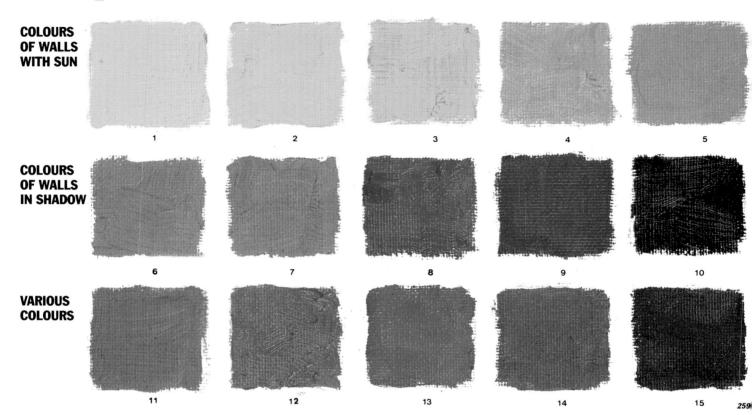

To work! Let's paint! First as an experiment, we'll practise the art of seeing and mixing colours, then we'll paint a coloured sketch which you will feel proud of.

Let's get down to it. Imagine you are painting the urban landscape in fig. 260. It's five o'clock in the afternoon: the sunlight, as the sun goes down, colours the old walls of this old square, gold, yellow, ochre and shades of orange; in the shadows the surfaces and the bodies run with vermilion and red.

You are going to compose these colours – I beg you to do it – painting just with the three primary colours.

Required materials

Oil colours: cadmium yellow medium; alizarin crimson madder, Prussian blue, white.

Canvas, cardboard, or heavy paper. Brushes: 5 flat, number 8 or 10 hog's-hair brushes.

Other: palette, turpentine, rags, pieces of newspaper.

1. Luminous walls. Mix yellow with

white and add a little crimson.

2. *More luminous walls.* Add a little more yellow to the previous colour, plus a touch more crimson.

3. General colour. (Clean the brush.) Take yellow and add a little white and crimson.

- **4.** Dark luminous colour. Use only yellow and a little crimson. Use no white.
- **5.** *Walls on the left.* Add crimson and a little white to the previous colour.
- **6.** Lighter walls in shadow. (Clean the brush or change it for a clean one.) Yellow and crimson with almost no white, plus a little blue.
- **7.** Turret shadows. Begin with yellow and gradually add crimson. No white or blue.
- **8.** *More intense shadows.* The previous colour with crimson added.
- **9.** *Darker shadows.* The same as the previous colour with a little more yellow, some crimson, and a little blue.
- **10.** Black in the shadows. Deep madder and a little blue. Try to get a warm black.
- **11.** *Greenish ochre.* Yellow, white, and a little crimson; add blue progressively.

(Careful with Prussian blue! It's very strong.)

- **12.** *Vermilion.* Lighten a little crimson with white and add yellow (but as you can see, it's not a brilliant red. This is one of the few colours that is not obtained with only the three primary colours.)
- **13.** *Warm purple.* Made up of crimson and white, plus a little yellow.
- **14.** *Dark sap green.* Begin by making up a medium brilliant green with yellow and blue. Then add crimson until you get this dirty green.
- **15.** Black with a greenish tendency. To the previous colour, add more blue and crimson.

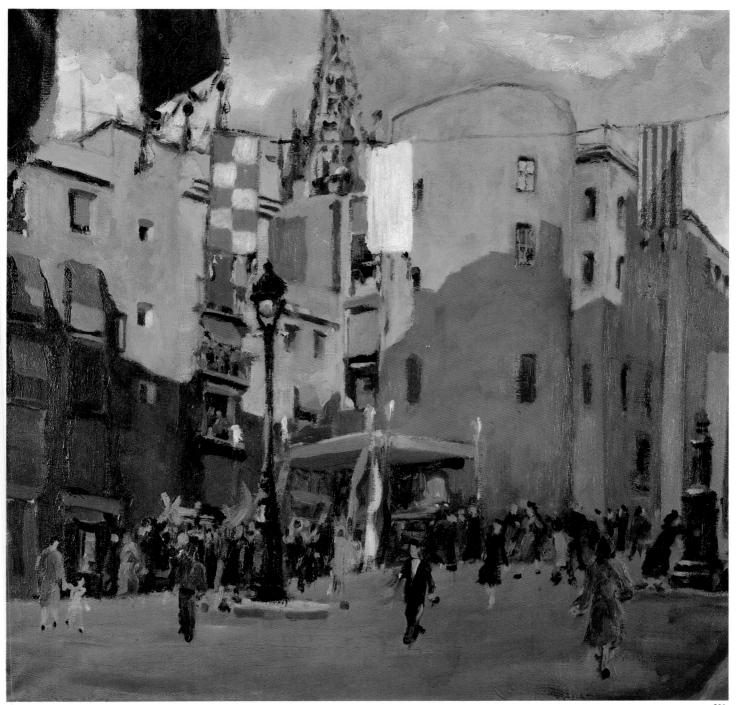

260

Fig. 260 J. M. Parramón, Plaza Nueva Fiesta de San Roc, private collection. Example of harmonizing warm colours.

Composition of warm colours

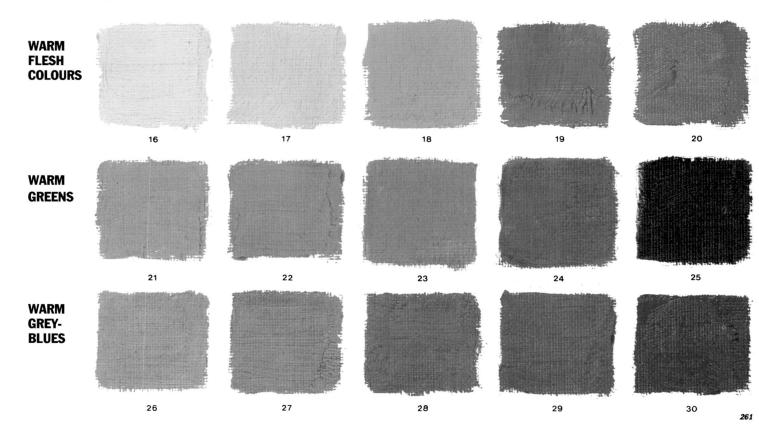

We are still painting with three colours, but this time we are not restricted by a particular model. We are going to paint three series of warm colours, the first of flesh colours, the second of warm greens, and the last of warm greys and blues.

Use the same colours as before: white, cadmium yellow medium, alizarin crimson madder, Prussian blue, and the same materials.

- **16.** Luminous flesh colour. A lot of white, a little yellow, and a little crimson
- **17.** *Pinkish flesh colour.* The previous colour with a little more yellow and a touch more crimson.
- **18.** *Yellow ochre.* Yellow and white in almost equal amounts, a little crimson, and a little blue.
- **19.** *Raw sienna.* The previous colour, adding more crimson, more yellow, and a little more blue.
- **20.** *English red.* Mix crimson and white until you approach this tone, then add a little yellow.
- **21.** Yellow green. (Clean the brushes, please.) Yellow and white, then add blue gradually. Lastly, add a little crimson to 'dirty' the green until you get this tone.
- **22.** *Light green.* The previous colour with a little more blue.
- **23.** *Bright green.* Yellow and blue (with no white) and a little crimson to make the colour warmer.
- 24. Warm dark green. The previous

- colour with blue, added gradually, until you get this intensity.
- **25.** Black with a greenish tendency. The previous colour with more blue and red.
- **26.** Warm grey. Mix white, blue and crimson to get a very light purple, then add yellow gradually, until you reach this colour.
- **27.** Warm blueish grey. To the previous colour add a very small amount of blue and crimson.
- **28.** *Warm neutral grey.* To the previous colour add a little yellow, blue and crimson.
- **29.** Warm greyish blue. (Better clean the brush.) A little white with a little blue and crimson until you get a blueish mulberry; this can then be made greyer with a little yellow.
- **30.** *Dark grey-blue.* To the previous colour add blue and a little crimson.

Composition of cold colours

As on the previous page, but now working with a range of cold colours, we are going to paint three series of colours, the first of flesh colours, another of greens, and the last of greys and blues.

Materials are the same as in the previous sessions.

I advise you to begin with a clean palette and brushes.

31. Flesh colour, shining parts. White and insignificant amounts of yellow, crimson and blue in similar proportions, emphasizing the crimson.

43

42

- **32.** *Cold flesh colour.* White, a little yellow, a little crimson, until you get a pale orange, then you must gradually add blue until you get this tone.
- **34.** Flesh colour in shadows. Mix white, yellow and blue, until you get a light green, then gradually add yellow and crimson.
- **35.** Dark flesh colour in shadows. With crimson, blue, and a little white, make up a purple with a reddish tendency. Now mix in a little yellow, and on the basis of this sienna colour, add white and blue.
- **36.** *Light green.* White, a little blue, and a little yellow.
- **37.** *Blueish green.* The same as before with a little more blue.
- **38.** *Bright green.* Yellow and blue. No crimson, no white.
- **39.** *Dark permanent green.* The same as before with more blue.

40. *Dark green.* Add more blue and a small amount of crimson to the previous colour.

44

45

- **41.** Light blue-grey. (Clean the brushes, please.) White and blue until you have a pale blue, then add a very small amount of crimson and the same of yellow.
- **42.** *Medium blue-grey.* The same as before, increasing the proportion of blue.
- **43.** *Cold blue-grey.* The same as before, increasing the blue and increasing the crimson.
- **44.** *Blue violet.* Add a little crimson to colour number 42.
- **45.** *Intense blue-grey.* The same as before, adding blue and a little yellow.

Composition of cold colours

Now we are going to paint a range of cold colours corresponding to the picture on the following page, a seascape where greens and blues predominate (fig. 264). We continue using the same materials.

- **46.** Colour of the earth in light. A lot of white with a little yellow and a touch of crimson. You get a cream colour which has to be 'dirtied' with a little blue.
- **47.** *Normal earth colour.* The previous colour adding more yellow, crimson, and a little blue.
- **48.** Earth colour in the background mountains. White, blue, and crimson are mixed until you get a warm purple, then add yellow and blue until you get this colour.
- **49.** Awning on the left. The previous colour with a little blue and a small amount of yellow.
- **50.** Awning on the right. The previous colour with a little blue and a small amount of yellow.
- **51.** Shining parts of the water. (Clean or change brushes.) White and a little Prussian blue.
- **52.** *Shining parts of the water.* The previous colour with a little more blue and a little bit of yellow.
- **53.** Colour of the water on the left. The same as before, with more blue and a small amount of crimson, no yellow.

- **54.** Colour of the water in general, and part of the sky. The previous colour with more blue and a little crimson.
- **55.** Colour of the sky. The previous colour with more blue and a little vellow.
- **56.** Blue-grey shadows. White, blue and a little crimson very little mixed until you get a luminous blue. Then add a little yellow to 'dirty' it.
- **57.** *Blue shadows.* Lighten the previous colour with white and then add a little blue.
- **58.** The green of the doors on the right. Add yellow to the previous colour, then mix with a little crimson to make it greyer.
- **59.** Dark siennas reflected in the water. Crimson and yellow to make an English red, then add blue gradually, until you get this burnt umber colour.
- **60.** Cold black inside the houses. Prussian blue and a little crimson.

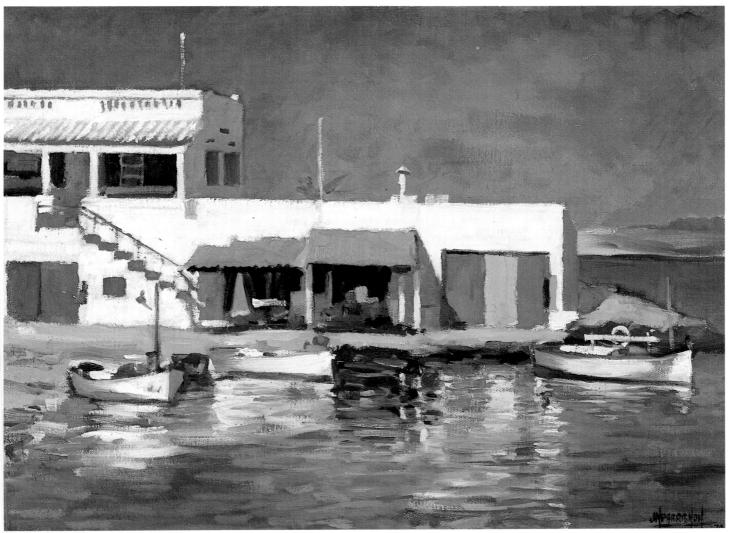

Fig. 264 J. M. Parramón, Fornells, private collection. Example of harmonizing cold colours.

Composition of broken colours

Imagine you are painting a countryside filled with a range of broken colours like the one in fig. 266. Here we have the way to obtain this extensive range of colours, tones, and shades, by mixing only three colours – yellow, crimson, blue – and white.

- **61.** Colour of the sky. (Clean the brushes.) Mix a lot of white and a little blue until you get a light sky blue, then add a little crimson and a little less vellow.
- **62.** *Colour of the mountains.* Blue, a little white, and crimson.
- **63.** Green of the field in general. First make a brilliant green with blue and yellow, then make it greyer with white.
- **64.** Dark green of the field. The same colour as before, adding the blue and crimson.
- **65.** Green of the field in the middle. The same green as before adding white, crimson and yellow.
- **66.** Grey house in left foreground. Mix white, blue and crimson, until you get a blueish brown; then add yellow until you get this grey.
- **67.** Colour of the shadow of the same house. Use the same colour but increase the proportions of the previous mixture.
- **68.** House in the background on the left. First make up a light green with white, yellow, and blue; then pro-

- gressively add a little crimson and vellow.
- **69.** *Reddish house in the background.* Mix white, yellow, and crimson, to get a light orange with a reddish tendency, then add a little blue.
- **70.** Shadow of the same reddish house. The same colour, adding blue and crimson.
- **71.** Colour of the path crossing the centre. White, yellow, a little crimson, and less vellow.
- **73.** *Greys in forms near the wall in the foreground.* The previous colour adding the same colours in proportion.
- **74.** The colour of the walls. Make the same colour as before, increasing the proportions of each colour.
- **75.** Colour of the tree trunks. Crimson and blue and a little yellow to get the warm broken colour.

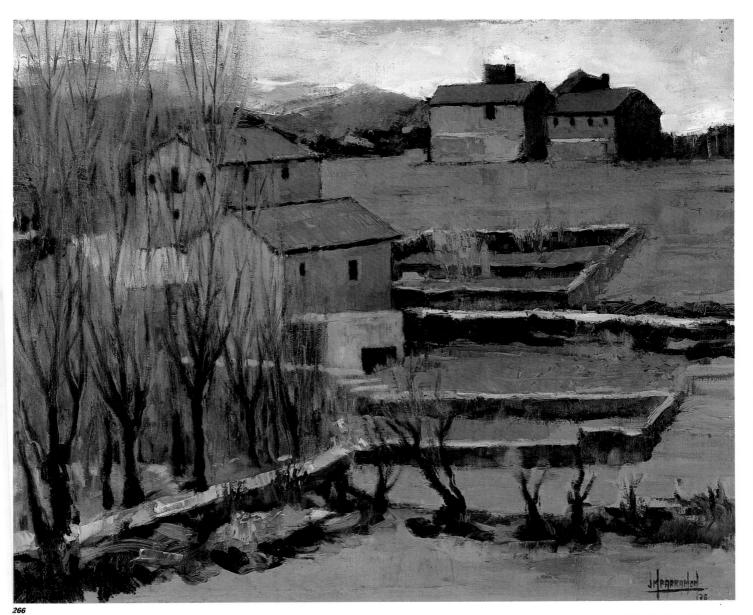

Fig. 266 J. M. Parramón, Landscape in the Catalan Pyrenees, private collection. Example of a theme painted with a range of broken colours.

Composition of broken colours

This is a range of broken colours which has not been created for any particular scene. I have composed a series of shades and neutral colours, which are neither warm nor cold, that is to say, they are broken.

- **76.** *Greyish ivory colour.* (Remember, palette and brushes must be clean.) First make up a rosy cream colour and then add a little blue.
- **77.** *Greyish ochre.* Use the previous colours, increasing the proportions.
- **78.** *Greyish purple.* The same as the previous colour, adding more crimson and a little blue.
- **79.** *Natural umber.* The same as before, adding more yellow and blue.
- **80.** *Dark purple.* The same colour as before, adding more blue and a little crimson.
- **81.** *Light ochre.* (Clean brushes.) White, yellow, a little crimson, and a little blue.
- **82.** Dark yellow ochre. The same as the previous one, slightly increasing the proportions, and adding a little more crimson.
- **83.** Burnt sienna. Mix white, yellow and crimson until you get a reddish orange, then add a very little blue.
- **84.** *Burnt umber.* Add to the previous one, crimson and a little blue.
- **85.** Dark raw umber. First compose a

- dark purple with blue, crimson and a little white, then add yellow and more white, if necessary.
- **86.** *Spoiled white.* (Clean the brushes.) White, crimson and yellow, in small amounts, then add very small doses of blue until you get this colour.
- **87.** *Light, yellowish green.* To the previous colour add a little yellow and blue.
- **88.** *Greyish light green.* To the previous colour, add a little yellow, less blue, and even less crimson.
- **89.** *Blueish grey.* (Clean brushes.) Compose a sky blue with white and blue and then add a small amount of vellow and crimson.
- **90.** Blueish grey medium. The same colour as before, adding blue, a little crimson, and a very little yellow.

Painting with three colours and white

If you are a professional painter, skip over this page and the four following. If you are an amateur with some experience, stop, read, and look at what is said and illustrated on these pages, and consider the possibility of doing this exercise which, as you will see, could be good 'gymnastics' for you. If you are an amateur who has never, or almost never, painted in oils, you must do this exercise. When you have finished you will be surprised

at your ability to paint pictures.

In the adjoining photograph you can see the model for the picture you are going to paint (fig. 268). It is a simple still life, placed on a corner of a table, covered with a white cloth, and made up of a plain clay vase, a dark green pottery dish with four or five pieces of fruit two oranges, a peach, a lemon - a bunch of grapes, a glass with a little wine in it, and an apple. In the background, we see the back of a chair against a uniform grey wall. The light comes from behind the subject. To soften the contrast of this lighting effect, I installed two white canvases on two chairs in front of the subject. These acted as reflecting screens, to diffuse the light and compensate for the strong back-lighting. In fig. 269 you see what I did to improve the illumination of the model.

Let me say that the important thing in this exercise is not the subject or the fact of painting from nature, although the latter can always be recommended, but rather the experience of painting a picture with all the colours present by using only the three primary colours, cyan, magenta and yellow, with white. If you paint this picture with these three colours, even copying it from what I myself have painted, which appears in fig. 275, I assure you that you will paint better in the future, because you will have practised the composition and mixing of colours.

In the adjoining chart you can see the materials required to carry out this exercise.

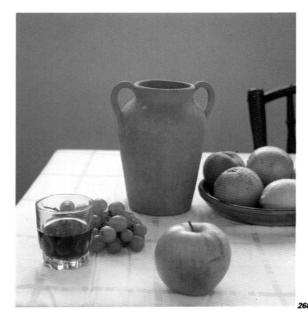

Fig. 268 This is the still life I prepared in order to paint a picture with three colours and white. The background is a grey wall in shadow. The light comes from behind the subject.

Fig. 269 The back-lighting creates a luminous outline on the upper rim of the objects while the rest remains in shadow. It turns out to be a subject with not much colour. and a lot of contrast. To soften this excessive contrast, I placed two large canvas reflecting screens to allow me to paint with more light and colour. In this photograph you can see the picture. It was done with a number 4 round hog'shair brush and with Prussian blue and burnt umber, mixed with turpentine.

Materials required to carry out this exercise

Charcoal Spray for fixing charcoal Cardboard-canvas no. 3 Figure Oil colours: **Cadmium yellow medium** Alizarin crimson madder **Prussian blue Titanium white** Palette

1 hog's-hair brush no. 4 2 hog's-hair brushes no. 6 2 hog's-hair brushes no. 8 3 hog's-hair brushes no. 10

2 hog's-hair brushes no. 12 1 spatula in form of trowel

1 oil dipper

1 small container for turpentine

How to begin a picture

Before starting to paint, it's natural for the artist to contemplate the subject for a while, considering the light and shade effects, studying the contrast, analysing forms and colours, imagining what the finished picture will look like, and in this way, entering the field of interpretation, where the artist imagines and mentally changes forms, contrasts, and colours. I, myself, before beginning to paint, made this analysis of the model: 'I don't like such a regular background. As there is a large window higher up on the wall, I'll paint it lower down to break the monotony of the background. I don't like the grapes, they're old and ugly. I'll paint fresh grapes from memory. I don't like the apple, it lacks colour; I'll paint it with reds as well as vellows. In the tablecloth in the foreground, I'll paint some grey-ochre cream wrinkles...

This series of reflections is usually made concrete in a preliminary sketch but we'll do without this step and pass directly to beginning the picture.

But how do we begin the picture? By first drawing the model? By painting directly, without a previous drawing? Here we have an old controversy. Artists who paint with hardly any shadows, illuminating the bodies with frontal or diffuse light, seeing and differentiating objects with stains or colour like van Gogh, Matisse and Bonnard - the 'colourists' - usually begin the picture directly on the canvas. Those who paint with light and shadows as did Chardin, Corot (Corot said to Pissarro: 'Start by drawing the shadows'), Manet, Nonell and Dali generally begin the picture by drawing the model. But let's say that between the two extremes there is an intermediate general plan which consists of drawing a fast sketch to orient yourself. As an example of this approach, look at the drawing in fig. 270. We are going to draw the theme with some precision, making sure of the dimensions and proportions overall, so that then we can paint

This is the charcoal drawing that I did as the first step to beginning to paint (fig. 271). Once the drawing is finished it has to be fixed.

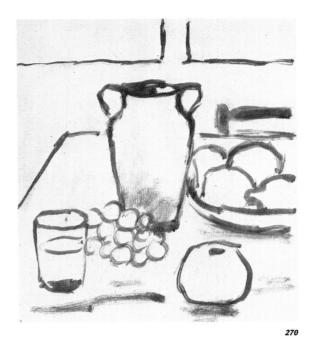

Fig. 270 The preliminary sketch with which the professional usually begins an oil picture. It was done with a number 4 round hog's-hair brush and with Prussian blue and burnt umber, mixed with turpentine.

Fig. 271 Some artists study the composition by drawing the model in charcoal with a few touches of the rubber. At this stage, we only stain the canvas lightly, in order to be better able to adjust the colour and the contrast of some elements in the later stages.

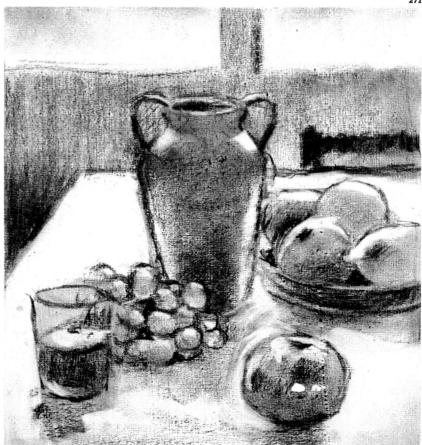

27

with more assurance.

Where to begin painting—first stage

The law of simultaneous contrasts, you remember, tells us that a colour appears lighter or darker according to the background colour that surrounds it. Keeping this rule in mind, it would be a mistake to begin to paint on the white of the canvas, for the values of the subject would become lighter or darker, according to the colour of the background we paint afterwards.

Consequently, we have to stain the entire large, white space of the canvas as soon as possible. In this picture we will begin with the blueish-grey background and then add the luminous colours of the window, the clay vase, the fruit...

Generally, I ignore some parts of the drawing, like the outlines of the handles on the vase, the back of the chair. These details will be added later. I paint the outside light from the windows, then it is time for me to change the brush for a clean one.

Be careful when changing brushes. Never try to paint a light colour using a brush on which there are still traces of a dark colour. It is essential to clean them from time to time.

Be careful with the grapes. They always present a drawing problem, easy to deal with if you are careful to draw them exactly and correctly. You have to count the grapes, watch their size, their positions within the bunch, and the shapes of the dark holes between grape and grape.

I put colour on the apple in the foreground and on the wine in the glass. I go on with a few cream-coloured stains in the foreground of the tablecloth, which later on I will use as the shadows of the creases. And I leave it (fig. 272).

I take a short rest. It is time to smoke a cigarette or drink a glass of something, time to reconsider, to study...

I clean the brushes, I clean the palette.

Fig. 272 In the first stage, we only stain the canvas lightly, in order to be better able to adjust the colour and the contrast of some elements in the later

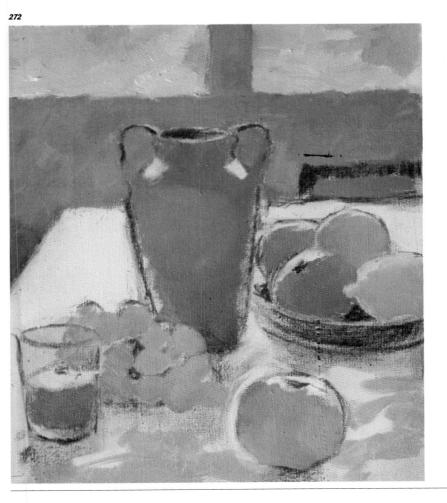

the help of a piece of newspaper. Then soak it for a few minutes in a small container of turpentine. Rinse and squeeze the brush with a rag two or three times, until it is practically clean.

Second stage

Fig. 274 At this stage the canvas begins to show the true colours and contrasts of the model. But we are still shaping, using washes of practically flat paint to indicate form and colour. At this point, we are thinking of possible ways of developing the picture towards the final version.

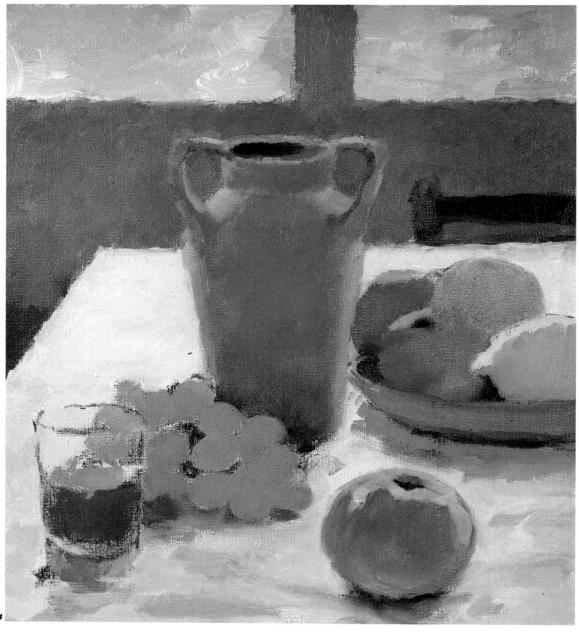

274

I resume. I begin with the tablecloth. As well as blue and white, I see that I'll have to add a few touches of the cream colour I used in the foreground. I paint the illuminated areas surrounding the fruit with light blue and a little crimson. I take advantage of this purple to stain the reflection of the wine in the glass. Now I paint the illuminated outline on the apple in the foreground and go on to repaint the vase.

I have darkened the background but I think I've gone too far. I work for a while on the

blueish lights around the vase. I paint the chair. I paint the dish. I paint the apple in the foreground, the shadow of the dish on the tablecloth, and the shadows of the apple, the grapes, the glass. I finish the apple in the foreground and I repaint the fruit in the dish with clean, bright colours. For today, I leave the painting as you are seeing it in fig. 274.

Last stage

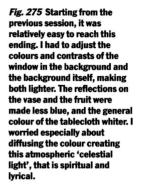

275

As you can see, in the last session – three days after the previous one – I 'repented' of many forms and colours, and I painted and repainted, until I had retouched all the colours in the picture.

Examine them and compare. In the final version, everything is less blue, the background is lighter, the tablecloth whiter, the vase more luminous, less dirty (how I suffered with that vase, doing and redoing it...!). In the end, I think the final version of the picture has more atmosphere and realism because the

forms and shadows are less concrete, more ethereal, presenting an effect of an instantaneous impression. For example, look at the shadows projected onto the tablecloth from the dish of fruit, the bunch of grapes, the glass, the apple...

And remember, for this particular project only three colours and white were used.

Direct painting

Fig. 276 This is the model that I selected to explain the technique of direct painting. It is a view of the village named Torla, in the Aragonese Pyrenees, a few kilometres from the French frontier.

Fig. 277 I used a round hog's-hair brush, lightly loaded with colour (Prussian blue and burnt umber), and soaked with turpentine, as if I were painting in watercolours. I made this rapid sketch in not more than a quarter of an hour. I simplified the complex model, sketching in the main elements.

277

The Impressionists were the ones who introduced the technique of direct painting. They painted their landscapes in a single session taking only three or four hours to begin and finish a picture. They tried to capture the 'impression' of the moment and they managed to do it! How? By painting directly.

By painting from the first moment with the same form as the definitive resolution.

To a great extent this depends on the experience and craft one has, but it also depends on the artist's attitude towards the picture.

The normal situation is that you and I and everyone who paints, never, or almost never, make use of all our intellectual capacity. It's common to work without concentrating completely because, we know 'there's always a second time', in a second or third session, to redo, regret, rectify. But with the formula invented by the Impressionists of 'one picture, one session', there's no second time! The artist has to think that there's only one opportunity to complete the picture, the form, the colour, and he has to discipline himself not to go back over what he's done, but to finish it alla prima, 'at the first try'. He has to feel compromised from the beginning to the end of the picture. It's a question of attitude. But there is also a technical process that you can learn in the accompanying pictures and text.

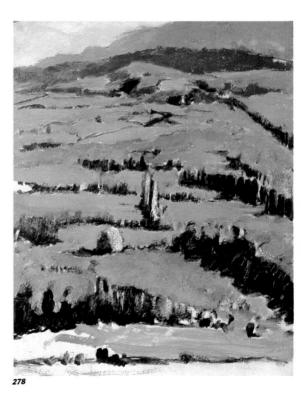

Fig. 279 The paint here is thicker, but not much. I applied a second layer, painting, as they say, from top to bottom, referring to the model but interpreting, synthesizing, simplifying forms and colours. Above all, I diversified the colour. Total time for finishing the picture: two and a half hours.

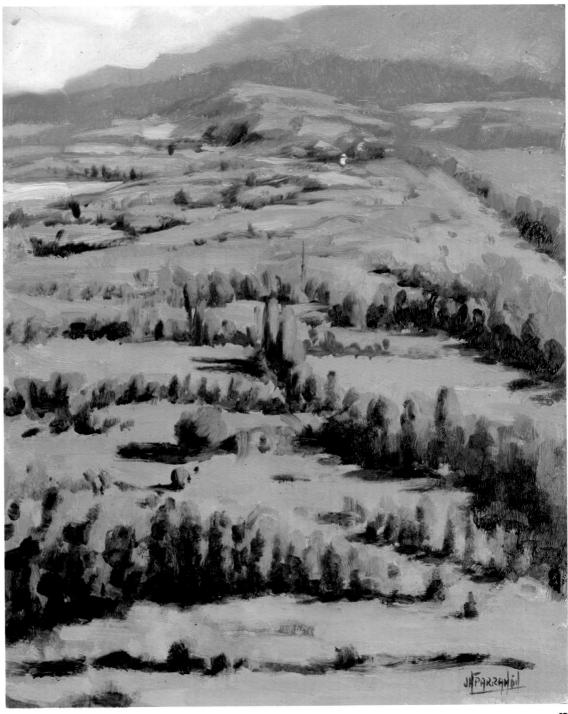

279

Painting in several sessions

Trying to define this technique we would say that: it's the one that resolves the picture in several sessions, waiting until the paint is dry or semi-dry to refine the drawing, the modelling, the contrast and the colouring.

This is the technique of the Old Masters, still put into practice by many artists, especially in easel pictures, pictures painted in the studio such as still lifes, portraits, and figures, which are in general large in size.

From the beginning, the procedure that is followed is completely different from that of direct painting. In painting in stages, we first have the worry of drawing and modelling – shadowing, illuminating – leaving the colour for later.

In the first stage the artist draws and models with thin layers of almost monochrome paint, barely suggesting the warm or cold colour range and harmonization worked out beforehand.

On this solid, initial basis, we then begin applying the real colour in thicker layers, painting and repainting, with its consequent rubbings and scrubbings.

This technique is seen in the oil painting by Francesc Serra, figs. 280 to 283.

Serra painted this picture on a number 40 figure canvas. First he drew several studies in charcoal to decide on the model's pose. He began the picture, drawing in charcoal on the canvas, and completed the first painting session with a very limited palette of only five basic colours: silver white, black, burnt sienna, yellow ochre and burnt umber – a very neutral range of colours that is greyish and rather dirty (fig. 280). Notice the remains of the charcoal lines from the initial drawing.

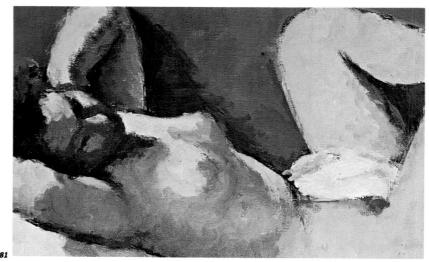

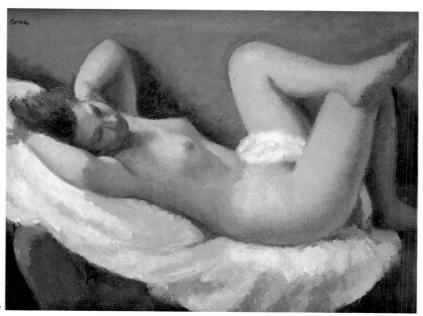

282

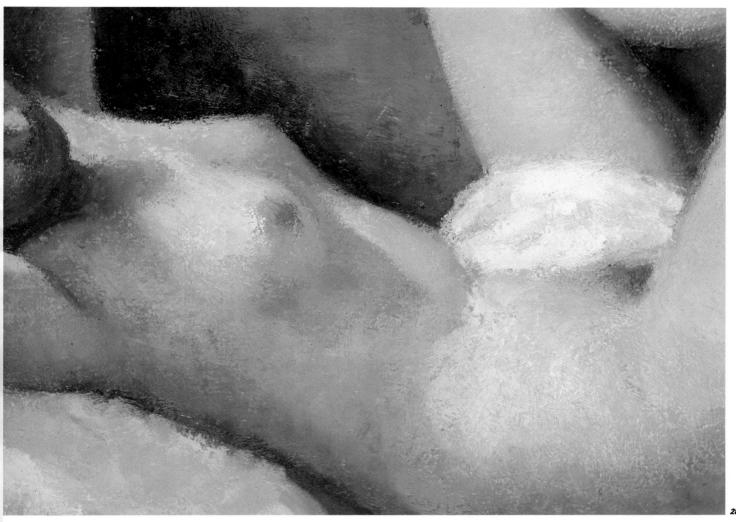

Five days later Serra returned to the picture with the idea of *painting* and with the intention of elaborating on the material, of enriching the dough. Serra, like many artists, was working on five or six pictures at the same time. He would leave one and take it up again three or four days later, working no more than two hours at each session (fig. 281).

The finished picture was reached after three more sessions. During this time the artist increased and intensified the colour; he studied and calculated slight changes, working with more and more material, applying the technique of frottage, as can be seen in the enlarged reproduction of fig. 283.

Francesc Serra died a few years ago. I was lucky enough to be with him in his studio in Tossa de Mar while he painted this picture. One can see his admiration for Titian.

Fig. 283 Francesc Serra, Nude (detail), private collection. As can be seen in this reproduction, Serra liked painting with thick impastos, delighting in the material as one layer was superimposed on another, and followed to a certain extent the techniques of frottage practised by Titian and Rembrandt (pages 28 and 36).

Fig. 284 The artist Francesc Serra talking with his model during a few minutes of rest during one of his painting sessions.

28

Painting a picture with a knife

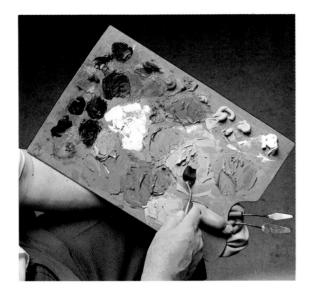

The technique of painting with a knife is somewhat complicated. It requires its own skill, different from using a brush.

In knife painting no solvents are used, the colours are mixed and applied thick, just as they come out of the tube. The palette is used in the same way to mix, collect and prepare colour, and one works with a maximum of three or four knives of different sizes, but generally with the trowel shape.

When starting to paint you can work with the knife, directly, or on top of a previous, very thin painting, done with brushes and colours diluted with abundant turpentine. The latter procedure gives the artist a little background. which covers those small areas or intersections where the knife hasn't touched. To achieve a more modern style, it is possible to mix shades and colours on the canvas itself, without using the palette.

The large areas are painted first; one tries not to touch or retouch them in the following phases. For the more broken-up areas with small and complex shapes, it is advisable to apply colours that have already been mixed on the palette. In the last stage, in order to put in the finishing touches, it is perfectly valid to touch up and repaint with a sable brush. But when painting a picture with a knife, try not to destroy the smooth, enamel appearance, characteristic of oil painting by knife.

Knife painting can be completed with large impastos of colour, superimposing some on top of others, or with a practically normal thickness of paint that covers the grain of the

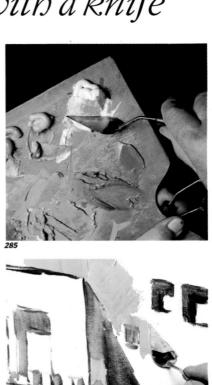

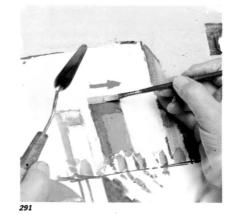

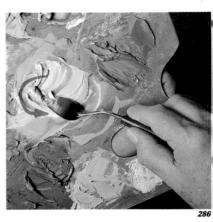

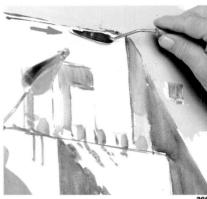

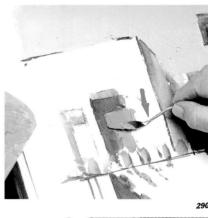

canvas. This technique of starting with a layer of thin paint by brush before using the knife was the one I used to paint the terrace, as illustrated in figures 293 to 296.

Fig. 293 First stage shows the under-drawing, painted in oil colour diluted in turpentine.

Fig. 294 Second stage is painted with a brush with very liquid paint.

Fig. 295 In the third stage, begin working with the knife, painting the largest areas first. I have begun adjusting and changing colour. Note the reliefs caused by the knife.

Fig. 285 To take colour from the palette the knife is used to cut off or scrape an area away.

Fig. 286 Mixtures are made by crushing one colour with another and beating them both, moving the knife in a circular fashion.

Fig. 287 Putting the colour on the canvas.

Fig. 288 To draw a line or outline, load the back of the knife with paint and scrape the knife along the canvas. Fig. 289 When painting a small area like the dark green shadow of the door, it is possible that the spatula will go over the line. This is normal and is not important...

Fig. 290 ... because it is also normal to superimpose colours in order to draw and reconstruct shapes.

Fig. 291 The small shapes have to be painted with a sable-hair brush.

Fig. 292 The knife can be cleaned perfectly well with pieces of newspaper.

Fig. 296 Painting with a knife can produce workmanship of great impastos, where the paint reaches an obvious thickness. It can also be done with a half-impasto, as in this picture, which covers the grain of the canvas with a finish that is typical of the knife. This would seem to be a better formula, for pictures of smaller dimensions than this painting done on a number 8 canvas (38 x 46 cm).

As you can see in the finished picture, the knife has resolved the form and colour of the walls, doors and windows. In the latter, a sable-hair brush was used to touch up small shapes like the bars on the lower window, the flower pots and plants, and their shadows projected on the front wall.

projected on the front wall.

The sable-hair brush should play only a minimal part, leaving the knife to construct the shapes and reflect the difficulties of the technique. Maintain the 'knife finish' – not very concrete, a little unsure, but it really creates something interesting and artistic.

29

You paint as you draw

Drawing makes up the quarters of what painted If I had to put a sign up my door, I would write of Drawing, and I am s

Jean Auguste Dominique Ingres (1780-1867

would produce painter

Construction of form and volume

Drawing the construction of your hand

This is an exercise that I invite you to try in order to better understand form, volume, light, and shadow. You can carry out this exercise on normal drawing paper, with a soft-grade pencil, 2B for example. Place your non-drawing hand in this position or a similar one and begin.

Fig. 298 Try to enclose your hand in a 'box' by drawing some straight lines around it which correspond to the general outline. This is the 'frame'; drawing the model well depends on this step.

Fig. 299 In order to calculate the dimensions and proportions of your fingers, thumb, and palm, try to see the 'countermould' of the model, the negative spaces or hollow areas that shape the silhouette.

Fig. 300 Another typical method for calculating proportions and dimensions consists of imagining linear references. These are horizontal lines that fix points or shapes as they coincide with this horizontal scheme. Vertical and diagonal lines cross the horizontal lines, giving us the relationship of points of reference.

Fig. 301 I have asked you to draw a fast sketch of your hand in order to practise construction, light and shadow, and tonal evaluation. It would be a good idea for studying light, shadow, and tone, to draw your hand again, this time larger and with greater dedication, in order to reach the same results as in the drawing in fig. 302.

Light and shadow, evaluation of tone

Light paints shapes; shadow creates volume. The light and shade explain the shapes of objects.

In order to represent volume we draw or paint tones or colours of different intensities or values. That is to say, we compare and evaluate some tones or shades, in relation to others. We give them a value – this shade is lighter than that, this is darker than that one. The *evaluation* is, therefore, a basic aspect, both of the art of drawing and the art of painting. Corot said to Pissarro: 'You are an artist, therefore you don't need advice, except for this: You have to study the values first. You can't paint well without them.'

In order to capture the values of a theme, you

have to know how to see, by observation and comparison, the different tones that model the object. It is not a question of hundreds of shades. In reality, with just a few different greys, and black and white, it is possible to represent practically the full range of tones offered by the subject. In order to understand these problems better, I invite you to draw your own hand, with a soft lead pencil such as a 2B, just as I have done in fig. 302. Try to study the factors that determine the volume of the bodies according to the text that accompanies fig. 302.

It's true that the hand is one of the most difficult subjects to draw, but I hope that these pictures and explanations will help you.

Fig. 302 This relief or volume of objects is produced by the play of light and shadow. It is important to understand their effects when drawing or painting. Here is a list of these effects.

Light. Illuminated areas where the colour is the *true colour* of the model.

Shine is achieved by contrast. Remember that 'a white is whiter according to how dark the surrounding tone is'. Accent. Darkest part of the cast shadow between the penumbra and the reflected light. Reflected light appears at the end of the shadowed part. It is more accentuated when there is a light-coloured object near the model.

Penumbra. Intermediate area between the illuminated part and the area in shadow. It is the same as 'chiaroscuro' which can be defined as 'light in the shadow'.

Real shadow. All the areas in shadow, as opposed to the illuminated part.
Cast (projected) shadow appears on the surface on which the object is located. Generally, it is darkest in the areas near the object.

Fig. 303 A reduced range of greys, limited to five or six tones, is enough to represent all the tonal values offered by the subject.

Contrast and atmosphere

Tonal evaluation, contrast, and atmosphere; these three factors create the illusion of volume in the picture. Contrast is an especially important factor in the expressive power and message projected by the work. El Greco, under Caravaggio's influence, accentuated contrast to dramatize the theme of his works. He surrounded his figures with dark brokendown colours in order to separate them from the background and achieve a relief effect. He was a real *evaluator*.

In modern painting, starting with Impressionism, contrast is obtained with less aggressive, less dramatic formulas. The juxtaposition of colours which in themselves explain the form has replaced the need for large, deep shadows. As Pierre Bonnard said: 'Colour, without any other help, is capable of explaining light, of representing shape, and expressing a pictorial idea.' Bonnard was a real *colourist*.

Among modern painters there is a preoccupation with representing space by defining the foreground and diffusing the areas behind, creating the *interposed atmosphere* as can be seen in *La Loge* by Renoir (fig. 304).

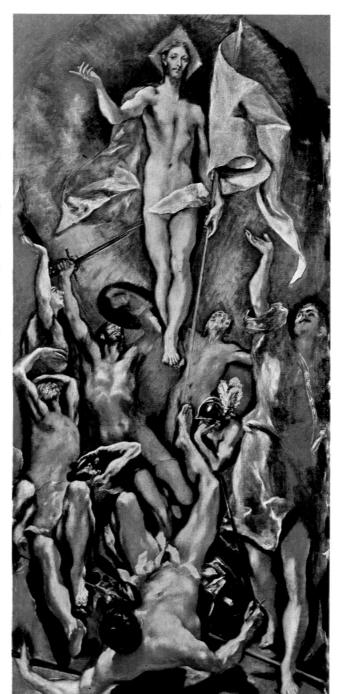

Fig. 305 El Greco, The Resurrection of Christ, Pra Madrid. Strong contrasts the the figures into relief. El Gre was one of several artists of time who was influenced by 'tenebrismo' of Michelange Merisi da Caravaggio established this style of painting based on extraordinary contrasts, wh revolutionized the art of the Rococco. Before Caravaggi light was a secondary element But from then on, light, shadows, and contrast beca important means to expres and explain the picture. Velázquez, during his first period, worked under the influence of this style of painting. El Greco also accentuated contrasts, highlighting the effect of lig shadow, and contrast.

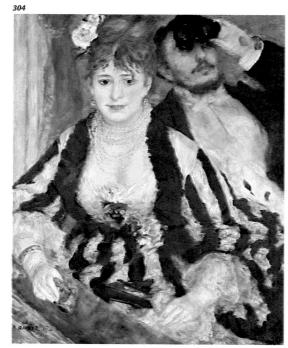

Fig. 304 Auguste Renoir, La Loge, Courtauld Institute Galleries, London. An example of creating atmosphere and depth by defining the foreground – the figure and face of the woman – while the figure of the man is less clear and distinct, purposely 'unfinished'.

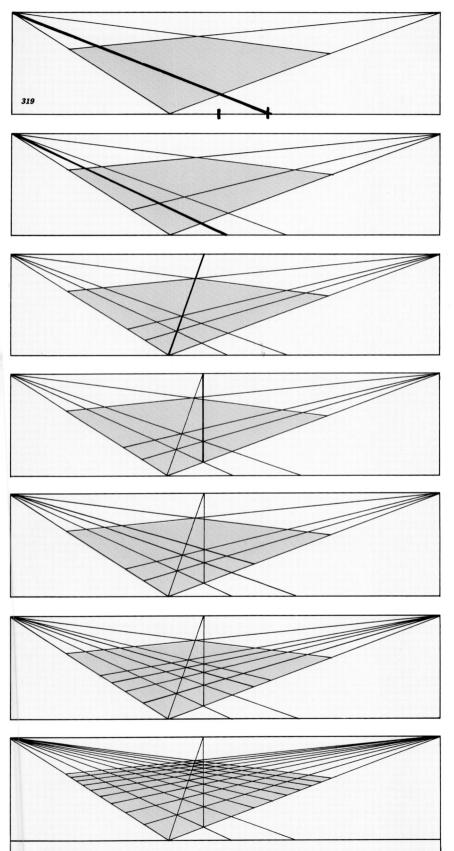

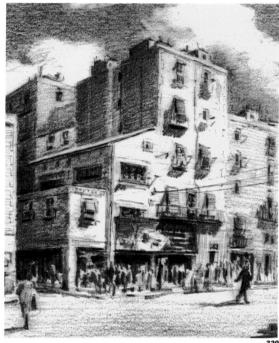

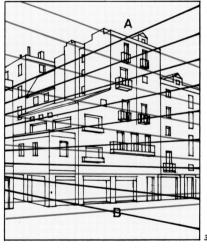

Fig. 320 In fig. 320A we see the formula for calculating the perspective of a house or a building when the vanishing points are outside the picture. It's a question of calculating the inclination of the extreme vanishing lines A and B and then dividing the two sides or

lateral margins of the picture into equal parts. Then draw a guide with vanishing lines that will allow you to draw the windows, doors, balconies, mouldings and projections of the building. The guide lines printed in red correspond to the other vanishing point.

Selecting the theme

'Irate young revolutionaries', wrote the novelist Emile Zola talking about his friends the Impressionists.

In fact, Impressionism was originally one of the great rebellions against decadence, later converted into 'official art'.

One of the most outstanding aspects of the Impressionist revolution was, undoubtedly, the renunciation of the big themes, the 'hulks', as people called these big pictures. Their themes were chosen, studied and prepared with obvious fantasy, idealizing the model which had nothing to do with reality (fig. 322). Fighting against this tradition, the Impressionists painted, as they used to say, motifs instead of themes, that is, living subjects, spontaneous scenes from real life.

The point to be deduced from this commentary is conclusive. Selecting or finding a theme or reason for painting is not difficult at all, they exist everywhere, in your house, in the very street where you live, in the room where you are now, in any village or city, garden or field.

'Themes, motifs!' said Renoir, 'I can get by with any buttocks whatsoever.'

The Impressionists, although they certainly confirmed their indifference for the theme, painting reasons as trivial as a band of workmen fixing a street (fig. 323) or a pair of old shoes (fig. 321), certainly considered the form and the colour of their motifs, and had analysed the formal chromatic composition and decided how to interpret it. In reality, they had selected the theme paying little attention to the subject, whether it was a bunch of radishes or a bunch of roses.

This selection of a theme depends on three factors, which are:

- **1.** Knowing how to see.
- 2. Knowing how to compose.
- 3. Knowing how to interpret.

Fig. 322 Claude Lorrain, Landscape, Louvre, Paris. Up until the middle of the last century, when Impressionism began to wake up, the choice and composition of the theme was done in the artist's workshop, working from notes and sketches drawn from nature, but 'fixing up' the theme according to the painter's vision.

322

Figs. 321 and 323 Vincent van Gogh, Shoes, Rijksmuseum, Amsterdam. Edouard Manet, The Stone-layers in Berne Street, Butler Collection. The Impressionists decided to paint motifs instead of themes. For them, one didn't need to look for and compose the theme, as their inspirations were the open air, the street, the most everyday objects.

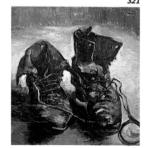

Interpretation

Let's hear what Delacroix says: 'My pictures are not completely real pictures. Those who simply reproduce their sketches will never give their spectators a living feeling of Nature.'

It's true, the subject copied faithfully has nothing to do with art. The primitive painters did not trace nature. Titian, Rubens and even the classical Raphael interpreted much more than they copied. In their work there is a preponderance of memory work. Very few studies have been carried out about this fact. Interpretation comes from the act of imagining, of idealizing, of 'shaping in the picture the inner impressions and visions', as Picasso said.

It is easy and necessary to imagine our own picture, to see it in our own way. But the difficult thing is to not lose sight of this ideal picture, which every artist begins with before beginning to paint. In an interview with Pierre Bonnard, written by Angèle Lamot in 1943, the famous Bonnard said: 'I tried to paint some roses directly, interpreting in my own way, but I got carried away by details ... and I noted that I was sinking, that I wasn't going anywhere, and that I had got lost. I could not

recover my first impulse, the vision that dazzled me, my starting point.' Bonnard then gave this masterly lesson:

'The presence of the subject, of the motif, is a disturbance for the artist while he is painting. The starting point of a picture is always an idea. The presence of the model while the picture is being carried out is a temptation, and the artist runs the risk of letting himself be carried away by his direct, immediate vision, forgetting his first impulse...! If he succumbs he will end up painting details which are in front of him and which did not interest him from the beginning!

'Very few painters have known how to interpret the model in their own way, and those who got their own way have their methods of self-defence.'

Bonnard described Paul Cézanne as being one of the few artists who 'had his own methods of self-defence'. 'Cézanne,' says Bonnard, 'had a solid idea of what he wanted to do and he only accepted from Nature what was in relation to his idea. He only accepted and painted the model as he saw it in his innermost self.'

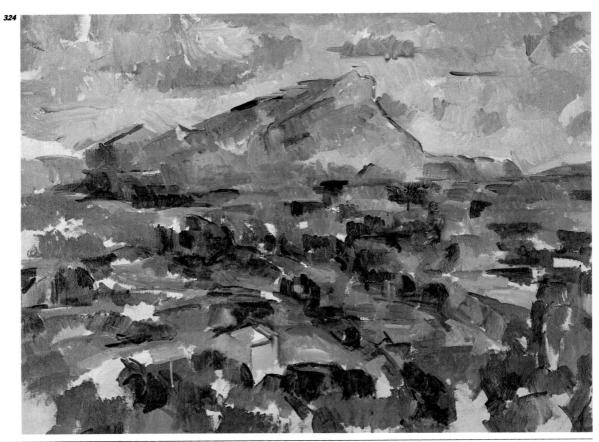

Fig. 324 Paul Cézanne, Mount Saint Victoire, Hermitage Museum, St Petersburg. Cézanne painted fifty-five pictures of the mountain Saint Victoire from the window of his house. All of them are different, even though the theme is exactly the same. Why? Maybe, for him, this represented the great 'conquest of the model', of painting the model as he liked, in his own way, without letting himself be dominated by what the model 'was saying'?

Basic rule of the art of composition

Composing is basically creating.

Delacroix said: 'The mind composes, that is to say, it idealizes and chooses. What we call creation in great artists is nothing more than a special way of seeing, coordinating, and reproducing Nature.'

It is difficult not to agree with these ideas, and the words of John Ruskin, that 'there are no rules about the art of composing. If there were, Titian and the Veronese would be common and ordinary men.'

Agreed. But we can and we must start from somewhere, from some standard that allows us to cultivate and perfect this 'special way of seeing, coordinating, and reproducing Nature'.

One of the basic classic rules about the art of composing was written centuries ago by the ancient Greek philosopher Plato, who in a few words summarized what the artist should do to order the composition of a picture. In the most simple of terms, Plato stated of composition that:

Composing consists of finding and reproducing variety within a unit.

Variety can exist in the form, the colour, the position and location of the elements of the picture. Variety means creating a diversity of forms and colours that draws the attention of the spectator, awakens his interest, incites him to observe, and then gives him pleasure while looking and contemplating. But this variety should not be so great that it manages to disconcert the viewer, dispersing the interest created initially. Variety must be organized within an order, a *unity* of the whole, so that the two ideas complement each other, establishing

Unity within the variety **Variety** within the unity.

On this page you can see a graphic, classical demonstration of this concept. The explanations analyse the defects and qualities of each different arrangement or composition.

Figs. 325, 326, and 327 Here we have a study on the art of composing in accordance with the basic rule of finding and representing the unity within the variety. See the three schemes below with corresponding commentaries.

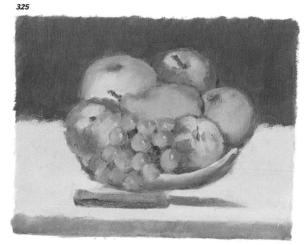

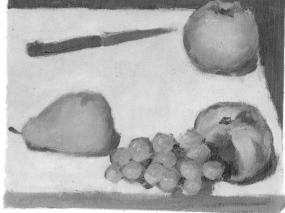

Fig. 325 Bad: Excess of unity. The arrangement is not at all original, it's monotonous. See how the horizon divides the picture in two. The plate and the fruit form a single block.

Fig. 326 Bad: Excess of diversity. Here the objects are dispersed, they draw attention separately, they do not lead to a reasoned, unified composition.

Fig. 327 Good: Correct use of unity within the variety. You don't have to do any more than compare this scheme with the previous ones to prove that in this there is unity due to the order of the elements, and diversity because of their arrangement.

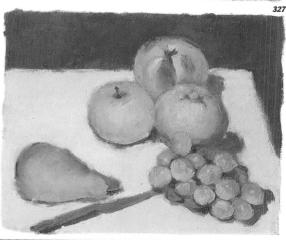

A classic norm

When you start to paint, while the canvas is still white, and the idea or theme is beginning to take shape in a sketch or drawing, an important decision about artistic composition arises, and it can be expressed in two questions. First, should I 'get nearer' the subject, or frame it 'from further away', reducing the proportion of the main motif and including more background? There is no absolute norm, of course, but for these two problems – proportion and framing - there are two rules, or principles, which can be followed:

1. 'Get near' the subject, close enough to create a centre of interest which 'explains' the content or theme of the picture.

2. The Law of the Golden Section.

Study this law in fig. 329 and in the commentary made on page 38 in connection with Velázquez's picture *The Adoration of the Magi*.

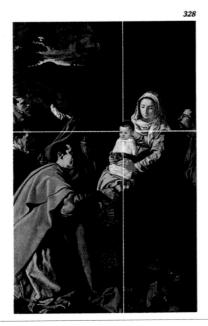

Fig. 328 Velázquez, The Adoration of the Magi, Prado, Madrid. It would be too much of a coincidence that the head of the baby Jesus is, by chance, exactly at the point where the lines of the Golden Section cross. We can be sure that Velázquez decided on the point by applying the said principle.

Fig. 330 Velázquez, Saint Anthony Visiting Saint Paul, Prado, Madrid. Is it also by chance that the bird bringing bread to the two saints coincides almost exactly with the point of the Golden Section?

Law of the Golden Section

Faced with a white canvas, where do you locate the main motif of a picture – in the middle, towards the top, towards the bottom, towards the right side, or towards the left? To resolve this problem, the Roman architect Vitrivius established the following:

Law of the Golden Section

For an area divided into two unequal sections to be agreeable and aesthetic, there should be the same relationship between the larger section and the whole as between the smaller and larger sections.

To find this ideal division, multiply the height or the width of the canvas by the factor 0.618. (See page 38.)

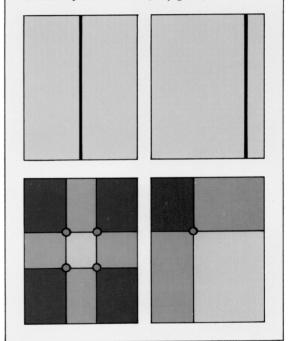

329

Symmetry, asymmetry

Symmetry is akin to *unity*. It means order, solemnity, authority. 'Symmetry is the order that appears in life whenever solemnity is needed,' said Böcklin, adding, 'there is no public ceremony, no religious ceremony, without symmetry in the participants.'

A symmetrical composition would include the repetition of the elements of the picture on both

sides of a central point or axis.

Asymmetry could be defined as a free and intuitive distribution of elements, balancing, however, some parts in relation to others. Asymmetry is a synonym for variety.

Most modern artists prefer asymmetric composition, which is more dynamic and gives more opportunity to express the artist's creativity. However, it is worth the trouble to study the symmetric form of composition, even rigidly, changing styles to give yourself practice, for by accentuating unity, the variety of a picture is also underlined.

Figs. 331 and 332 Velázquez, The Coronation of the Virgin, Prado, Madrid; and Degas, The Glass of Absinth, Musée d'Orsay, Paris. Velázquez's picture is an example of symmetrical composition, even though the figures do not offer

a mathematical repetition 'on both sides of a central axis'. Degas, in *The Glass of Absinth*, uses informal composition, moving the figures off-centre, and even letting them be cut off by the frame.

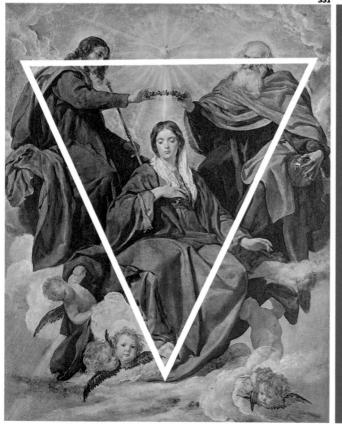

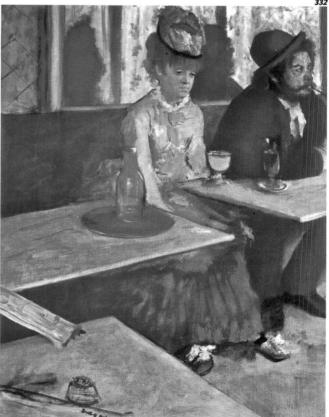

158 The Complete Book of Oil Painting

Schemes and balance

By a simple fact, which in art could be translated as 'maximum enjoyment for a minimum effort', man prefers geometrical forms (an outline in the form of a square, circle, triangle) to abstract forms. The psychophysicist Fischer carried out a survey on this fact, which demonstrated that most people prefer this type of simple form.

From this fact came the idea of composing from basic forms or geometrical schemes like those in fig. 333. The first scheme, by Rembrandt, uses a classic formula of composition: a diagonal that divides the picture into two tri-

angles.

Important in composition is the *balance of masses*. The 'weight' of the forms is compensated for by an off-centre axis, balancing some masses against others. The Roman balance or fulcrum (fig. 335) is a perfect example of this idea. In order to balance the unequal masses, the axis is to the right of centre.

Fig. 333 The artistic composition of a picture may be based on geometric schemes, as we see in these examples. The first of these schemes, in the form of a triangle, is known as Rembrandt's formula.

Figs. 334 and 335 Pissarro, The Seine at Marty, private collection. The composition is based on a geometric scheme similar to Rembrandt's formula. Pissarro has achieved perfect balancing of masses.

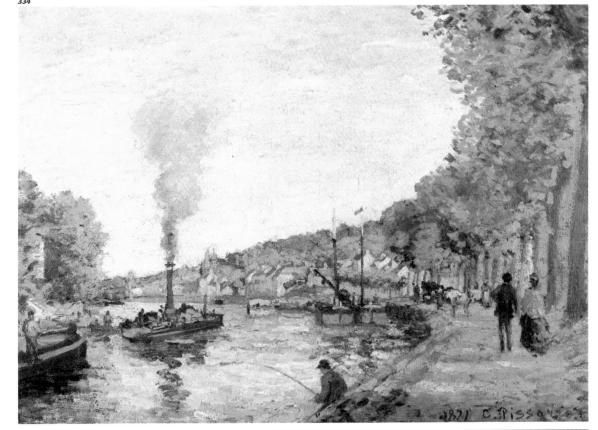

The third dimension

Physically, a picture has only two dimensions, width and height. The third dimension, depth, has to be imitated, the artist has to create it by means of forms, lights, shadows and perspective. Representing the third dimension forms a part of the artistic composition of a picture. Basically, the artist can use three formulas to

create depth.

A) By including a foreground. Use a frame which allows you to include a familiar shape in the foreground. The viewer will instinctively relate the size of this shape to the size of the objects situated further away. In Pissarro's picture of Dulwich College (fig. 336), there is a tree trunk in the foreground. We can also see the width of the river and its banks. These elements serve as visual cues. We refer to their size and location to mentally determine the distance and the dimensions of the building in the background, thereby creating the illusion of depth.

B) By the effect of perspective. In this case the artist selects a motif which, in itself, shows a perspective effect that emphasizes depth and three-dimensionality. In Pissarro's Pont Neuf (fig. 337), the perspective and, therefore, the depth is already implicit. But we must think of paths, roads, entrances to villages, and so forth, where the idea is not so obvious, but equally effective.

C) By superimposing successive planes. What we would see in such a composition is a frontal plane superimposed on a second plane, in turn superimposed on a third (fig. 338).

Of course, what is nearer is larger, and what is further away is smaller and partially obscured by the nearer objects.

Depth can also be highlighted by means of atmospheric perspective. The foreground is always clearer and better contrasted than the background. Leonardo da Vinci said in this connection: 'If you finish off the far-away objects with great detail, they will seem to be nearer instead of distant.'

Fig. 336 Pissarro, Dulwich College, Collection J. A. Macaulay, Winnipeg, Canada. The third dimension is achieved by including a prominent object in the foreground (the tree trunk on the right).

336

Fig. 337 Pissarro, Pont Neuf, Collection Mr and Mrs William Coxe Wright, Philadelphia. In this case, the illusion of depth is created by the vanishing perspective lines.

337

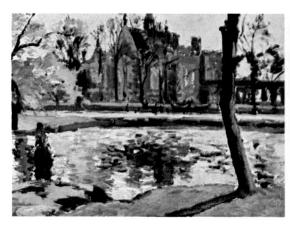

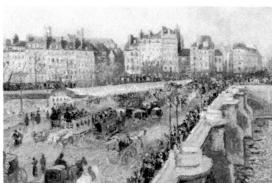

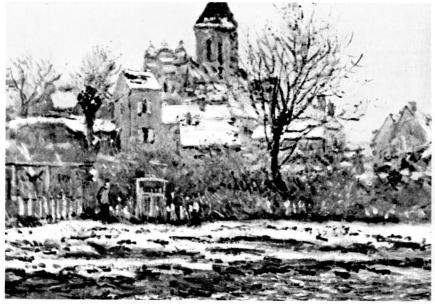

338

Fig. 338 Monet, Snow in Vétheuil, Museé d'Orsay, Paris. Here, depth is achieved by the superimposition of planes, that is, by the succession, one in front of the other, of the planes

formed by the frozen river, the trees, and the houses in the background.

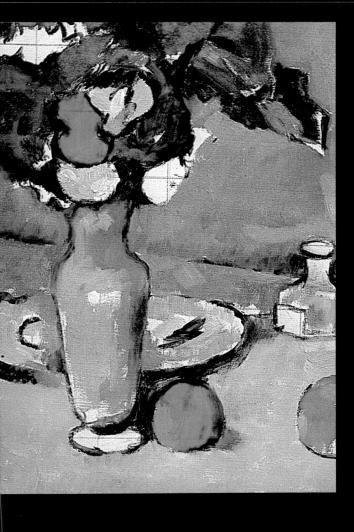

Oil painting in practice

'I put on colour until it escapes.'

Jean Baptiste Siméon Chardin (1699-1779)

Painting a figure in oils

In the following pages we begin a series of oil-painting practice demonstrations where, step by step, you can study painting figures in oils, an urban landscape, a seascape, a country landscape, and a still life. The first of these graphic demonstrations was carried out by the renowned Barcelona artist Badia Camps. Badia Camps has his studio in his own home. This is a room about 3×4 m. Camps always paints by daylight. Using a model he draws every day in charcoal, sienna, or chalks, taking notes and making studies of poses, lighting, contrast, which will later become projects in colour, and finally, definitive pictures.

We are going to analyse in detail Badia Camps's way of painting, what he does, what he does with it, and how he obtains the magnificent results you can see on these pages.

'I have thousands of drawings and sketches like these,' Badia Camps told me, while he showed me the sketches for figs. 339 and 340. 'If you were to ask me for a piece of basic advice on painting figures, I would say that you have to draw and draw again, always from a model. Every day make sketches, studies, and drawings of men and women, dressed and naked, until the anatomy of the human body—dimensions and proportions, evaluation of tone and contrasts—are as familiar to you as taking up a pencil or brush.'

As is his custom, Badia Camps drew no less than five sketches for the picture started on this page. In the last (fig. 340) he drew the rectangle that frames the definitive composition.

Badia Camps makes the under-drawing directly on the white canvas with a brush and oil paint diluted with turpentine. He uses a basic colour mixture of light cobalt violet with a little cobalt blue, natural sienna, and white (fig. 341). In this step, following the procedures of the Old Masters, Camps constructs the composition with lines and tones, basically resolving the effects of light and shadow. The violet-blue-sienna colour he uses is similar to the colour of a neutral shadow. Note that the construction is very carefully executed, as if it were (and in fact it is) a 'last dress rehearsal' for the work.

The way Badia Camps begins to paint reminds me of Titian's famous 'base of the painting'. Both artists use really thick impastos when beginning the picture and throughout the painting. Two or three days after the 'bed', when the picture has enough bite, Badia Camps, like Titian, goes on painting, working, forcing himself. 'I have to insist, and I have to

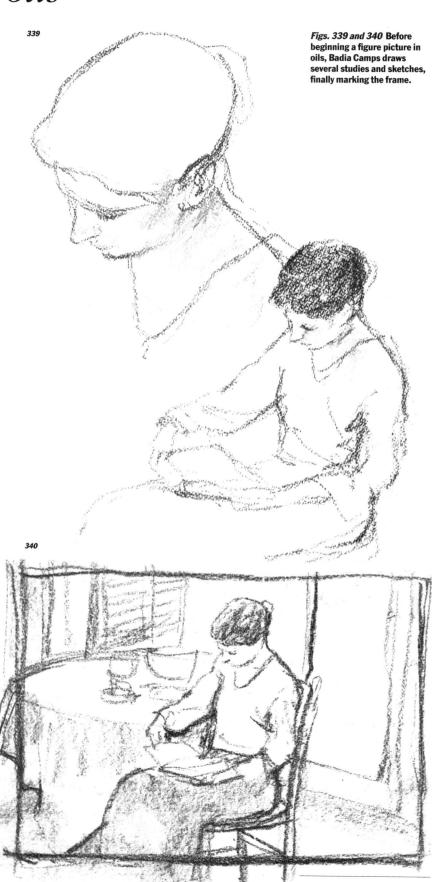

work and I have to struggle, for the emotion of painting to reach me so that I feel capable of painting, he will say

painting,' he will say.

Observe how the picture is progressing in the second stage (fig. 342). Note that it is basically the same as the initial drawing, but with some slight rectifications. The size of the head is larger, but the range of warm colours, which appeared in the initial stage, has been kept.

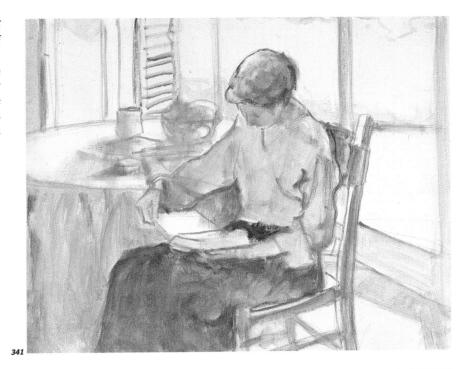

Fig. 341 Mixing together light cobalt violet, with a little cobalt blue, and a little natural sienna, diluted with abundant turpentine, Badia Camps draws and constructs the theme of the picture, using transparent lines and tones, as if he were

painting in watercolour.

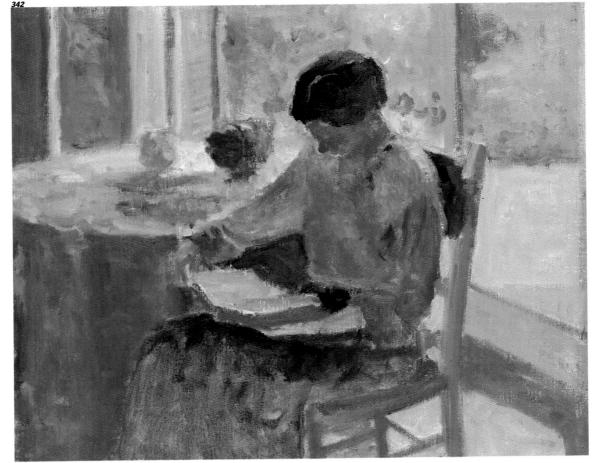

Fig. 342 Here we have the first phase of 'base of the painting', a first impasto, on top of which the artist will work, persisting and struggling 'for the emotion of painting to reach me so that I feel capable of painting'.

Painting a figure in oils

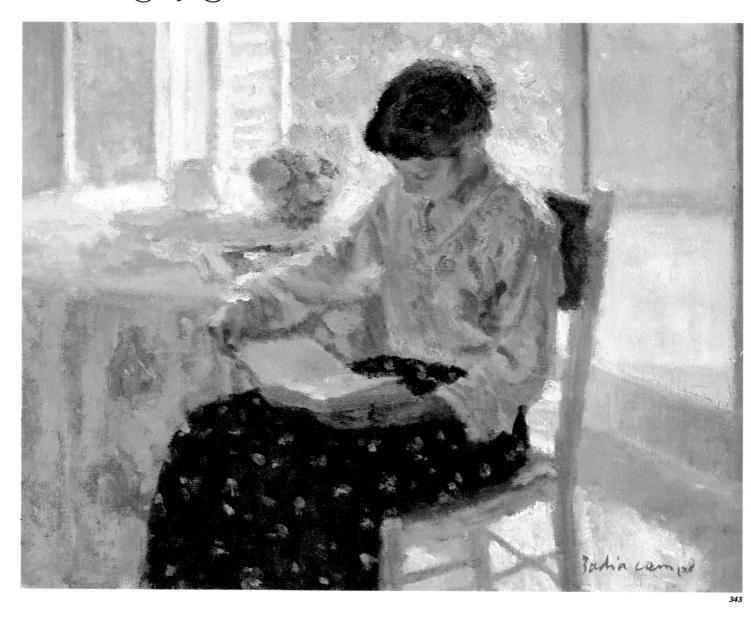

Badia Camps takes up to ten sessions to paint a picture. After the second or third session, when the layer of paint is thick enough, half dry, sticky, Badia Camps paints in his peculiar style, which he himself describes, saying, 'To paint in my way, I need a thick layer, a base, a bread of paint, on top of which I can apply the colours by scrubbing the brush, depositing the paint, rubbing, and leaving the colour on top of the previous colour, which is dry or half dry.'

Badia Camps applies the technique of 'frottage', similar to the manner used by Titian and Rembrandt.

Badia Camps takes ten, fifteen, and even more days to finish a picture. He is a perfectionist

and he is never satisfied. He has reached the extreme of rectifying and changing pictures only when they are hanging in one of his exhibitions. He is usually painting three or four pictures at the same time. Pictures 343 and 348 were painted at the same time.

Fig. 343 The finished picture shows that Camps has practised the technique of frottage, the same technique we talked about in connection with Titian and Rembrandt in the first section of the book.

As always, the artist first studies the model by drawing several sketches.

In figs. 344 and 345 the rectification is obvious. The first sketch shows the figure seated almost in profile, with the balcony door partially open. In the second study, the figure is seen in a three-quarter view and the balcony door is completely open. In the second sketch, moreover, the posture of the figure is clarified by the dark hole between the tablecloth and the model's right arm.

Badia Camps's perfectionism is reflected in these sketches, especially in fig. 345, a finished sketch worthy of being framed.

He is ready to paint. In this chart you can see the oil colours currently used by the artist.

Figs. 344 and 345 In these sketches, preludes to the picture reproduced in the following pages, Badia Camps studies and rectifies the pose of the model and the objects around her. In the right-hand sketch, he has made some changes: the nearest balcony door is open, allowing us to see the shutter in the middle distance and the light from outside.

Colours used by the artist Badia Camps

Titanium white Cadmium yellow Yellow ochre Raw sienna Burnt sienna Umber Cadmium red Crimson lake
Deep madder*
Emerald green
Cinnabar green
Light cobalt violet
Light cobalt blue
Prussian blue

* (Alizarin crimson madder)

Painting a figure in oils

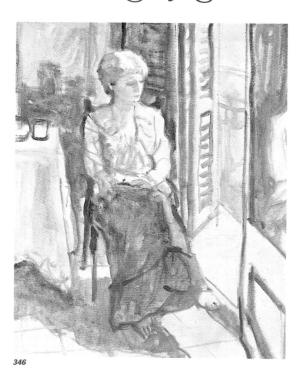

Fig. 346 With the same mixture of colours, diluted with plenty of turpentine, Camps paints with studied precision, using lines and halftones, as if this were a wash drawing.

Fig. 347 Note that in this phase of the painting when the artist is completing the first layers, the range of colours is tending towards warm. In the background there are greyish ochres and siennas, and in the tablecloth the influence of yellow and ochre is obvious.

First stage: construction

The same colour mixture is used as in the construction of the previous picture.

Observe a detail which I disregarded before. Here and there, Badia Camps constructs by drawing, determining the forms by means of lines, adjusting, enclosing, limiting forms and outlines.

Second stage: general harmonizing of colour

Here the lines and outlines disappear. 'I paint by volumes,' says Badia Camps. So, in this stage, we begin the 'base of painting'. Later, with frottage, the picture will assume the personal style of Badia Camps.

Here, too, begins his struggle to achieve a unity between the figure and the surroundings, so that the figure will not be an isolated element, out of context, with no relationship to the background. 'I don't paint figures, in which case I would paint a neutral background. I paint a theme in which a figure plays a part.' Hence the struggle to incorporate the figure into the intimate atmosphere of the room, for this also forms part of the picture. At this stage he also begins the struggle to balance and harmonize the colour. 'When I begin a picture, I often don't know exactly which range of colour I'm going to use. Sometimes, as in this case, I begin with a neutral

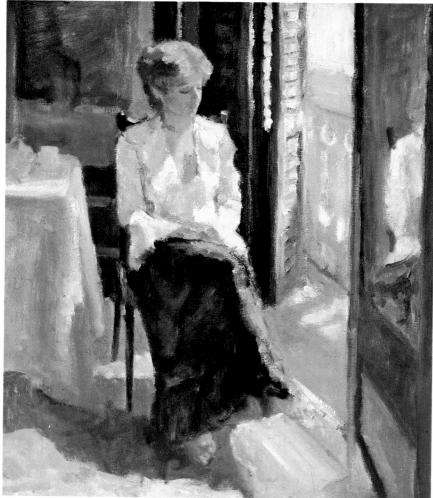

34

range of colour, rather warm (fig. 347) and later, as this picture advanced, I decide on a cold range (fig. 348). In these changes I am almost always influenced by the range of colour I have at that time on the palette. The remains of the colours on the palette always represent a source of inspiration for me.'

Fig. 348 The artist Badia Camps is now working on a thick, solid 'bed of paint', scrubbing with thick paint, just as it comes from the tube. Leaving the paint on the canvas, he applies the brush gently or energetically, painting with the frottage technique. Study the workmanship of this way of painting, in areas such as the head, the hair style, the blouse, the lights from the shutter in the background. Compare the general harmonization of the picture in relation to the previous stage (fig. 347), verifying that the colour tendency is bluer here, colder. We can also see that the contrast has increased, giving the figure greater emphasis.

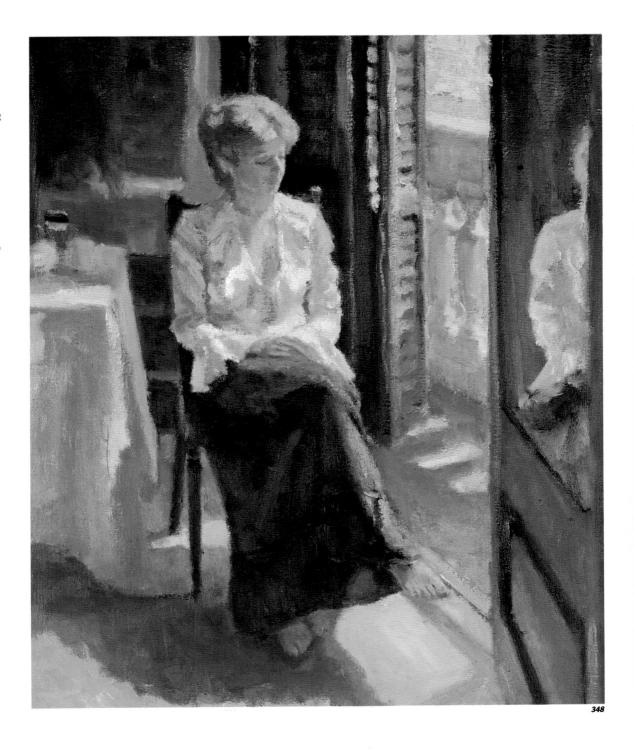

Between this penultimate stage (fig. 348) and the final picture (fig. 349) are few differences, but it's worth noting them. The picture in fig. 348 looks practically finished. The face, hands, and feet have not been modified. Yet most of the forms, light and shadow effects,

reflections, and penumbras have been painted or touched up again in the search for perfection and to give the final touch so dear to Badia Camps. 'Without going to extremes, of course. The great problem is leaving unfinished the finished.' Thank you Badia Camps.

Painting a figure in oils

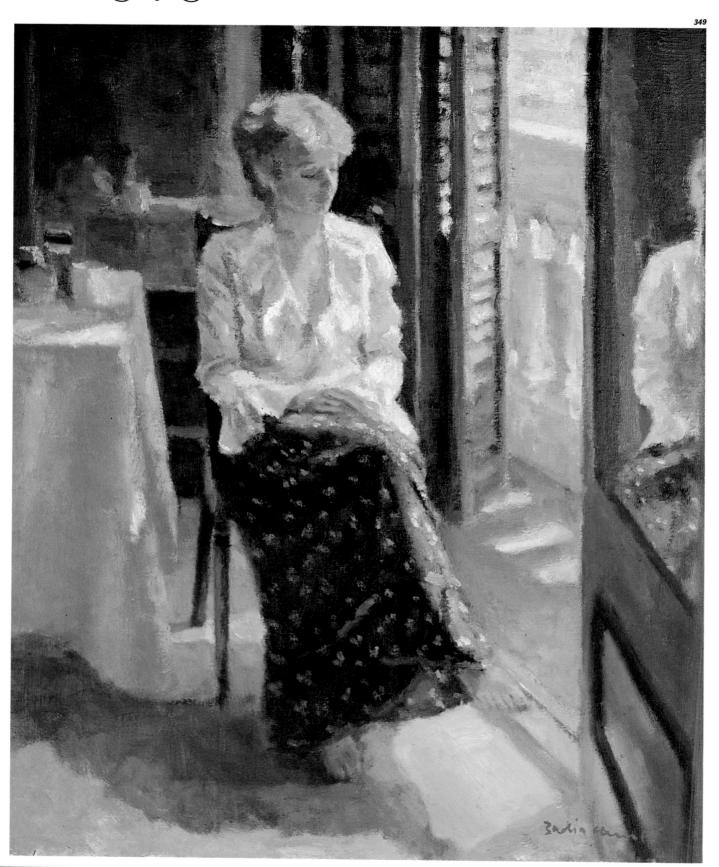

Painting an urban landscape in oils

Painting in the street, in the squares and avenues of the cities, in large and small towns. slums, industrial areas, in a word, painting urban landscapes, is a marvellous experience. It is a classical theme which appeared in the Renaissance. Since then, and especially since the middle of the last century, many artists have brought the cityscape to canvas with extraordinary success. Let us just recall a few of the Impressionist painters - Pissarro, Manet, Sisley, Monet, Guillaumin - who were all excellent painters of the urban landscape. Here is the picture: a street in an old quarter of Barcelona at eleven o'clock in the morning when the light of the sun first 'enters' the street. Note the classical form of street illumination, with one side in shadow and the other lit by the sun.

First stage

I am painting on a canvas size of figure stretcher number 12. To draw the first stage, I use a round number 10 hog's-hair brush. I prepare the colour for the initial drawing. On the palette I mix Prussian blue, raw umber, and ochre diluted with quite a lot of turpentine until I have a practically liquid, transparent paint, as if I were painting with watercolours. I draw the basic outlines of the houses, windows, doors, even some figures. Look at the initial sketch in fig. 350.

Second stage

Remembering Corot I begin by painting the shadows with rather thin paint, trying to get close to the tones of the model. This would be range of dark blues with Prussian blue prelominating, combined with deep madder, raw itenna and ochre. Different colours will be nore or less influential depending on the area of the painting I am working on (fig. 351). I paint without worrying and I don't mind misakes because later, as the picture advances, I can always come back and rectify them.

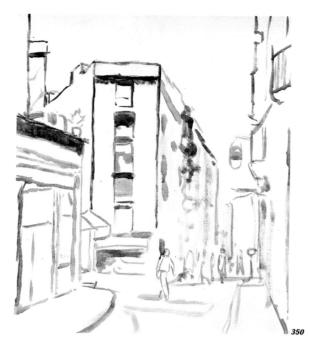

Fig. 350 First stage: underdrawing with Prussian blue and raw umber diluted with turpentine. This transparent, inky paint allows fast drawing as if painting in watercolour.

Fig. 351 'Where do you begin painting in your pictures, maestro?' Corot was asked. He answered. 'With the shadows.' Certainly the shadows create volume, define the subject, influence the composition, and create the contrast of the picture.

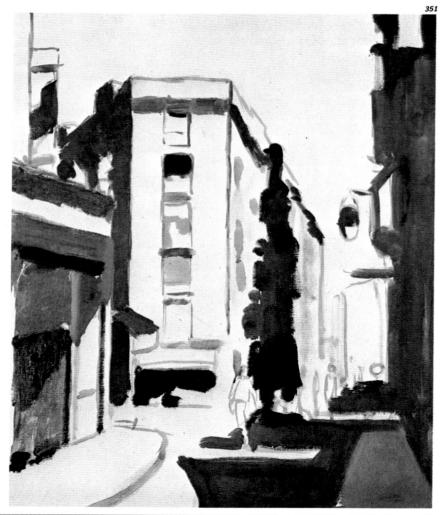

Painting an urban landscape in oils

Third stage

At this stage I am concerned with diversifying the colour of the main wall with ochres, yellows, crimsons, and siennas, almost always mixed with a little blue and white. In some cases I mix the colour right on the canvas, looking for variations which brighten and capture the reality of the prominent wall. Then I paint the side wall, the house in the background, the ground, and the awnings. Throughout, I try to enrich the shades and get nearer to the real colour and the definitive form. I have been working with flat hog's-hair brushes, numbers 14, 16 and 18.

Fourth stage

I paint the sky and the clouds, remembering two basic principles:

1. The sky is not only blue.

2. The sky is always brighter on the horizon line.

Either Prussian blue or ultramarine blue make up the basic colour of the sky, depending upon the area you are painting, the time of day, and whether the sky is clear or not. But, as well as the blues (reduced with white) that have been mentioned, we also need deep madder and sometimes raw sienna (a very small amount) to resolve the darkest and highest parts of the sky. And near the horizon, where the sky is clearer, there may be a little touch of vellow or cadmium red or emerald green, according to the time of day. The direction of the brushstrokes in the sky need not necessarily be horizontal. The best formula is to paint without any fixed direction, but 'with small strokes', as Pissarro did.

On the other hand, when the clouds are cumulus, as in this case, the brushstrokes must be enveloping, following, to a certain extent, the spherical forms of the model. Note that when merging the shadows and lights of the clouds it may be useful to use your fingers, without going to extremes.

I go on to paint the houses in shadow on the right side. I paint mostly with Prussian blue, dark ultramarine blue, ochre, deep madder, raw sienna, and emerald green.

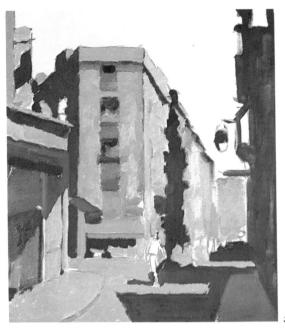

Fig. 352 First of all fill the canvas. Paint with colours that are as near as possible to the model's. Cover most of the space in order to neutralize the effect of false constracts.

Fig. 353 Once the canvas is 'full', I begin painting on top, constructing, adjusting forms and colors. Observe in this stage, the resolution of forms and colors in the outline of the houses in the shadow on the right-hand side. Good, isn't it? Note that these are really brushstrokes laid over a firm base of color painted in a previous session (fig. 352).

35*2*

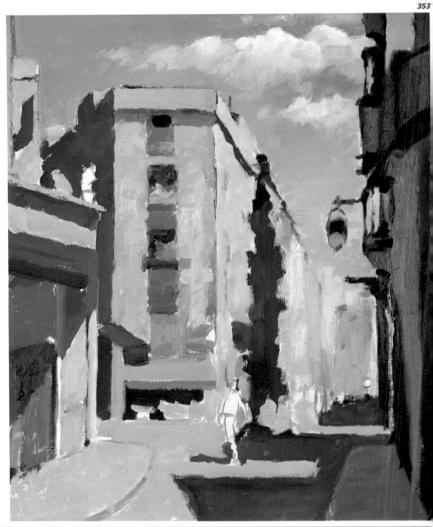

170 The Complete Book of Oil Painting

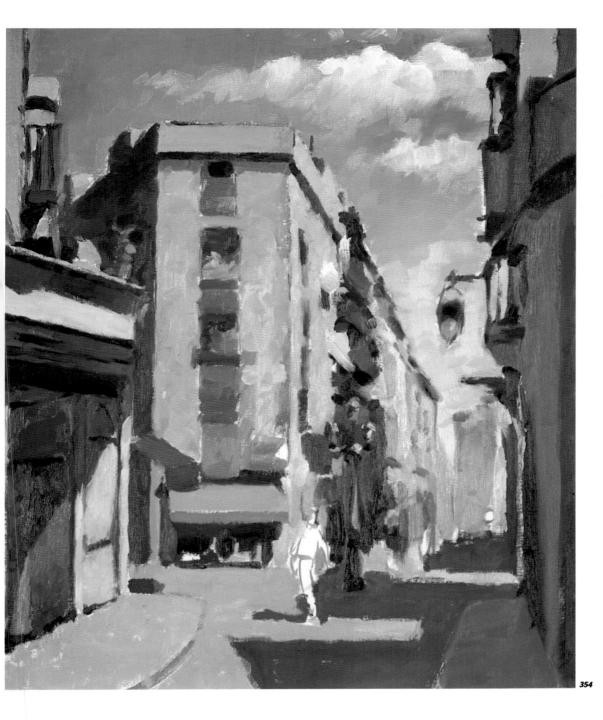

Fig. 354 This stage of the work called for more intense and expressive labour. In the first place, I painted the shop on the left drawing with colours. I then corrected the perspective of the street on the left side. You can see the change I made if you look carefully at fig. 353 and compare the line of the rooftops with fig. 354. Lastly, I squinted my eyes to look at the long shadow in the middle. I painted a group of blotches to represent windows, balconies, clothes hanging out, and a lamp post with four lamps.

Fifth stage

I go on to paint the shop on the left-hand side. The colour painted earlier was mixed with quite a lot of turpentine and is now dry, allowing me to paint on top. I paint the side of the house in the centre, which is covered by a shadow from top to bottom. Painting this projected shadow and everything that is mixed in with it is not easy. Here we have a

complexity of shapes caused by projections, balconies, clothes hanging out, and even the lamp post with four lamps in the middle of the street. I had to look at the model with eyes half closed, substituting the detailed vision for a series of blotches which synthesized the scene's complex forms. I also represented space through a lack of contrast and definition.

Painting an urban landscape in oils

Fig. 355 Not much was needed to finish the picture: the façade of the house in the centre, the payement in the left foreground, the outline of the houses in shadow on the righthand side, and the figures. I want to stress the fact that having constructed a basis of form and careful colour selection, it was relatively easy to resolve the painting. Look, for example, at the outline of the houses in shadow on the right-hand side of the picture. Observe the process followed from fig. 352, the third stage, up to this picture and the last stage. You will see that the first stage used a uniform stain of colour. On top of this initial base, a few simple brushstrokes of colour were added (fig. 353). Finally, in this last demonstration, a little more constructed - very little a few colours were painted very few - and the final effect was achieved. It is a problem of synthesis, which I ask you to analyse by observing the progress of this picture.

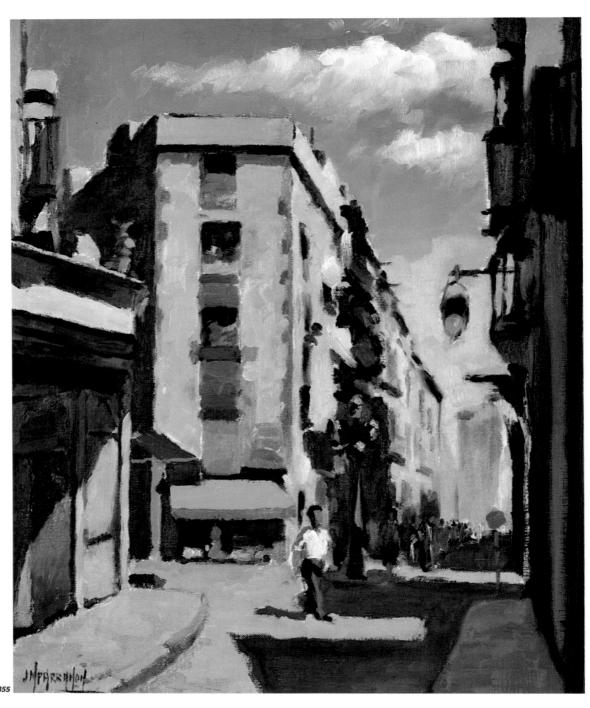

Last stage

Now I only have to complete the façade of the centre house, the ground, some forms of the house in shadow on the right, and the figure. These have to be constructed and painted from memory. I construct and paint these figures with care and attention, but without pretending to an excessively formal finish, because I believe that this would not be in keeping with the general feeling of the picture.

I have finished.

Keep the picture at home in the studio and go over what you've done a few hours later, in case you need to touch up something – which you always have to. Then sign it.

Painting a seascape in oils

Here we have another traditional theme painted by many artists all over the world, especially in countries such as Britain and Spain which border the sea and offer extensive thematic material, including everything from the fishing port of a small village on the coast with its boats, beacons, nets and buoys, to large city ports with ships, to beaches with figures, to sea coves with waves surging against the cliffs. This last, the cliff overhanging a beach on the Costa Brava in Cataluña, in the town of Lloret de Mar, is going to be the subject of this demonstration of how to paint a seascape in oils.

When I contemplated this picture for the first time, I immediately associated the form of the rocks with cubes, parallelograms, and pyramids. So, before beginning the picture it seemed essential to me to draw stones and rocks having the shapes of these geometrical forms. Fig. 356 is an example of these exercises

First stage

I begin with a quick schematic sketch of the complex cliffscape made up of numerous projections and groups of rocks. On the palette I have made up a blueish-grey colour using Prussian blue and a little raw umber. I dilute the paint with turpentine for a transparent wash which lets the brush move quickly and smoothly in uninterrupted lines (fig. 357).

As this initial scheme is being drawn, it may be interesting to sketch the basic shadows of the scene and to try to approach the basic colours with a blueish tendency in some cases, a sienna tendency in others.

I painted the linear parts with a round hog'shair number 8 brush and the shadowed parts with a flat number 12.

Second stage

In the second stage (fig. 358), I try to paint the basic colour of the sea and sky. I work with flat, number 16 and 18 hog's-hair brushes.

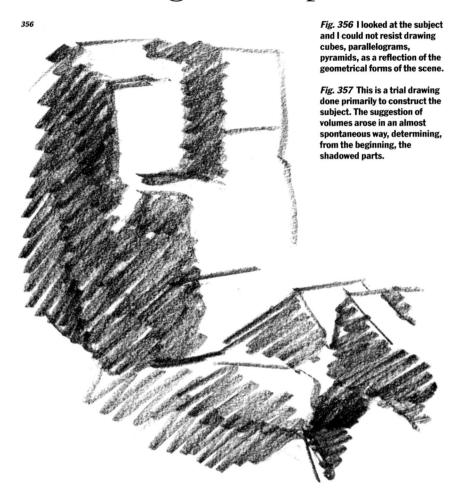

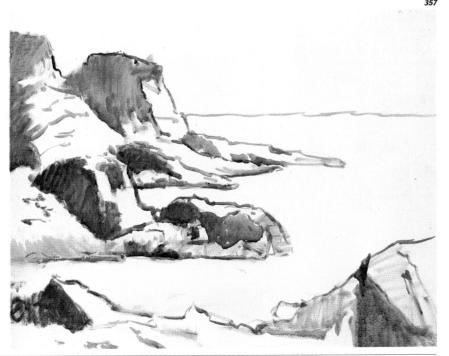

Painting a seascape in oils

In the sea there is Prussian blue, ultramarine blue, burnt umber, a little crimson, a drop of madder, and a little white. As a basic rule, the brushstrokes in the sea have to be horizontal, but in some areas, due to the currents caused by the channel over the rocks (foreground and left part of the finished picture), the waves come towards us diagonally. In these areas we may have to change the direction of the brushstrokes to suit this diagonal movement. Except in the darkest areas in the foreground of the sea, white always intervenes to brighten the blue. But use only a very small amount.

Third stage

This is a picture to be completed in several sessions with the technique of *painting by stages*. It is a laborious theme, which has to be executed with good, careful construction, and therefore demands to be painted and

359

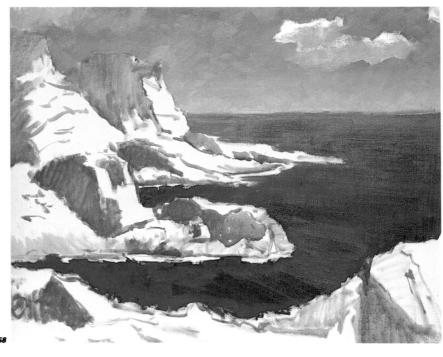

Figs. 358 and 359 These two stages of this seascape painted in oils graphically explain how and where to begin a picture. To cover up the white of the canvas as soon as possible would be the immediate priority. First, draw the basic lines of the picture and stain the shadowed parts which create volume (fig. 357). Next. 'cover' the sky and the sea (fig. 358) and paint the group of rocks - lights and shadows with paint diluted with a lot of turpentine. At this point the picture begins to live and approach reality. The thinned paint dries quickly and is ready for repainting: the beginning of the real picture (fig. 359).

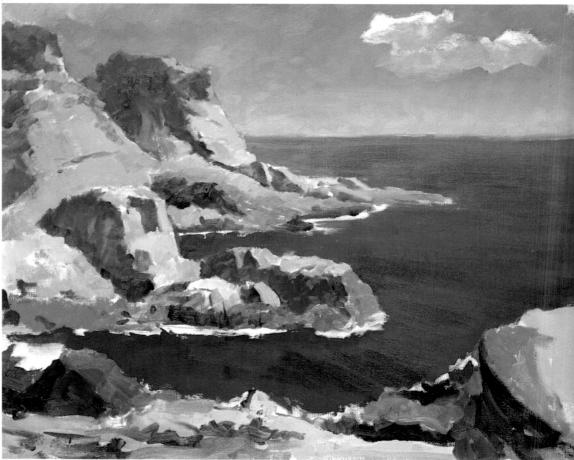

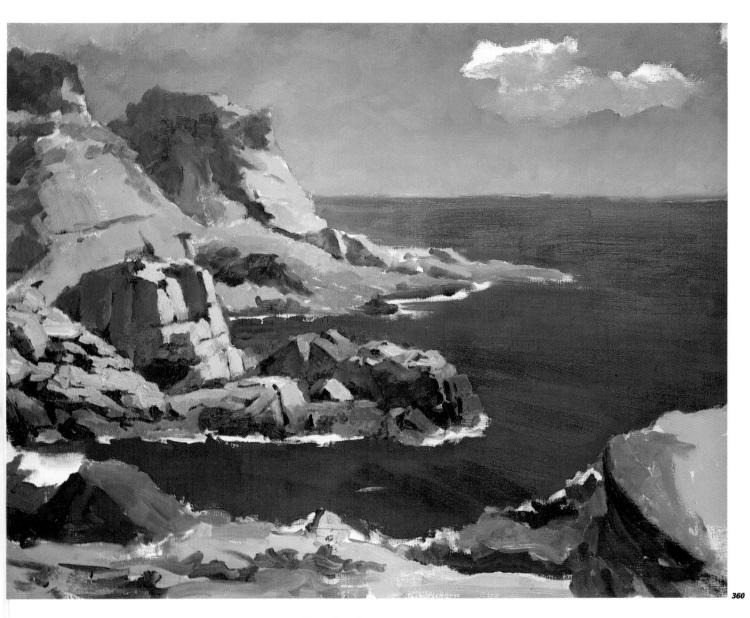

repainted in successive stages, to properly represent the volume, and draw the complicated forms of the rocks, waves, and foam on the water.

Therefore, to paint the illuminated parts of the stones and rocks, I still use paint thinned with turpentine (fig. 359), so that it will dry more quickly. Tomorrow I will be able to paint over it with greater security and cleanliness.

I paint the illuminated colours of the stones and rocks, trying to get as close as possible to the real colour of the subject (see fig. 362).

Fourth stage

Now it's time to definitely complete the drawing and paint the rocky forms situated in the middle distance. But, I remind myself, this could be a monotonous, grey theme, without much interest. To make it pleasant, alive and interesting, I need to interpret the colour carefully, trying to see the many colours in the illuminated and shadowed parts. And this is what I do in this session. I work unhurriedly, trying to see the tones which are always different, applying the colour with flat wide brushes, numbers 12 to 18 (fig. 360).

Fig. 360 What follows is a question of work well done, of looking at the scene and carefully copying forms and colours, while still trying to diversify and enrich the colour with contrasts and accents. I am always asking myself if I can improve them. Here I dedicated my efforts to the rocks in the middle distance.

Painting a seascape in oils

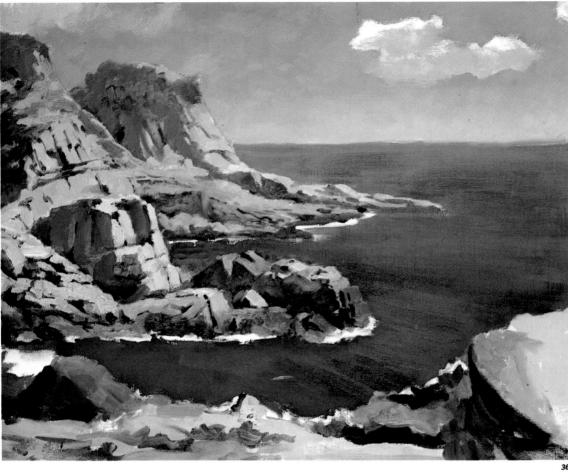

261

Fifth stage

I am working on the two hills in the background, using a technique of direct painting. I am painting with less brilliant colours than in the middle distance, greying and diffusing to create a feeling of space, distance, and atmosphere (fig. 361).

Sixth and last stage

At last I paint the sky and the sea. I brighten the colour of the sky on the left, thus managing to outline the silhouettes of the hills. On the right-hand side I paint some clouds in a luminous spring sky (fig. 362).

The colour of the sea is basically made up of Prussian blue, ultramarine blue, and white, but burnt umber, madder, yellow ochre and emerald green are also present in varying degrees. Yellow ochre and burnt umber, when mixed with Prussian blue or ultramarine blue and white, give a broken sea-blue. All together, these slightly different mixtures create the colour of the water.

The construction of the waves and foam as the water breaks against the rocks is found by observing the movement and play of the water, studying the forms and colours which are created for a few minutes, and then painting directly from memory, interpreting what you remember.

Lastly, in the foreground I have tried to create the maximum contrast of forms and colour, to bring the foreground nearer to the viewer.

Figs. 361 and 362 The process begun in the previous figure continues applied to the group of rocks and hillocks in the background. I want to make these objects greyer, to dissipate and diffuse outlines, paying close attention to the

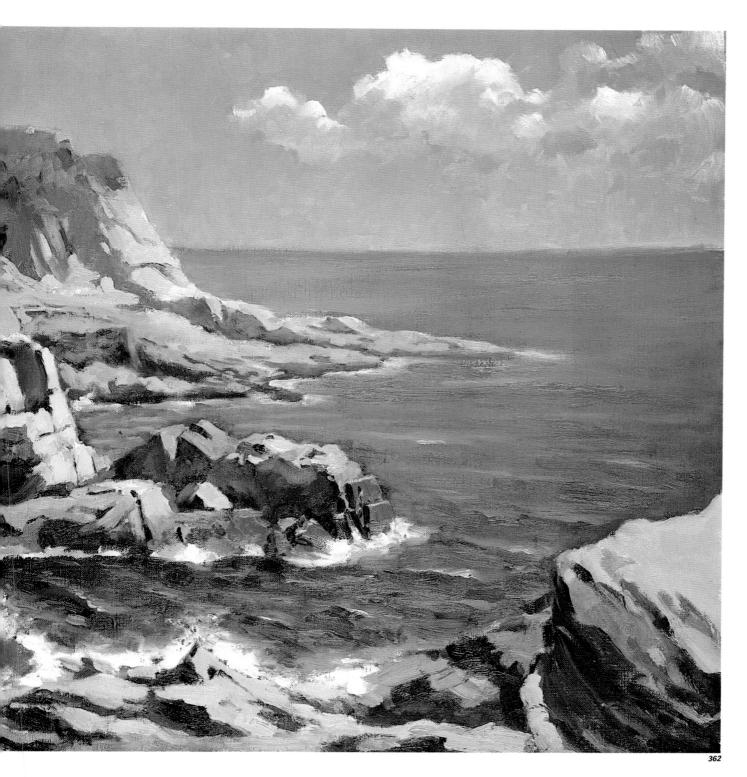

mospheric effects. In ainting the rocks in the reground, I struggle to chieve a maximum contrast of rm and colour. Then I work on e sky. Finally, I propose ainting the sea, the foam of waves as they break against

the rocks – an element of the picture which has to be painted from memory, following careful observation.

Painting a landscape in oils

It was five o'clock in the afternoon on a day in September when this lighting effect surprised me. I was at an altitude of almost a thousand metres halfway up the mountainside in Montseny, Cataluña. I decided to make a quick sketch with a 5B lead pencil (fig. 363). The result looked hopeful to me, so I went on to paint an oil sketch. I used a cardboard canvas number 1, figure size.

The early studies of a scene in sketches and colour notes form part of the normal work of an oil painter. This sketch or note gives the artist closer identification with the theme, as well as a trial picture for evaluating the artistic merits of the idea. Painting the same theme two, three times is good. Great artists, like Cézanne, in *Mount Saint Victoire*, Manet in his cathedrals, Picasso in his series on the artist and the model, did so. A note on colour made beforehand means painting the final picture with better understanding and greater enthusiasm.

It was like this in my case. I selected a canvas with a frame, number 30 landscape, and I began to paint.

First stage

With charcoal, I draw happily and vigorously, as can be seen in fig. 365. But still, I am calculating, constructing, evaluating light and shadow. I know that later, at the first painting session, I will erase and destroy all these details and tonal shades, but I know also that this study remains in the memory and influences the making of the picture.

Second stage

I begin to paint. I try to cover the canvas with a minimum of colours: the luminous green of the meadow, the dark green of the trees, the colour of the mountains in the background, the sky...

Note in fig. 366 that for the present I have not bothered to conserve some of the branches of the trees. Even the two trees on the right are now covered by the sky, but later I will paint them in on top of this light blue. This is a stage in which the picture is resolved in large masses, in a very primitive way, but with bases on which we can paint and repaint.

Figs. 363 and 364 It is always profitable to study a theme first by means of sketches and notes on colour. You have the chance to really study the frame, the form, the contrast, the colour.

364

Fig. 365 In a landscape like this where the form is as important as the colour and is heightened by the against-the-light effect, it seemed to me important to first draw with charcoal and study the values, foreground, and background.

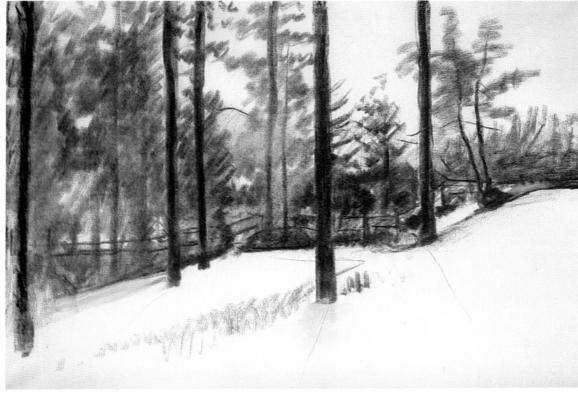

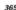

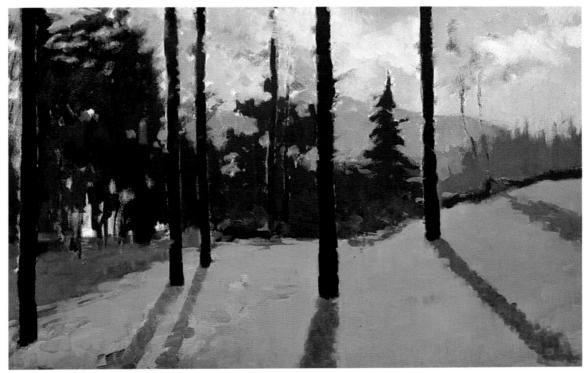

Fig. 366 Stain, stain! The first thing was to cover the canvas with a layer or base of colour on which to develop the picture.

366

Painting a landscape in oils

Figs. 367 and 368 Ingres gave his pupils some advice we should not forget. 'A good picture is the one which, at any moment, can be considered finished. When it's just a drawing, when one is beginning to paint, when it's half done. Don't stay stuck in one place in the picture, draw and paint everything at the same time, go over the canvas, make the whole picture progress at the same time, all of it at the same time.'

While I was painting this landscape I remembered and tried to follow Ingres's advice. I believe I was able to fulfil it thanks to the sketches I made before beginning to paint. On the basis of these, I became familiar with the theme. For me, it was easier to 'go over' the picture, reworking and refining.

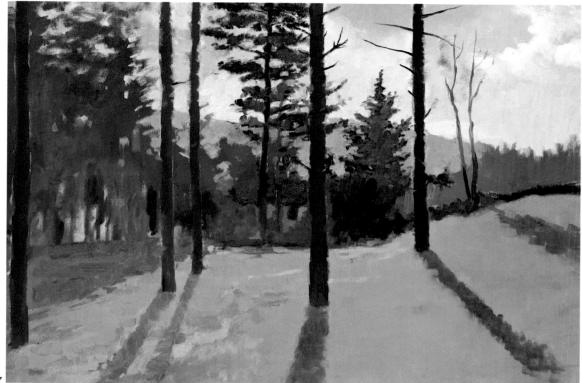

267

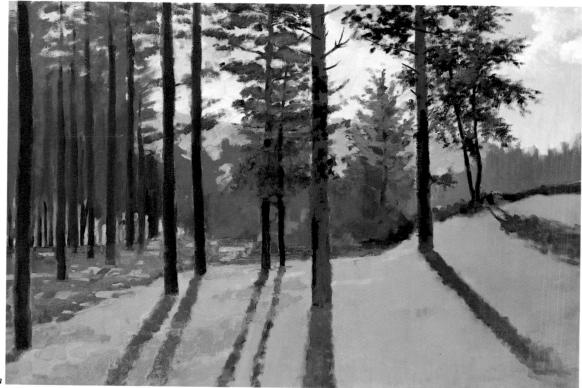

368

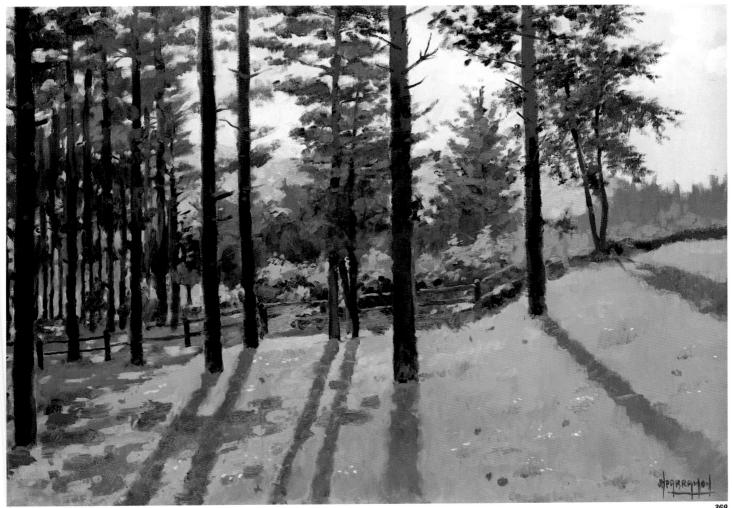

Third stage

I begin the third stage (fig. 367), adjusting the colour of the sky, brightening the area which borders on the horizon. I heighten the white of the clouds in the background, enriching the colour. I sketch the trunks of the two oaks in the right middle distance, and I paint the fir tree in the middle distance. I paint some small branches on the vertical trunks and then I go on to the Canadian pine in the centre. The construction of this pine compels me to repaint the small areas or 'holes' through which the colour of the sky appears.

Fourth stage (fig. 368)

I paint the two small oaks, a slow job. I am directed by what the subject 'says'. I continue with the burnt or dead tree, ochre-red in colour, just in front of the fir tree. I paint trunks in the little wood on the left, and I 'open' the lights in the earth and in the background.

Fifth and last stage (fig. 369)

It's now time to reconstruct, first the little wood on the left by painting and repainting tree trunks, 'opening' lights in the lower part, opening 'holes' in the foliage of the trees to represent the interstices through which we see the sky. I add colour to the dark foliage with a mixture of Prussian blue, raw sienna and ochre. Then I paint the lights of the grass and plants near the fence, in the middle of the picture. I paint the areas of earth in the green meadow, and the shadows caused by the trees on the left-hand side. Lastly, I paint over the green meadow, producing slight differences in colour and adding little white and red flowers.

Fig. 369 There are considerable differences between this picture and the previous one. The radial shadows of the tree trunks are somewhat brighter in colour. The colour of the earth in the foreground is more lively. The branches and leaves of the trees show some green shades, trying to illuminate and create volume. The whole area of the wood (left-hand side of the picture) has been reconstructed both in terms of colour and of form. Last of all, I have painted the grass again, diversifying the colour and adding little flowers. Forms and colours have been added that did not appear in previous stages. This has to be the final work on a picture.

Painting a still life in oils

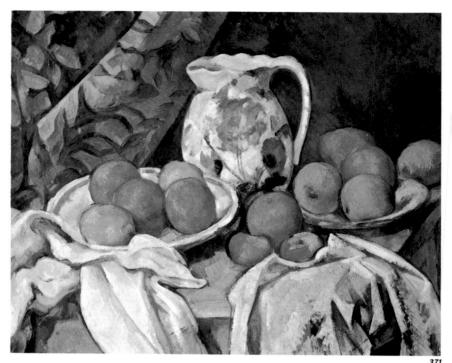

370

This last demonstration will also serve as a practical lesson; an exercise that I offer you and which I beg you to carry out as a summary of the teaching from this book. The still life, according to van Gogh in one of his letters to his brother Theo, is 'the best model for learning to paint'. The still life allows us to paint at home, without witnesses, with all the comforts and advantages that this offers. There are, moreover, previous histories, samples, hundreds of reproductions of still lifes painted by great masters, which can help you to select the subject, compose, determine the lighting.

For example, in fig. 370 we have a still life that I composed in the style of Cézanne, the great Impressionist master of still life. Note that, following Cézanne's example, I have arranged a plate of fruit, a vase, a tumbler, and some scattered fruit, over a table that is partly uncovered. This was Cézanne's favourite formula for his still lifes (fig. 371). Well – do it yourself! Try to find a vase like Cézanne's somewhere in your house, buy some fruit, put it all on a tablecloth... and paint!

Fig. 370 Photograph of the model.

Fig. 371 Cézanne, Still Life with Curtain, Hermitage Museum, St Petersburg.

Fig. 372 Begin with a drawing in charcoal, using only lines for the moment.

Initial construction

The size of the picture is a 25 figure canvas. Lay out the picture with charcoal. Make some small sketches with lead pencil, charcoal or chalk, studying the shapes and values.

Let me take a brief pause.

In the still life that you and I are painting, there is a flower, a rose. Flowers are a very appropriate theme for an oil painting. But there are people who think that painting flowers is difficult, both because they haven't a concrete form – I'm talking about roses, irises. gardenias, daisies, flowers that don't offer us a geometrical shape – and because they have to be painted when they are freshly cut, before they lose the beauty of the first day.

In the first place, we are going to clear up the idea that drawing a rose is more difficult than drawing a hand. Remember that the same lessons on 'countermould' and points of reference that we discussed in 'Form and volume' apply to drawing a rose. Painting a rose is no more difficult than painting an apple, as you can see in the examples in this box.

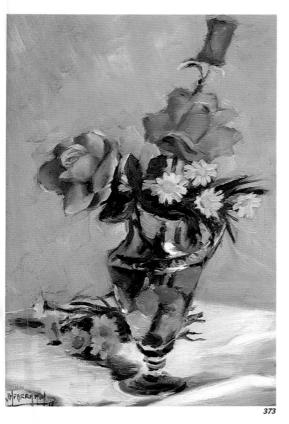

Fig. 373 J. M. Parramón, Glass Vase of Flowers, private collection. Flowers are an excellent subject, but they have to be painted in one day, in one or two sessions, before they change shape or wilt.

How to paint a flower

Fig. 374 First I advise you to draw the form of the flower as perfectly as possible. Starting

from this very accurate drawing, here is the process I followed to paint this example.

Fig. 375 First I painted the background, then the leaves a dark green, and lastly, using dark red with hardly any variations, I filled in the general form of the flower. This may seem contradictory because it covers and eliminates the initial drawing, but this initial drawing helps us to remember forms, which we can discover by painting and drawing at the same

Fig. 376 Notice that in this stage, painting with

bright colours on top of the dark red background, I have modelled the basic form of

Fig. 377 This is the final result. The same system was applied to the leaves. Observe the following important details: in this last phase I used the background colour again to outline and fade out shapes. On the flower, as well as alizarin crimson, madder, red and white, I used Prussian blue and burnt umber.

Painting a still life in oils

First stage: study of lights and shadows

After the short aside on how to paint a flower, we continue with the first stage of the still life (fig. 378), confirming the construction and, at the same time, studying the masses or blotches that determine the scheme of the picture. This drawing, done in charcoal directly on the canvas, must be fixed with a spray fixative.

Second stage

I begin to apply paint (fig. 379), trying to stain and cover the canvas, painting the background colours, the grey areas of the cloth, the dark sienna of the table. I am eager to eliminate the large white spaces and adjust the colours of the model.

Third stage

In fig. 380 we can see the state of the picture once the first colouring phase is completed and the entire canvas is lightly covered. We are in the middle of the development of the picture, but there are already some elements, such as the folds of the cloth, which can be considered definitive.

On the other hand, there are aspects of the picture, such as the bunch of grapes, which will go on evolving and changing until the end, requiring involved, laborious work, reconstructing and correcting.

Notice that up to this point I have painted one peach less and a different apple than will appear in the following stage.

Fourth stage

It seemed to me that I should add a peach to the background, and that I needed to change the apple in the foreground. In this fourth stage I make these changes (fig. 381).

All the fruit is practically completed in form and colour in this phase, except the bunch of grapes which still appears confused and badly constructed. In this, and in every case, we have to follow literally what the subject 'says'. It is not good to improvize or to paint from memory. A bunch of grapes is something complex which forces us to copy its forms and colours exactly.

Observe the basic colour of the tablecloth, grey, in this fourth stage. This overall grey is ready for me to paint in the lights and shadows expressing the wrinkles and the whiteness of the model.

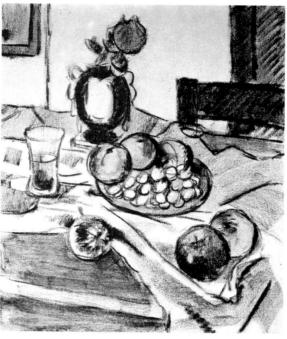

Fig. 378 I believe that making an initial contour drawing, as I did in fig. 372, and later finishing the drawing adding lights and shadows as I have done here, is very helpful.

Fig. 379 As always, my first preoccupation is to cover up the whiteness of the canvas and avoid optical effects caused by false contrasts.

37

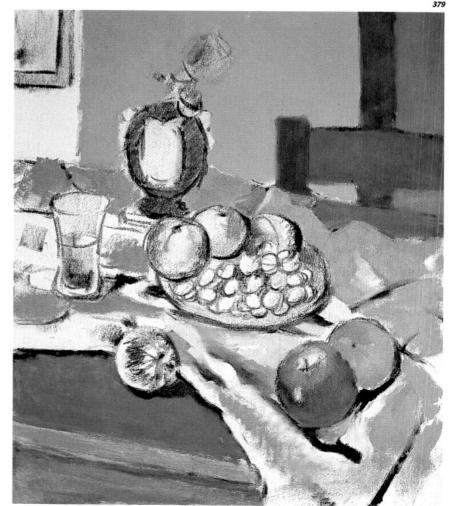

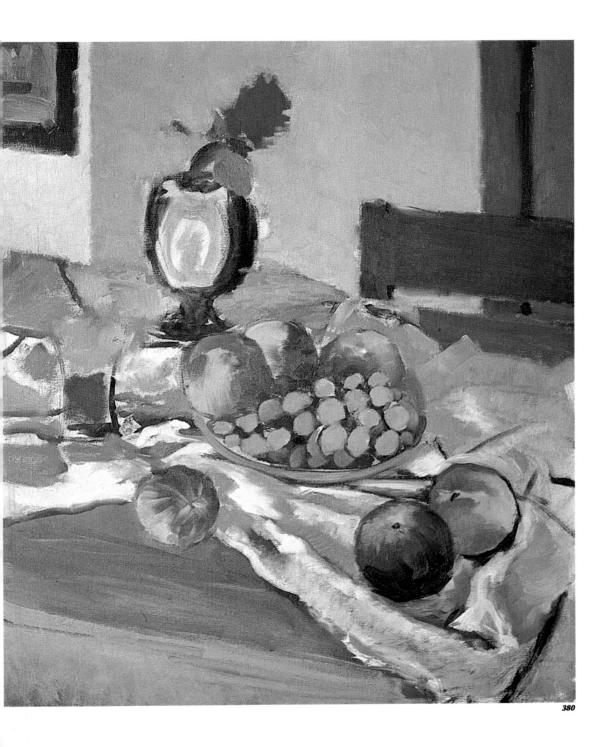

Fig. 380 First attempt at colour, with not much impasto yet; sticking to the drawing and the structure of the previous stage. The paint already covers the whole canvas. At this point, it seems obvious that we need to carry out some changes in composition. In the first place, the apple in the left foreground

is not very easily identifiable; it's small and its shape is not typical. In the second place, the three pieces of fruit on the plate, together with the grapes, are very similar in colour and form, they offer no variety. The arrangement of the grapes also sins by excess of unity. Lastly, in the background, near the

back of the chair, I miss something. I find the space empty. Well, all these defects can be corrected, as long as one does not paint like an automaton. One should think, analyse, contemplate, criticize, and change, if necessary.

Painting a still life in oils

Fig. 381 Here is the solution: a typical apple in the left foreground, three types of fruit in the dish, reconstruction of the grapes, and a peach added to the background near the back of the chair.

The picture here is one step from finished. There are some elements which can already be considered finished, like the three fruits in the dish and the peach in the background. The grapes will be reconstructed again, and the glass of wine, the vase, and the rose will be painted directly during the last session.

(*Note:* This phase of the picture was photographed when the paint was still wet, so there are reflections bouncing off the paint in the reproduction.)

Fig. 382 In this last stage the work was certainly laborious. I began by reconstructing and definitively painting the background, the bare table in the foreground, and the tablecloth. All of this was painted over earlier stages which served to aid and support my work in the later stages.

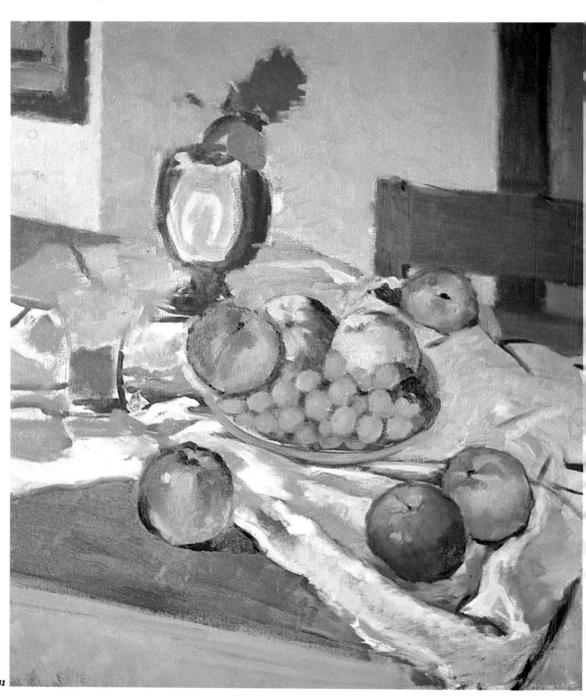

Fifth and last stage

I painted this picture (fig. 382) in four sessions of two hours each. Are you going to paint a still life during the next weekend? It would be the best lesson of all those I've tried to give you in this book.

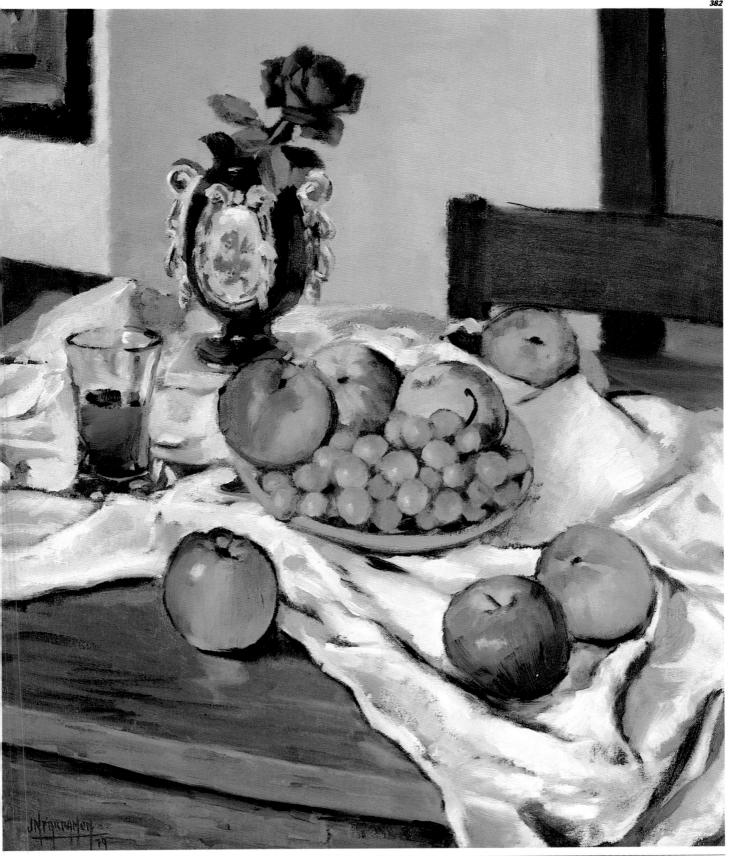

Glossary

A

Acrylic paint. Acrylic colours, basically made of synthetic resins, a product of modern technology, adopted for artistic painting from the sixties onwards. They are sold in tubes, as a fluid paste similar to oil colour. Acrylic colours offer a certain similarity to colours that are soluble in water (watercolours and tempera), with the peculiarity that the freshly applied, still damp, colour is soluble in water, but when it's dry it's practically indelible. Alla prima. Italian expression which can be translated by 'at the first try'. It's used to mean the technique of direct painting which completes the painting in a single session, without previous preparation or later stages. Asymmetry. Free and intuitive distribution of the elements of a picture, but still balancing some parts in respect to others.

В

resin used in varnishing. It comes from the resin of a tree from the conifer family. Base of the painting. Initial draft of the picture, painted with a relatively thick layer - half-impasto on a base of which Titian would begin the real picture. Binder. Liquid products such as drying oils, solvents, resins, balsams, waxes, etc., used to bind finely ground colours or pigments. Bite. State of a layer of paint when it is almost dry, slightly sticky, but lets you paint on top with thin impastos, while offering a certain

Balsam, Canada. Raw

resistance and softness which can condition and improve the workmanship of the picture. Bitumen Judea. Asphalt. A tarry compound, dark brown in colour, used in the 17th and 18th centuries for oil painting. It is shiny and has a warm attractive tone, but the fact that it never dries completely has been the cause of deterioration and imperfections in pictures painted when it was in use.

C

Canvas-covered cardboard. Cardboard for painting, covered and bound with canvas. Canvas-covered cardboard is available in the sizes indicated in the international stretcher table. up to number 8. Carbon pencil. For drawing with lines and softness, with similar characteristics to a lead pencil. It has several different names: 'Conté pencil', 'Paris pencil', 'Carbon pencil'. The lead is made of vegetable carbon as the basic material. It gives a finer, more fixed line than charcoal. Cardboard. Thick sheet made of wood pulp, usually grey in colour, used as a support for oil painting. Often the preparation for painting on a piece of cardboard is carried out just by scrubbing it with raw garlic. Cartoon. A drawing or plan for a mural painting or 'Cat's tongue.' Popular term used to describe the filbert brush, which is flat with a rounded end. Chalk. A cylindrical or square stick which colours by rubbing. It is made of powdered earths, ground

with oils, water, and other substances. Chalk is similar to pastel, but it is more stable and gives a harder line. There are chalks that are white, black, light sienna, dark sienna, cobalt blue, and ultramarine blue. Charcoal. Thin, carbonized branch of willow, hazel or rosemary, used for drawing primarily sketches. Chiaroscuro. Those parts or areas of the picture which, even though they are in shadow, however intense, allow the model to be seen. It can be defined as the art of painting light in shadows. Rembrandt was one of the great masters of chiaroscuro. Colour, local. This is the real colour of objects, found in the areas not modified by light, shade, or reflected colours. Colour, reflected. Colour bounces off one object onto another, particularly onto shiny surfaces. The colour

received on one object. reflected off another, is the reflected colour. Colour, tonal. This is a colour that varies to a greater or lesser extent from the local colour, generally influenced by the reflection from other colours. Complementary colours. Speaking in terms of *light* colours, complementary colours are secondary colours made from one primary plus white light. Example: when yellow – made up of the light colours green and red - is added to blue, white light is recomposed. In terms of pigment colours, a complementary colour is the contrasting or opposite of a given colour. For instance: the complement of the primary magenta (madder) is the secondary, green. Cotton canvas. Cloth designed to support oil paint as a substitute for linen canvas or cloth. In comparison with linen canvas, cotton canvas has a lighter colour, less compact weave, and is more economical. Some manufacturers dve the cotton cloth, imitating the colour of linen cloth. Cracked. Fractures or splits that appear in impastos and layers of oil paint when the old rule of painting 'fat over lean' has not been observed. (See 'Fat over lean'.)

D

Dammar. One of the resins most frequently used in making varnishes to be applied to oil paint. It comes from certain trees of the conifer family. It is soluble in benzol and in petrol. It dissolves well in alcohol and in turpentine. Dippers. Small containers, usually metal, for holding liquid solvents, turpentine, and linseed oil. The classic model consists of two small metal vessels with a spring or clip on the base that can be used to attach them to the edge of the palette. There are also individual dippers with just one container.

E

Emulsion. Liquid in the form of microscopic particles, suspended in other liquid without mixing. Example: the emulsion for tempera painting made of distilled water and egg yolk. The egg yolk keeps the oil and the watery, albuminous mixture of the yolk in a stable suspension.

Fat over lean. Oil paint is fat; diluted with turpentine it is *lean*. When, by mistake, lean is painted over fat, the lean layer dries more quickly than the fat, and when the latter is dry, the lean layer on top contracts and cracks. Fauvism. Term of French origin derived from the word fauve (wild beast). Applied for the first time by the critic Vauxcelles talking about an exhibition that took place in 1905 in the Autumn Salon in Paris. The Fauve movement was headed by Matisse and also included Derain, Vlaminck, Marquet, Vandongen, Dufy, and others.

Ferrule. In a brush for painting, the ferrule is the metallic part which holds the hair.

Filbert. Term used to distinguish flat brushes with a rounded point, common known by the name 'cat's

tongue'.

Frottage (scrubbing). Term derived from the French verb frotter (to rub), this is a painting technique that consists of lightly loading the brush with thick paint and scrubbing on top of an area that has already been painted and is dry or almost dry. It is generally used with light colours on top of dark colours.

Gesso. (See 'Spanish white'.) Glaze. Transparent layer of oil paint applied to an area of the picture with the aim of modifying a colour that has already been painted. Grev, optical. (1) The effect achieved by means of light glazes on top of a dark background. This can be

compared with a drawing done on a blackboard with plaster chalk rubbed with the fingers to promote a series of grey graduations, which later, when local colours are applied, goes on showing through, forming the classical 'optical grey'.

(2) The terms 'optical greys' and 'optical blacks' are also applied to mixtures of the three primary colours, yellow, magenta and cyan, which can be adjusted to form a final colour without hue. Similar optical colours may be obtained by mixing one primary with the appropriate secondary colour, which amounts to the same thing as mixing three primaries.

Grisaille. Painting carried out with white, black, and greys, imitating low-relief sculptures. It is often used in studies and sketches for sculptures. By extension, we talk of painting grisailles when there is an abundance of grevish shades in a picture or part of it.

Impasto. Thick, dense, covering layer of oil paint. The characteristic way of painting is to load the brush with paint and leave a considerable amount of it on the canvas.

Induction of complementary colours. Explained by the saying 'to modify a certain colour, simply change the background colour that surrounds it'.

Lead pencil. Term used to mean a common pencil made of cedar wood and a 'lead' of graphite and slate. Linen. Textile cloth used to make canvases for oil painting. It can be distinguished by its rigidity and somewhat dark ochregrey colour. It is considered to be the best cloth for oil painting. Linseed oil. Drying oil for oil painting, extracted from flax seeds. It is used with a mixture of turpentine to thin oil paint.

Mahl stick. Thin stick, about 70 or 80 cm long, topped by a small ball. Used as a rest for the hand holding the brush when painting small areas, so as not to touch the painting. Medium. Solvent for oil paint composed of a mixture of synthetic resins, drying varnishes and solvents that evaporate slowly or fast. For a traditional medium one can prepare oneself, we recommend a mixture of equal parts of linseed oil and rectified turpentine. Motif. This is the modern definition of the 'theme' introduced by the Impressionists, meaning a model without any apparent preparation, just as it appears in daily life. Mummy. An oil colour with similar characteristics to those of bitumen of Judea (q.v.).

Palette. Surface for arranging and mixing colours. Palettes are rectangular or oval-shaped, most commonly made of wood, although there are some made of plastic and of paper. The term palette is used, too, to refer to the colours used by a painter.

Panel. Term for the wood surface used as a support for oil painting, tempera, acrylics, etc. In earlier times it was common to use the wood of white poplar in Italy, of oak in Flanders, and of oak, beech, walnut, cedar or chestnut in Spain. At present the favourite is mahogany.

Pentimento. Term used when an important part of the picture is modified and reconstructed, signifying that the artist regrets what he has already painted. Velázquez's examples of pentimenti are well known, and have been discovered in modern times by infra-red

rays. Perspective. This is the science that graphically represents the effects of distance on size, form, and colour. Linear perspective represents the third dimension, or depth, by means of lines and forms; aerial perspective represents depth by means of colours, tones, and contrasts. Pigments. Pigments are the ingredients which provide the colour for painting. They are ground into a powder and mixed with a binding medium to make paint. They can be organic or inorganic. Poppy oil. This comes from the seeds of the opium poppy and is mainly used in the manufacture of oil colours. It is a suitable oil for painting glazes. Primary colours. Basic colours of the solar spectrum. Primary light colours are blue, green, and red; primary pigment colours are yellow, magenta, and cvan blue. Primer. Layer of plaster and

glue applied to the cloth,

as a preparation for oil

painting.

cardboard or wood surface

R

Resin. Gummy substance coming from certain plants, which hardens on contact with air. It is used to make varnishes in the manufacture of oil paints.

Sable hair. Sable-hair

brushes are used in oil

S

painting as auxiliaries to hog's-hair (bristle) brushes. A sable-hair brush is soft and offers less resilience to touch. It is suitable for retouching and painting thin lines, small forms, and details. Sacking. Cotton cloth or canvas with a very thick weave, used as a support for oil paint on certain occasions. Sacking takes broad workmanship, suitable for large murals painted in oils. Sanguine. Square stick of chalk of a reddish sepia colour with similar characteristics to pastels, but more compact and harder. Sanguine is suitable for drawing by rubbing, like carbon and pastel. It is also available in pencil form. Secondary colours. Colours of the spectrum made up of the mixture in pairs of the primary colours. The secondary light colours are cyan blue, magenta, and yellow. The secondary pigment colours are red. green, and blue. Sfumato. Italian term applied to Leonardo da Vinci's practice of blurring the outlines of the model. Siccative (dryer). Solution

added to oil colours to make them dry more quickly. It is not a good idea to add an excessive amount because it prejudices the conservation of the painting. Simultaneous contrast. Optical effect according to which a colour appears darker to the extent that the colour surrounding it is lighter, and vice versa. On the other hand, the juxtaposition of two different tones, of the same colour, promotes the exaltation of both tones, brightening the bright one and darkening the dark one. Soaked in. Part or area of a canvas where the layer of paint appears matt next to the shining parts or areas, either because the oil or varnish has been absorbed, or because of the action of turpentine. *Spanish white.* The common name given to the plaster made up of natural calcium carbonate, which is mixed with glue to size canvas that

name given to the plaster made up of natural calcium carbonate, which is mixed with glue to size canvas that is going to be painted on. Commonly sold as 'gesso'. Split colours. Also called 'broken colours'. Colours made of a mixture of two complementary colours in unequal proportions plus white

Squirrel hair. Squirrel-hair brushes are auxiliaries to hog's hair brushes for oil painting. Squirrel hair (of animal origin like sable) is softer and has slightly less resilience than sable hair. It fulfils the same purpose and is cheaper.

Stretcher. Wooden frame that can be taken apart on which to mount the cloth for painting.

Stretcher-carrier. A piece of equipment made of two strips of wood, each with two metallic angles and screws, which are mounted on two stretchers with

canvas to keep the surfaces of the two canvases separated, allowing a freshly painted canvas to be carried around without being stained or spoiled. Successive pictures. Rule established by the physicist Chevreul according to which 'the vision of any colour whatsoever creates, by sympathy, the appearance of the complementary colour'. Support. Any surface on which a pictorial work can be carried out. Examples: canvas, panels, paper, cardboard, walls, etc. Symmetry. This is related to artistic composition and is defined as 'the repetition of the elements of the picture on both sides of a central point or axis'.

Τ

Tacks. Small very sharp nails with wide, flat heads, used to attach the canvas to the wooden stretcher. Nowadays, this is often done with metal staples. Tempera. One of the oldest painting procedures, already used in the 12th century and widely described in the 14th and 15th by Cennino Cennini. It is characterized by the use of egg yolk as a solvent and binder for coloured earths. Tertiary colours. Series of six pigment colours obtained by mixing primary and secondary colours in pairs. The tertiary pigment colours are orange, scarlet, violet, ultramarine blue, emerald green, and light green. Turpentine. A volatile oil. free of fat, used as a solvent in oil painting. Mixed in equal parts with linseed oil, it supplies a classic medium. Used as a thinner on its own, it gives rise to a matt finish.

V

Value. The relationship between the different tones of one picture. To 'evaluate' is the same as comparing and resolving the effects of light and shadow in terms of different tones. Varnish for protection. The varnish applied to the picture to protect it, once it is finished and dry. Protective varnish is sold in bottles and in aerosol sprays and can be matt or glossy. Varnish for retouching. Used to retouch areas of the picture where the paint seems matt, unlike the rest which is glossy. These differences in shine also suppose differences in colour which are eliminated with the retouching varnish. Verdaccio. Oil colour used by the masters in the first phase or construction of the picture. Applied with solvent, verdaccio was a mixture of black, white, and ochre.

Walnut oil. This is a solvent or oil painting, coming rom the pressing of ripe valnuts. Very liquid, slow Irying, and suitable for painting styles that demand hin lines, outlines and letailed finishes. Wax colours. Basically made ip of pigments and colour bound with wax and fatty naterials, melted with heat it high temperatures, orming a homogeneous paste which, once it is dry, is isually in cylindrical form. They are stable colours; they colour by rubbing and cover ip to a certain point, illowing a light colour to be upplied on top of a dark colour and lightening it by nixing with it. Wedges. Small triangles of wood, about five millimetres hick, which are inserted in the four corners of a stretcher, in order to pull the canvas tight.

•.